Focal Book of Practical
Photography

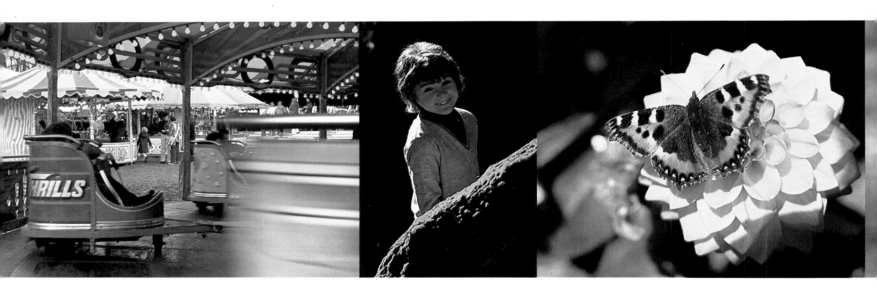

Focal Book of Practical
Photography

PAUL PETZOLD

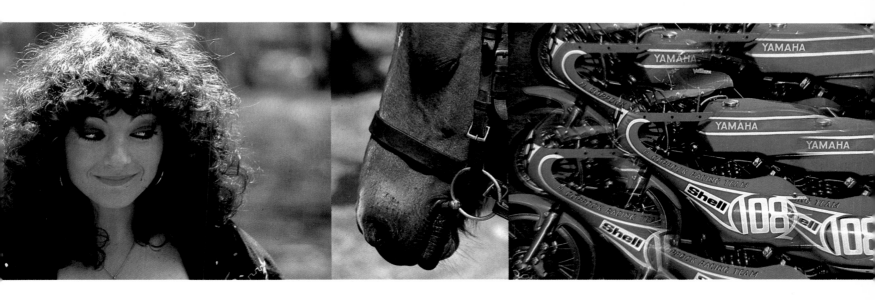

Focal Press/Pitman House

First published 1980 by Focal Press Limited, 31 Fitzroy Square, London W1P 6BH and
Pitman House Limited, 39 Parker Street, London WC2 5PB.

Associated companies
Focal Press Inc, New York
Pitman Publishing Pty Ltd, Melbourne
Pitman Publishing New Zealand Ltd, Wellington
Copp Clark Pitman, Toronto

ISBN 240 51065 8

Acknowledgements

All photos by Paul Petzold except for those on the following pages:
37 Raymond Lea; 47 (top) Ed Buziak; 48 Ed Buziak; 56 Ed Buziak; 57 Raymond Lea; 60 (bottom) Raymond Lea; 64
Ed Buziak; 65 (bottom) Ed Buziak; 66 Ed Buziak; 67 (bottom) Ed Buziak; 68 Raymond Lea; 70 Raymond Lea; 72
Raymond Lea; 74 (right) Wolfgang Strunz; 76 Otto Verrant; 77 Colin Ramsay; 82 Ed Buziak; 84 H Krobl; 85 Ed
Buziak; 86 Colin Ramsay; 87 Colin Ramsay; 88 (left top and bottom) Ed Buziak; 89 Ed Buziak; 90 Ed Buziak; 99 Ed
Buziak; 100 Ed Buziak; 102 Ed Buziak; 104 (left) Michael Barrington-Martin; 106 (top) Ed Buziak; 106 (bottom right)
Raymond Lea; 108 Raymond Lea; 109 (left) Raymond Lea; 109 (right) Ed Buziak.

Designed by Fred Price
Illustrations by Drury Lane Studios
Typeset by Inforum Ltd, Portsmouth, England
Printed and bound by New Interlitho SpA, Milan, Italy

Contents

The mechanics of basic photography

So you want a camera?

Some people love choosing a new camera. Most people don't. In fact, they wouldn't have anything to do with the problem if they could avoid it. But they need something to take pictures with – and that means buying or borrowing a camera of one kind or another.

Cameras are confusing. There are so many types, and they all seem to behave in a different way. But they are more alike than they look. Like new friends, once you have made the choice you can get to know each other better. Sooner or later you feel so happy together that you wouldn't want to change your friend or your camera for anything. But how do you make the choice?

Snapshot cameras

There is no point in buying or borrowing a camera that is too complicated for the job it has to do. The fact is, a simple camera can take most subjects, and in ideal conditions any camera, if used properly, can always produce excellent results. On a bright day you should have no difficulties. If it is raining, you may. But how often do you want to take a picture in the rain? If you and your subject can stand still for long enough to take the picture, a simple camera will do it well. If you want to take a picture of someone riding past on a motor-cycle, the simple camera will let you down. If you want to take pictures in dull weather, or of subjects on the move, you need a more complicated camera and, in some cases, possibly a few extras like a filter or a tripod.

Simple cameras: **A** Camera taking 35 mm film. It has a direct-vision viewfinder; a lever winds on the film. **B** Pocket camera taking 110 drop-in film cartridge. **C** Instant-picture camera (shown open) that produces a print one minute after taking the picture. Folding-type cameras may be closed for carrying about.

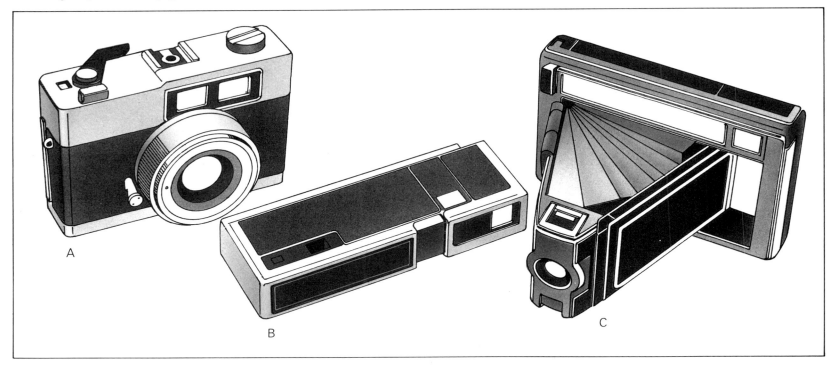

A

B

C

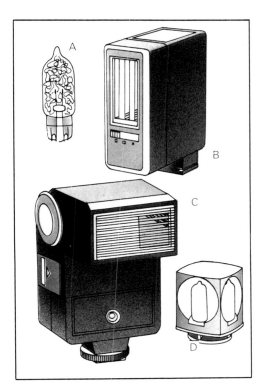

Add-on flash: **A** Flashbulb. **B** and **C** Electronic units. **D** Flashcube.

Simple cameras take various forms according to the size of film they use. The smallest popular cameras are the pocket 110 type, which literally slip into the pocket or handbag. They take 110 size film in easy-to-load drop-in cartridges. A larger type of simple camera takes drop-in 126 size cartridges; such cameras are too large for the pocket.

Some simple cameras take 35 mm film in cassettes. Though a little less easy to load, these cameras may offer some features not found on typical 110 and 126 cameras. You may need to make a few adjustments to take a picture, but the more complicated models sometimes do all this automatically, so they are just as easy to use as the simplest snapshot cameras — but give better results.

Some very old snapshot 'box' or 'folding' cameras use roll film. Most of these cameras are rather big by today's standards, and not so convenient to carry about.

Instant cameras

You may be in a great hurry for your picture. You may want to give a person a print before they leave, rather than send it to them weeks later when you have had the processing done. For this, there are instant cameras that process the picture themselves and give you a print a minute after taking the picture. If the person was po-faced when they ought to have been smiling, you know immediately and you just take another one.

As with ordinary cameras there are simple instant models and more complicated ones. All, however, are much larger than other kinds of camera. The simpler instant cameras are as easy to use as the ordinary type and their advantages are obvious; once home, you can't go back on holiday if the pictures didn't come out. If you were at a wedding, you can't ask the couple to get married again!

But with instant photography there are one or two snags. It is more expensive than ordinary picture-taking, and you only get one print per picture you take, so every picture is unique. You can have it copied, but then that takes as long to do as your ordinary pictures. The easiest way round this is to take several pictures (or as many as you need), one after another. They will probably all be slightly different, especially if they are pictures of people.

Flash

To take pictures indoors you may need to provide the light yourself — usually flash. Like a momentary burst of sunshine, it gives the camera the light it wants just while the picture is being taken.

Nearly all simple cameras can work with flash. Sometimes you need to add it on; often the flash facility is already built into the camera. Provided you use it as you should and don't ask it to do impossible things, you will not be disappointed by the results.

Built-in flash: Electronic flash units built into 35 mm and 110 pocket cameras. Powered by a battery contained in the camera, they are fired by the shutter and synchronise with it.

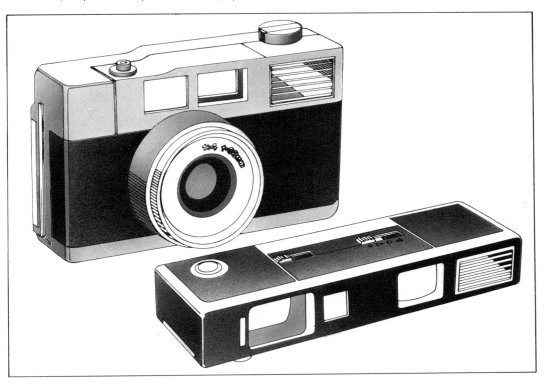

The camera's arms and legs

The body of a camera is rigid, light-tight, and made of metal or plastic or a combination of these. Do not despise the plastic camera. It is usually a special plastic which is exceptionally tough and able to withstand quite rough treatment. Because it is light in weight it is more likely to survive being dropped; it won't dent or distort. The *body* may take various shapes according to the type of camera – as seen on pages 6-7. These are simple cameras. If yours is more complicated, look it up on page 34 where it is described in detail.

All cameras work in roughly the same way, and so their basic features are more or less similar. If you want to know *how* the camera works, turn to page 32 and you can find out. Here we are concerned only with what does what, and how you use it.

The *lens* on most simple cameras is permanently fixed to the camera and on pocket cameras is usually inside the body. The lens must be kept clean and undamaged. With fingerprints or dust on the lens, the pictures will suffer. The lens should be protected with a *cap* or the cover built into some cameras. Some people have a clear filter over the lens all the time to protect it. This, too, must be kept clean. But if damaged it is much cheaper and easier to replace than the lens itself.

The *viewfinder,* through which you look at the subject and frame the picture, may be simply a tunnel through the camera with a plain glass window at either end. Or the finder may be the optical type showing a reduced image of the subject, perhaps incorporating a bright rectangular line to show the actual area of the picture.

For *loading,* a door in the camera body opens to give access to the *film chamber.* Most simple cameras accept film in a (110 or 126) *cartridge* or special (35 mm) *cassette,* which is placed inside. The loading door when closed is secured with a lock. To *wind the film* on for each exposure there is a lever, knob or slide. Some cameras advance the film by a push-pull movement of the whole camera body. A *frame counter* shows how many pictures have been taken, or this may be seen through a window in the back of the camera. A *double exposure prevention device* inside the camera prevents you from taking two pictures on top of one another. The camera refuses to

work until you have wound the film on. And usually it won't let you wind on again until you have taken a picture. So you can't make either error.

To take a picture you press the *shutter-release.*

After the last picture has been taken – and before the camera is opened – the film is either *wound off* with the film winder if it is a cartridge-loading camera or, if it is a 35 mm camera, it is rewound into the cassette, using the *film rewind* crank or knob, having first pressed the film *transport lock* or *rewind button,* which disengages the film winder and releases the film so that it can move freely back into its cassette. There may be a *film reminder* disc that you set when you load the camera, in case you forget what type of film you put in it, or you set this on the *film speed dial* (see below) or *ring.*

Flash

Almost all cameras have some means to allow you to use flash which is triggered by the camera as you take the picture. There may be a *flash cube* or *Magicube* socket to allow you to use one or other of these two different types of non-reusable bulb flash, perhaps with an extender arm. Or the flash socket may be designed for a *flash bar,* another arrangement of several non-reusable flash bulbs in a sealed pack.

The camera may have a *'hot' (accessory) shoe* contact on top of the camera by which it can connect with any separate flash unit that has a corresponding shoe contact. Or it may have a *flash sync (PC) socket* connecting with a separate flash unit via a short cable.

A more expensive version of the simple camera may have its own battery-operated *built-in flash,* which need only be switched on before a flash picture is taken.

Many simple cameras have a *fixed focus* lens set so that everything from a few feet in front of the camera to the far distance (infinity, marked by the symbol ∞) will appear sharp on the film. A few of these cameras have a built-in close-up lens which clips over the lens and allows you to take sharp pictures of subjects that are quite nearby.

But these arrangements are a compromise

because a lens cannot focus very well at all distances. So, many fairly simple cameras have a *focusing lens,* to make sure that the subject is as sharp as it can be. The distance of the subject is perhaps set by a symbol such as a face (close up), a full-length person (mid-range), or a mountain (distance). Or distance settings in feet or metres are marked and you rotate a *focusing ring* on the lens barrel to the actual distance you estimate for the subject. In a *rangefinder camera* a light patch in the viewfinder gives two images of the subject which merge into one as you turn the lens to the correct focus setting for the subject distance. With this device it is very nearly impossible to have your pictures wrongly focused. Some cameras have an *automatic focusing* device which automatically sets the lens to the correct distance. Complicated in its internal mechanism, such a feature makes the camera quite expensive. It is, usually found on the highly automated types of 'simple' camera that are, in fact, quite complicated but made straightforward to use by skilful harnessing of technology. These cameras are for people who are prepared to pay for a good quality, versatile camera, but do not want to bother with the mechanics of taking a picture.

Exposure control

To take account of difficult light conditions, some simple cameras provide for *exposure control.* What this really means and how it works is explained later. The controls, however, may be a symbol denoting settings such as 'bright', 'hazy', 'dull', 'flash'. Or there may be a choice of *apertures* in a sequence such as 2·8, 4, 5·6, 8, 11, and so on. These are worked in conjunction with *shutter speeds* set on a separate dial and probably running in the sequence 15, 30, 60, 125, 250. Together, they control the light reaching the film (see p.32). The whole process of judging how much light there actually is and how much exposure should be given to the film, may be taken care of by an *exposure meter.* This 'reads' the light and tells you what settings to make. On *automatic exposure* cameras it makes the settings itself as you take the picture, and it may, or may not, depending on the camera model, tell you what those were.

The exposure meter, however, must be told something about the film you have loaded in the camera. In some cameras it gets this information automatically as the cartridge is

specially keyed to inform the exposure mechanism in the camera. On many cameras you have to set the *film speed dial* or *ring* with the speed or sensitivity of the film, which is marked on the film pack or carton as an *ASA* or *DIN* figure (such as 64 ASA). The exposure meter may run off batteries held in a *battery compartment*.

These then are the two main features found on various types of simple camera. Additional facilities may include a *self timer*, a delayed action device that fires the shutter after a delay of several seconds, giving you enough time to appear in the picture yourself. Sometimes the release button has a small threaded socket designed to accept a cable-release accessory, a plunger-type shutter release on the end of a flexible cord, for use in certain cases where you don't want to touch the camera while taking a picture.

Many cameras have a ¼ in. or a 'continental' threaded socket on the underside by which to secure the camera to a *tripod*. There is also a lug for attaching a wrist strap or two lugs to accept a neck strap so that you can carry the camera, with or without its case, around the neck or from the shoulder. Most cameras are sold with a case and although this protects the camera, it can also be a nuisance – people use one, or not, according to temperament.

Typical camera (*right*) taking 35 mm film. It has a direct vision or 'optical' viewfinder often incorporating a coincident image rangefinder coupled to the focusing control ring. As the film is wound on after each picture, the shutter is tensioned ready for the next exposure and the counter indicates the number of pictures taken or remaining. The built-in battery powered exposure meter, when set for the ASA speed of the film loaded, may automatically set the aperture or shutter speed (or both) or it can be used for exposure readings taken and set by hand. The self-timer delays the action of the shutter for 8–15 secs. The camera accepts a flashgun fitted to the accessory shoe which is synchronised directly or indirectly with the shutter. The loading door (camera back) is opened by a catch at the side or by pulling up the rewind crank. Film from the cassette in the film chamber feeds across the drive sprockets and on to the take-up spool. In the viewfinder a bright line shows the area of subject included in the picture, with framing limit for close-range pictures. The rangefinder is in the centre, and signals for manual exposure and flash operation are included. The exposure meter readout indicates the aperture in use and warns of over- or under-exposure.

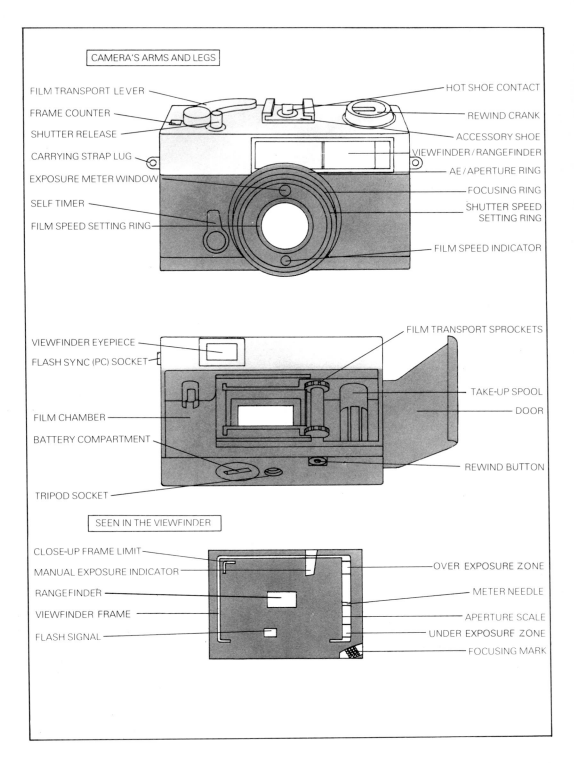

CAMERA'S ARMS AND LEGS

FILM TRANSPORT LEVER
FRAME COUNTER
SHUTTER RELEASE
CARRYING STRAP LUG
EXPOSURE METER WINDOW
SELF TIMER
FILM SPEED SETTING RING

HOT SHOE CONTACT
REWIND CRANK
ACCESSORY SHOE
VIEWFINDER / RANGEFINDER
AE / APERTURE RING
FOCUSING RING
SHUTTER SPEED SETTING RING
FILM SPEED INDICATOR

VIEWFINDER EYEPIECE
FLASH SYNC (PC) SOCKET
FILM CHAMBER
BATTERY COMPARTMENT
TRIPOD SOCKET

FILM TRANSPORT SPROCKETS
TAKE-UP SPOOL
DOOR
REWIND BUTTON

SEEN IN THE VIEWFINDER

CLOSE-UP FRAME LIMIT
MANUAL EXPOSURE INDICATOR
RANGEFINDER
VIEWFINDER FRAME
FLASH SIGNAL

OVER EXPOSURE ZONE
METER NEEDLE
APERTURE SCALE
UNDER EXPOSURE ZONE
FOCUSING MARK

Which film shall I buy?

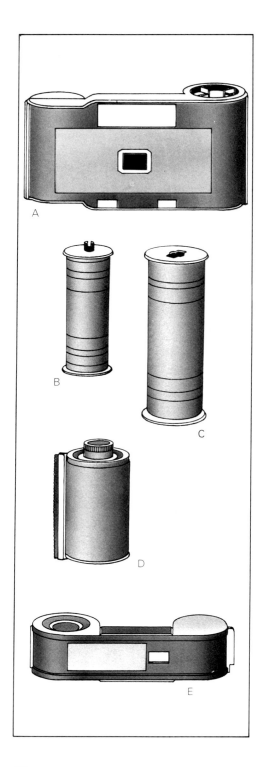

You must be sure to buy the right size of film for your camera. The simple pocket type usually accepts size 110 cartridges that you just drop in. The larger cartridge-loading cameras use the 126 type which load in the same way. Most other cameras use 35 mm film, normally supplied in metal cassettes. There are also cameras that take the larger 120 (or, more rarely, 620) roll film size and some older cameras designed for 127 roll film.

Pocket-size 110 films. With this, the smallest film size in popular use, the actual pictures on the film measure only 13 × 17 mm. So, although the camera is very compact and convenient to handle and carry around, the pictures themselves must be enlarged considerably even to reach the size of print that would go in a photo album. The quality of prints should be adequate for this purpose, but enlargements of greater size tend to look 'grainy' or unsharp. If you intend to make prints larger than en-print or postcard size from time to time, then you should use a camera that takes pictures on the larger 126 or 35 mm size film. The films used in 110 cameras are the popular medium speed (around 100 ASA) materials (see below). But high speed, 400 ASA, film is accepted by some models to allow a faster shutter speed for steadier hand-held pictures (rather than for picture-taking in low light or very dull weather, for which this film is often used in other cameras). Besides the normal colour films, a black and white negative (print film) material is available in 110 size. This general purpose film is intended for all-round use where the exposures might be marginally incorrect, and not for special high quality 'fine-grain' processing and the making of large prints.

126 cartridge films. These film cartridges are loaded with a film that gives a square image area of 28 × 28 mm. A negative of this size can produce a much better quality of print than that from 110 film. The cameras are, of course, much larger and hardly pocketable. Colour slide films are available in 126 size cartridges and the screen images from this are bright and clear. Slides are held in a standard 50 mm (2 in.) square mount.

35 mm. The film size used by the majority of creative photographers, this offers the widest choice of film types for colour and black and white picture-taking. The metal cassette contains a strip of double-perforated film along which most cameras expose a series of rectangular (full) frames measuring 24 × 36 mm (1 × 1½ in.). So-called 'half-frame' cameras expose an image of, nominally, 24 × 18 mm. The 35 mm full frame negative can give excellent quality for print sizes up to 20 × 35 cm (9½ × 12 in.) provided that most of the image area is used.

Slides made from 35 mm film are easily the most commonly used, so this format is the natural choice for someone intending to do much photography for slide presentation. The film is cut and inserted into standard 50 mm (2 in.) square mounts. Half frame slides, fitted into similar mounts with a special aperture cut to the smaller dimensions, may be shown on the same projector (as may those from 126 film).

Cassettes are loaded with standard lengths of film allowing 12, 20, 24 or 36 exposures, the most common being 20 and 36. (The smaller pictures taken by half frame cameras allow twice as many exposures for each of these loadings.) The film has no backing paper and each exposure is counted off by a dial on the camera body.

120 film. A spooled film wound with a numbered backing paper, and the largest film in amateur use. Cameras using 120 film take either twelve square images measuring, nominally, 6 × 6 cm (2¼ × 2¼ in.), eight rectangular 6 × 7 or 6 × 9 cm pictures, or sixteen 6 × 4·5 cm exposures. There is a wide choice of film types although a few may only be obtained by special order.

For the obsolescent roll film sizes, 620 (as 120, but different spool), 127 and 828, only a few popular general purpose snapshot films are available.

The quality of prints made from roll films is excellent and the negative is large enough for good prints to be made, even by enlarging from only a section of the available image area. When roll film slides (especially 120 size) are

projected, they give brilliant screen images of the greatest clarity.

Prints and slides

You may have already decided whether you want your pictures as prints or slides. If not, consider the following points:

Colour print film (colour negative) is available in all film formats. The image quality obtained in the print greatly improves in sharpness and smoothness the larger the original negative, but this does not affect the accuracy of the colours reproduced. Special advantages of colour print film are: (1) the film is tolerant of slight exposure errors, yet still gives an acceptable result and (2) it can be used under lighting conditions that are not quite ideal because the colour rendering can, if necessary, be adjusted in making a print.

Colour slides (transparencies) are most conveniently made in the 35 mm format, although the other sizes used by simple cameras do provide for this type of presentation. The image quality does improve with larger film sizes but the difference is not as noticeable as with prints. The colour rendering in slides is much more accurate and the projected image more realistic than with prints. However, exposure must be very accurate. With over-exposure, colour may be lost in parts of the scene. Colour errors cannot be compensated or corrected in processing a slide, but special film is available for use with, for example, indoor photo lighting.

Colour prints can be made from slides and these may have exceptionally good lasting qualities. However, the high contrast of a slide designed for projection prevents the most detailed image from being obtained in printing, involving perhaps some loss of detail in shadow areas. But some colour correction is possible.

Colour print film would seem to be more expensive than making slides because you have to add the cost of the printing. On the other hand, you do not need a projector and screen, magazines, slide mounts, or a viewer to see them by; although you will probably want to put them in an album.

Slide and print film is available at various ASA speeds, at prices inclusive or exclusive of the processing charge. Good black and white prints may be made from either, using suitable materials. There is at least one black and white slide film available to special order, but black

and white photography normally means making prints from a negative film exposed in the camera. Black and white images are always of far finer quality than colour because the structure of the film itself is simpler and there are fewer things to go wrong. Many enthusiasts prefer to take their pictures in black and white because it is easier, and they have control over the results.

Films of different speeds

The 'speed' of a film is its sensitivity to light. Slow films, those of low speed, are less sensitive and need more exposure to light to get an image than fast films, those of high speed which need very little exposure. Medium speed films are of average sensitivity. Why have different speeds? Broadly speaking, you get better image quality from the slower films, especially colour films, with greater sharpness, less grain, better colour rendering (explained in greater detail on p. 54).

Film speed is calibrated in a scale of ASA (American Standards Association) or DIN (Deutsche Industrie Norm) figures. Equivalents are shown against one another in the table on this page. Most film cartons show the film speed in one or both ratings. After choosing the film you prefer, it is best to stay with it and learn its characteristics and what it can do, rather than change around to different films whose properties are less certain.

ASA and DIN film speeds

ASA	DIN	ASA	DIN	ASA	DIN
6	9	40	17	250	25
8	10	50	18	320	26
10	11	64	19	400	27
12	12	80	20	500	28
16	13	100	21	640	29
20	14	125	22	800	30
25	15	160	23	1000	31
32	16	200	24	1250	32

Film sizes and nominal picture areas with various cameras (A, B, C, mm; D, E, F, cm). **A** 110. **B** 126. **C** 35 mm. **D** 828 (obsolescent). **E** 127 (obsolescent). **F** 120 (620 obsolescent, uses a different spool).

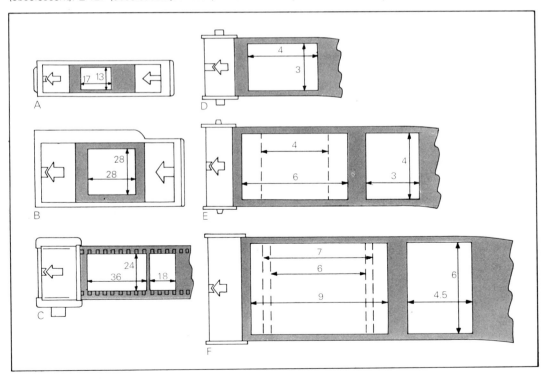

Loading your camera

You may load and unload your camera in daylight. But to avoid the risk of light leaking into the cartridge or cassette and spoiling the film it is advisable to do it in a shady place. Never load a camera in direct sunlight. If there is no convenient shade, turn away from the sun and do it in the shadow of your own body.

Pocket sized simple cameras are loaded with 110 type film supplied in plastic cartridges shaped like a dog's bone. Larger simple cameras may use a 126 type cartridge which itself is much larger. To load, open the back of the camera and drop the cartridge in. It will fit properly only if inserted the right way round. If it doesn't fit easily don't force it, but try it the other way about.

After inserting the cartridge, close the back of the camera and make sure it is securely locked. When starting to wind ignore the figures that show in the back window. *Just keep winding the film on until it won't go any further.* The first exposure should now show as number 1.

The cartridge for a pocket sized camera is specially keyed automatically to tell the camera something about the film loaded inside. But you can ignore this unless your camera allows you to set the film 'speed' independently. It may indicate that the film is 'fast', which means that it is very sensitive to light and, *on certain cameras* only suitable for use in cloudy weather, or 'slow', which means that it is less sensitive and suitable for sunny days. The 'speed' of the film is rated in ASA figures. In this case the slower film is 100 ASA and the faster type 400 ASA. You can tell which is which by checking this figure on the packing. But most cameras accept either the slower speed only, or both types.

The larger type of simple cartridge-loading camera does not use the fastest film but is set for films of around 100 ASA. (80 or 120 ASA are near enough to be almost the same.) This system is less confusing as there is no choice to be made. But the camera is really suitable only for use in good light or with flash.

On many cartridge-loading cameras the film is advanced from one picture or 'frame' to the next by a sliding lever or similar device. On others you move the film on between taking pictures by a push-pull movement of the whole body of the camera and the outer casing which, when pulled out reveals the viewfinder. However many times you pull out the body section the film will not advance until you have taken a picture. So the camera does not waste film every time you pull it open to look through the viewfinder. After you have finished the film and the final number has come up, *wind it off before opening the camera* to remove the cartridge.

Many cameras use film loaded in cassettes. A cassette is a metal case containing a spool of 35 mm film, the end of which protrudes from a velvet-lined light trap in the outer edge. Although very popular, these cameras are not so easy to load because you have to thread the film yourself. Nevertheless, most of the better quality cameras use this method, and once you have understood how it is done it becomes simple and reliable.

Most 35 mm camera models are loaded as follows:

Open the hinged back door of the camera and make sure that the inside is free from dust or hairs, etc. Take the cassette out of its packing and insert it in the left-hand chamber with the longer (protruding) end of its central spool downwards and the lip, with the film end sticking out, to the right. Make sure that it is properly in place and that the spindle at the top of the chamber engages with the top (short) end of the cassette spool. Holding the cassette in place with the left thumb, pull the narrow tongue of film out of the cassette and across to the take-up spool on the right side. Tuck the end into the central split in this spool. The spool itself may be rotated with the thumb to tighten the film once it is engaged. Now advance the transport lever to see that the film begins to wind on to the spool. Some spools

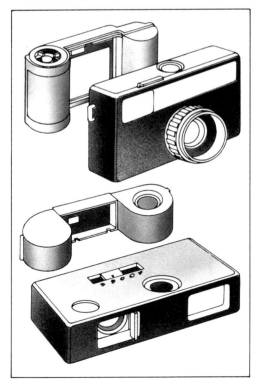

Cartridge-loading cameras are convenient, quick to use and dust-free. The film is bought in a plastic cartridge. You just open the camera and drop it in. Wind on to the first frame and you are ready to shoot. In some cameras with built-in exposure meters, the keyed 110 cartridge can automatically set the ASA film speed according to the film in use.

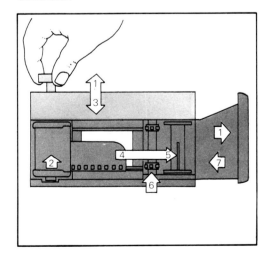

Loading 35 mm film. **1** Pull up rewind button to open camera door (and, on some models, to withdraw spindle). **2** Insert cassette. **3** Push down spindle to engage cassette spool. **4** Pull out tongue. **5** Insert tongue in take-up spool. **6** Engage perforations in sockets and tighten film by rotating take-up spool. **7** Close door.

wind the film over, others double it back underneath – it makes little difference. But the sprockets of the roller must engage with the film perforations and the film must be taut between the cassette and the take-up spool. Keep winding until the narrow film tongue is passed and the full width of the film rests across the roller with the sprockets engaging both sets of perforations. Without letting the film slacken, close the back of the camera and advance the transport lever until the film counter reads '1'. The left-hand knob on the top of the camera should rotate as you do this to indicate that the film is being drawn properly from the cassette. On cameras that count down from the last frame, set the dial to 12, 20, 24 or 36 according to the number of exposures indicated on the film packing. Most cameras however count upwards, so that when you arrive at this figure you know you have finished the film.

Set the ASA film speed according to the number quoted for the film in use. Also set the film type indicator disc to show whether the film loaded is colour or black and white. It is surprisingly easy to forget what kind of film you have loaded, so this disc is a very useful reminder. You are now ready to shoot.

Loading roll film

Some larger cameras use roll film, which is mounted on a protective backing paper and wound on a plastic spool. To load, first open the camera back and place an empty spool on the take-up spindle. If you are not sure which is which, turn the film transport knob and if the spool rotates, it is in the take-up position; if not, it is on the feed side so transfer the empty spool to the other side.

The unexposed roll of film is secured by a narrow paper strip. Remove this *entirely* and insert the full spool into the empty chamber with the paper feeding off the top. Pull off a short length and take it across to the other spool. The black side of the paper should face the camera lens, the printed side (yellow or other colour) should face you. Push the tapered end of the paper through the central slot in the take-up spool, and tighten by turning the transport knob. Make sure that the paper is positioned centrally in the spool and is not askew, and that the paper lies perfectly flat between the spools. Some cameras require the paper to be threaded *under* or *between* rollers, so be sure to do this if necessary. Wind

the film until two arrows printed on the backing paper are aligned with indicator spots or arrows in the film plane. (On some cameras this is unnecessary.) Close the camera door and lock it; then wind on to the first frame, which may be shown as '1' in a window in the camera back. The number for each frame may be seen in this window as you wind on between shots. Or the camera may count the frames itself, with the numbers appearing in a separate window elsewhere in the camera body. After the last picture has been taken continue to operate the film transport until the spool revolves freely and the paper has disappeared from the back window.

When you unload, be careful to keep the spool fairly tight and not let it unravel. Stick down the paper strip immediately. Then trans-

fer the empty spool to the take-up chamber *as a matter of routine*. You can then unload the next roll without confusion, even if you are in a hurry.

Very simple roll film cameras without adjustments are designed to take film of around 80 ASA. Adjustable or simple automatic cameras with an exposure meter built in require the speed of the film to be set manually on an ASA dial.

Some 120 cameras accept 220 roll film, a variant type permitting your camera twice the normal number of exposures at a single load. You usually have to make a small adjustment when you change from one kind to the other and rephase the counter for the new number of exposures.

Loading roll film. In this case the camera is a twin-lens reflex. **1** Open door. **2** Pull out spindles. **3** Insert empty spool in top take-up chamber. **4** Push in spindle to retain spool. **5** Insert unexposed film roll, with paper band removed, in bottom feed chamber. **6** Push in spindle. **7** Unroll a few inches of backing paper (the black side faces the lens) and thread the tongue in take-up spool slot. **8** Turn film transport until printed arrow is opposite index. **9** Set for 120 or 220 film lengths. **10** Close door. **11.** Wind on film until it reaches frame 2.

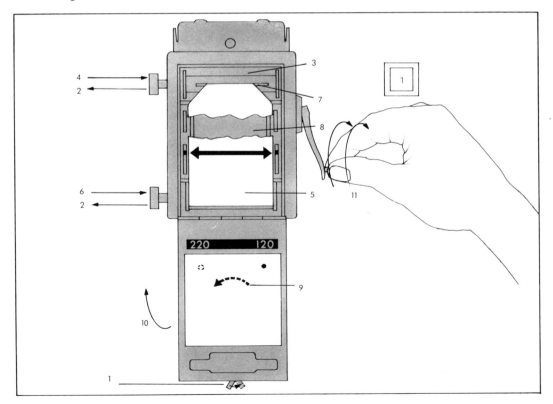

The picture above suffers from camera shake due to an unsteady hold or jerking the camera while releasing the shutter. Below, the same scene taken with the camera held firmly and the shutter released smoothly.

Holding the camera

The most common fault in photographs is blur, usually caused by slight movement of the camera while taking the picture. To avoid camera shake you must try to hold it as steady as you can when you press the release button. That is much easier if you are holding the camera correctly in the first place. The camera should *rest* securely in the hand and be supported by it in the way shown, which varies according to type. It should not be grasped tightly – indeed that may cause your hand to shake more than normal.

You can gain extra support and steadiness by tucking your elbows into your waist or sometimes resting them on any solid surface or object that happens to be available and in the right position, such as furniture or a fence. Occasionally you can hold the camera against a wall, tree, pillar or a door-jamb. This can give you rock-steady pictures even in the most difficult shooting conditions, where you are forced to use slow shutter speeds or time exposures. The ideal solution to this problem is to mount the camera on a tripod. You can then place the camera in almost any position. But tripods can be an encumbrance and you may not wish to carry one around with you. So

you must try to use whatever means are available to you or the methods just suggested.

The simple pocket camera which has no (or few) controls is held between the thumb and fingers at either end, leaving one finger free to press the button, in effect squeezing the camera between fingers and thumb. The camera is held against the face and this offers additional support. Unfortunately with all small cameras it is only too easy to let a stray finger creep across in front of the lens or built-in flash. So be sure that the whole of the camera front is unobstructed.

The larger type of simple camera and the 35 mm rangefinder models are held with the hands as shown. The controls are designed to fall in the right place for easy operation. With some models it is possible to shoot successive pictures without even taking the camera away from the eye.

With focusing cameras you support the camera in the palm of the left hand leaving the thumb and index finger free to focus the lens from underneath, clear of the viewfinder window, lens, etc. With the right hand index finger you press the release, and with the thumb you operate the film transport lever to wind on to

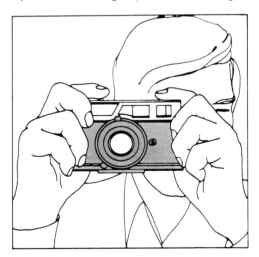

After focusing (if any) hold the camera as shown and squeeze the release gently with the index finger.

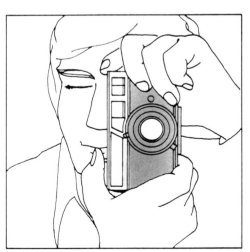

An alternative hold for upright pictures. Release the shutter with the thumb.

For any long exposures put the camera on a tripod and fire the shutter using a cable release.

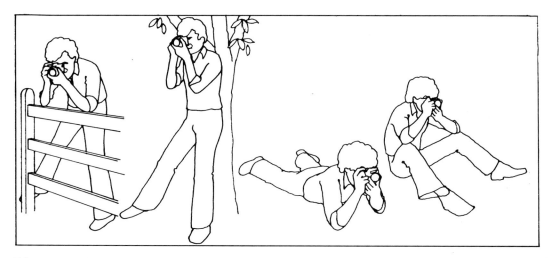

Wherever possible, use you own body or the objects around you to support or steady the camera, especially if you are using slow shutter-speeds. This will help to give you sharper pictures.

Different holds for different cameras. **A** Pocket 110 type. This hold keeps your fingers clear of the lens and viewfinder. **B** Focusing cameras. Hold the lens from beneath, palm towards the camera, to keep fingers out of view. **C** Simple non-focusing cameras. Keep your fingers clear of lens and other windows.

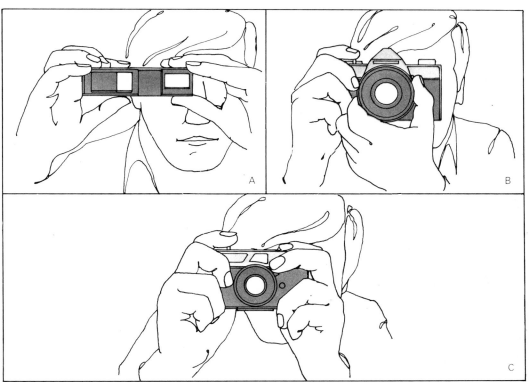

the next shot. You can usually make all the other adjustments with this hand.

Larger cameras such as roll film twin-lens reflexes, etc, are usually supported underneath with the left hand, while the right hand operates focus and shutter release.

The correct hold is more important than it may seem. The most humble camera can give good sharp pictures if it is held correctly, and the difference between a good 'hold' and a bad one is very noticeable if you ever want big enlargements from your negatives or transparencies.

A long camera strap can help you steady a camera. Some people wind it round the wrist to shorten it and tighten the camera solidly against the face. A camera that is used at waist-level or chest-level may be steadied by pulling down on the strap while holding the camera firmly against the body. Occasionally you may even wind a strap around a convenient object and tighten the camera against it.

It is best not to take a picture immediately after you have been very active — running or climbing a hill, for instance. Wait a few minutes until your heartbeat has slowed down and you will have far less difficulty holding the camera steady.

Looking through the finder

The viewfinder shows you the limits of the picture space available so that you can position the subject correctly on the film. You may see a natural sized or reduced image of the subject depending on the camera type; the actual size is unimportant provided you can see the subject clearly. Some viewfinders show the entire picture area that can record the scene; others have a bright rectangular line within the field of view which represents the actual picture while also letting you see a little more outside this area.

With every kind of camera except the reflex type (see page 34) the image in the viewfinder always looks sharp, whatever the distance of the subject. In fact with cameras whose lens must be focused, the image on the film may not be sharp even though the scene through the viewfinder is.

On reflex cameras, when the lens is not focused properly on the subject, this may be quite obvious when you look at it through the finder. Because focusing the lens correctly on the subject can be a matter of making a very fine adjustment, a rangefinder is often incorporated in the viewing system of a camera. On rangefinder cameras this usually shows as a central slightly coloured spot in the viewfinder, and on reflex cameras it may take the form of a split image, a pattern of microprisms, or a frosted area, all of which show the focus more precisely than the ordinary viewfinder. Many people prefer one particular method, or like to use different methods, according to the kind of subject they are shooting, so some cameras offer more than one system.

Simple cameras and all rangefinder type models use this method of viewing. It works

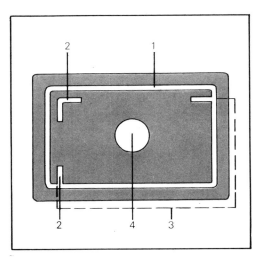

The viewfinder may have a bright line to show what you actually get, **1,** at normal range, and **2** and **3,** close-up, when area covered shifts a little. A rangefinder focus spot, **4,** shows two images (*below*) which merge as you turn the focus ring to the correct distance.

An out-of-focus picture becomes even more so when enlarged. A sharp picture is still sharp even in a big enlargement. Always focus carefully. To identify correctly the cause of unsharpness, compare your picture with this one, *left*, and with camera shake, page 14.

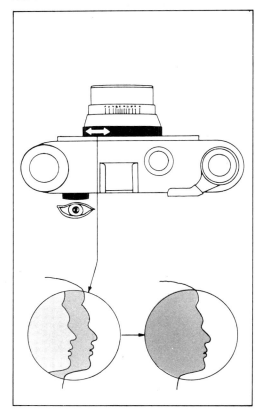

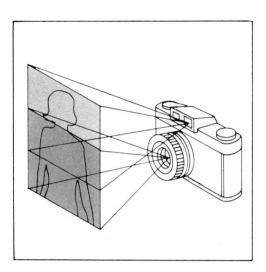

With close range subjects the viewfinder and lens cover slightly different areas — parallax error. Use the close-up markings in the finder.

well with subjects at medium range and beyond, but is not so accurate when photographing nearby. This is because with all these cameras the viewfinder and the actual lens that takes the picture are not in quite the same position and so present a slightly different view, known as parallax error. To indicate the correct framing at the closest focusable range, the rectangle contains two or three marks within the rectangular line and you must imagine these as the limits of the picture frame when the camera is used at close range. If you ignore this problem it is likely that you will cut off part of the subject when you are taking subjects nearby.

Reflex cameras do not share this problem because the viewfinder provides a view through the actual lens that takes the picture and you are therefore seeing exactly the same image and viewpoint as appears on the film, whatever the range of the subject.

Focusing on the subject

The camera with a focusing lens must be adjusted so that the subject of main interest appears perfectly sharp. The focusing ring on the lens rotates between a position marked with the minimum focusable distance, which might be 1 m or 3·5 ft for instance, to the setting for maximum range, infinity

(marked ∞). Some simple cameras use symbols to indicate focusing positions for subjects nearby (e.g., a face) and far off (e.g., a mountain). Setting approximate distances on such cameras is easy, but the better type of camera must be focused on the subject with some care.

With a rangefinder camera you can focus very quickly because of the focusing aid built in to the viewfinder. In the central spot you see two images of the subject. All you have to do is make sure this spot is on the main subject (the part of the picture that you want sharpest) and turn the lens focusing ring until the two images merge into one. This is called a coincident image rangefinder.

With a reflex camera you may have a split image rangefinder in which a small section of the subject appears split in half by a line. You turn the lens focusing ring until the two halves join up. If it has a microprism type rangefinder the subject appears to shimmer within the small focusing area. As you turn the focusing ring this shimmering gradually reduces and stops altogether when the subject is sharply focused. With a plain 'ground glass' focusing

screen the subject gradually becomes less blurred as you turn the lens until, at the correct focus point, it appears sharp and clear. The best way to find the sharpest point with this method is to move the lens back and forth, through the sharpest point, gradually reducing the movement until you feel you have the best position. It is not as quick to focus as a coincident image rangefinder but, with practice, it can be nearly so.

When you are lining up one of these rangefinders on the subject you do not necessarily have the best framing of the subject. You may be cutting off someone's feet. So be sure, once you have focused, to rearrange the subject just as you want within the picture area, but *don't change your distance* or you will have to refocus. Take as much time as you need to focus and compose the picture and don't let the subject bully you into pressing the shutter button before you are ready.

If, however, you have a moving subject or very little time in which to take the picture, then you have to resort to the pre-focusing techniques described on page 87.

A reflex viewfinder can have any or all of these focusing aids, arranged, in this example, with split-image centrally, surrounded by microprism, and a plain frosted 'ground' glass outer area. As you focus, the split image joins up, the shimmering microprisms disappear and the image becomes sharp on the frosted area.

Taking the picture

Your body is a good camera support provided you use it in the right way.

Balance yourself

When you take a picture you should have a comfortable hold on the camera and have your body relaxed and balanced. If you are reaching or stretching to get the camera in the best position it is unlikely that you can operate the controls or view the subject properly, or even hold the camera steady enough to be sure of a sharp picture. When standing, place your feet slightly apart and tuck your elbows into your sides. When kneeling, you can rest your elbow on a knee, and your elbows can provide a very steady support when lying on the ground for low angle shots or photographing small subjects at ground level.

Keep it horizontal

It is very easy to spend so much time looking at the subject through the viewfinder, that when you take the picture you have forgotten to hold the camera straight. It is very inconvenient in printing later on to try and straighten up pictures taken this way, and a normal processing house won't do it unless specially instructed, and such hand printing costs a lot more. With transparencies there is no way to correct a crooked picture effectively. The best thing is to get it right to start with.

Often the scene itself provides a convenient reference against which to line up in the viewfinder. A straight horizon such as the sea is not only a good feature to align with, it shows only too clearly when you haven't bothered! If the subject itself does not suffice, objects in the scene such as buildings, telegraph poles, a box, help with getting the picture straight – the reference object can be quite small. All you have to do is ensure that the sides or surface of that object are parallel with the edges of the picture.

With a straight-sided subject such as a building, don't tilt the camera upwards unless you have to, otherwise the sides will converge and in the picture the building will seem to be falling over backwards. It is much better to move further away and be content with a smaller image of the building which at least

looks upright and so natural. If, on the other hand, you go right up to it and point the camera steeply upwards, the view is obviously taken from underneath and although this gives a worm's eye view, it *does* seem a natural one. A picture of a high building taken with the camera held level usually includes more foreground than you want, so you should look for something of interest to fill that void. A slight

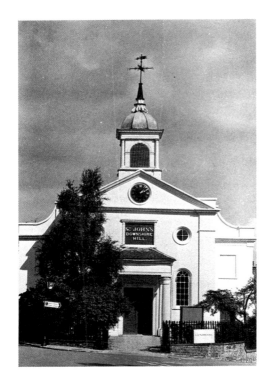

change of camera angle could provide an answer and give you a well-composed picture.

If you want to be close enough to see details then you can move right in and select only the details you want and leave the rest of the subject – and the problem – out of the picture. You can sometimes disguise the tilting sides by hiding the tell-tale feature behind something, such as a tree.

Look before you shoot

It is almost always possible to get a better picture by taking extra care with the way you arrange it in the viewfinder. Even a small change in camera distance or angle can make the difference between an ordinary picture and one that catches the eye.

What is the subject?

Even the prettiest picture is a failure if it doesn't show what you, and any other people looking at it, want to see. You must first decide what the main subject is. If you are showing a friend on holiday, which is the more important? Showing the person against an unusual background? Or is the attractive view the main object, with the friend just standing in the picture to add human interest and a sense of scale to the surroundings?

Pictures of people

If the main subject is a person or a group, it must appear large enough in the picture for the facial features and expressions to be seen

You can show a subject with empty sky and foreground areas. However, a different viewpoint (*below*) can frame the subject with foreground interest to stress the effect of distance.

Family groups. The camera shows the whole house and everyone large enough to be clearly identified, without cutting off arms or legs or distorting them by having the camera too close. Make them react; then press the shutter.

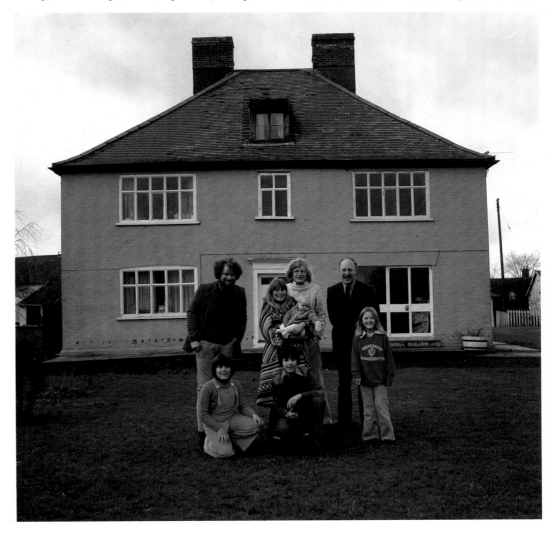

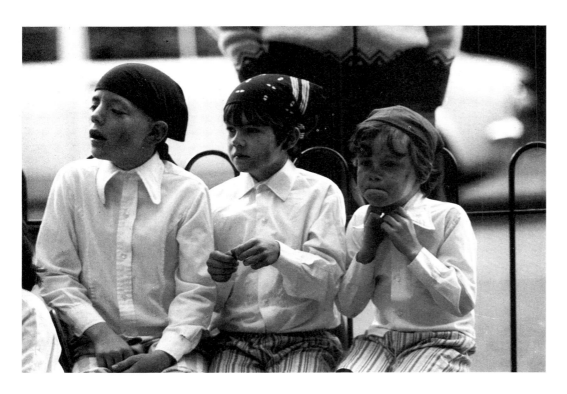

It is easiest to photograph people in an interesting way if they are actually doing something, even if it is just listening to a concert (*above*) or watching other people (*below*). Look out for good expressions (*above, left*) and try to catch them unawares (*below, left*).

clearly. It sounds a simple fault, but the fact is that in many pictures of people – and this includes most ordinary snapshots – the subject is too far away from the camera and too small to be readily identified. The opposite fault is that it is so close that part of the body is unintentionally cut off (it may even be the head!) and the camera does not focus close enough for it to appear sharp. In some cases the person is so close that he or she appears distorted because of the unnatural perspective of a close viewpoint. If you want a full-length picture, look at the top and bottom of the frame before pressing the button and make sure that there is a little space above the head and below the feet. Simple non-focusing cameras give their best results at this range when the lens gives its sharpest image.

If you want to go closer there are good and bad places at which to cut the body. The subject should look well-balanced in the picture. The best place to cut the body is the waistline or, if you want to go very close, at the chest. With a simple camera it is advisable to go no closer than cutting at the waist, with the subject's head clear of the top of the frame. Extremely close shots showing the head only require a camera whose interchangeable lenses (see page 36) include one of longer than normal focal length. Even a head and shoulder portrait is better taken with such a lens. Otherwise, if you want a picture like this and you only have a simple camera, take the picture to the waistline and then have only the head-and-shoulders portion of the picture enlarged. To take a picture of a person you should never go closer than five feet whatever the camera or lens.

When looking through a viewfinder it is only too easy to forget that your main subject is only a part of the picture that eventually becomes a print or transparency. So, whatever the size of the subject try to look at the picture *as a whole*.

The right surroundings can give a particular atmosphere or mood to a picture but choose them carefully. Place your subject in a good position and then look beyond. Do not let background objects obtrude into the picture in an irritating way – a post, wall or wire may make an ugly hard line that cuts across the subject so watch out for this kind of thing. It can often be avoided by a slight shift in camera angle. On the other hand objects in the scene can often be used to frame the subject or provide a centre of interest or fill in an other-

The camera cannot see as much detail in the shadow areas as you can. On bright days make sure that the picture will look good even if the shadows are just large black areas.

wise uninteresting background, provided they do not dominate or draw the eye from the subject.

When photographing people you have the advantage that they can be moved. If the background does not seem right, try another. Remember that the view the camera sees is normally quite a narrow one. Even a small yard or garden often has a good piece of background in one direction or another.

If you can't find a good background then choose a plain or, at least, neutral one. By deliberately choosing a large aperture on a focusing camera with an adjustable aperture diaphragm you can throw an unsuitable background out of focus and so disguise it.

If they are posed get your people to look straight at the camera rather than above or just beyond it, which appears very unnatural and self-conscious.

Pictures of places

You can always make a place look more interesting by the way you photograph it. It is best to select a principal point of interest and arrange the picture around that. Avoid large areas of void in the picture unless that is the point of it. By slightly changing the camera position an 'empty' sky can often be filled with the overhanging branch of a tree, a shop sign, or even an interesting industrial feature. A hedge, seat, path, puddle, or perhaps an animal, can provide interest for the foreground.

A picture that has a feature in the foreground and something visible beyond, gives the impression of actual depth especially if the foreground subject is unsharp. One way a photographer can direct attention to the main subject of interest is to make it sharp and leave all the surroundings blurred.

Selective focusing can be used for a large or small object in the scene. A large object is naturally dominant. But, attention can be shifted by selecting a small object instead and having the large one sufficiently out of focus. You can juggle with the relative sizes of subjects by changing the camera distance.

A light-toned subject tends to stand out when the surroundings are significantly darker. This is all very well if the light grey house you are photographing is surrounded by a dark forest. But if they are more or less the same colour, you may have to go closer and photograph the house on its own.

The viewpoint you choose is important because this is often your only means of excluding unwanted subjects. Sometimes, an attractive subject is cheek-by-jowl with an ugly or dominant one. Many old buildings are small and overshadowed by vast modern con-

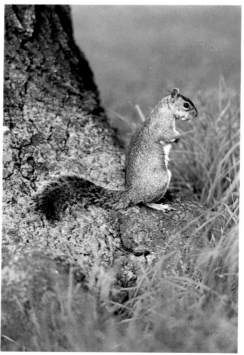

The unexpected can make the picture (*top*). With a quick change of focus the last roses of summer became a completely different picture when these two ladies walked into the scene. The festival queen (*far left*) spotted the camera and looked straight at it — much better than self-consciously looking away. The squirrel was lit by weak sunlight directly behind the camera, so there is even illumination and little shadow. Compare with the canal scene on the previous page.

structions. Whenever you have this problem make a change in viewpoint first by walking around the subject, and watch how it appears to change. It may be that the clearest view is not the best because it does not make the subject itself look so impressive. The difference between a good and bad angle can be very small. Occasionally you have to pick your way carefully between other things in order to get what you want.

Sometimes the scale of a subject has no meaning in a picture unless there is an object of known size with which to compare it. Even the Colossi in Egypt look average-sized until you put a human figure alongside.

Shadow

Finally, keep a sharp lookout for shadows because they can spell trouble. You may not notice them – but the camera does.

The camera cannot cope with the full range of highlight and shadow from direct sunlight or even a bright sky. So do not expect to see much detail in the shady areas unless you over-expose (see p.42) deliberately with an adjustable camera. Then you lose some of the detail in the lighter areas!

Hard shadows across the face may spoil the expression, distort the features and even make a person unrecognisable. Avoid direct sunlight unless the reflections from the ground are also very strong. You may get better pictures of faces in shady spots where there is no need to squint or shield the eyes with a hand. You may place the subject with his back to the sun and then give an extra stop or two in exposure over the normal indicated by a meter.

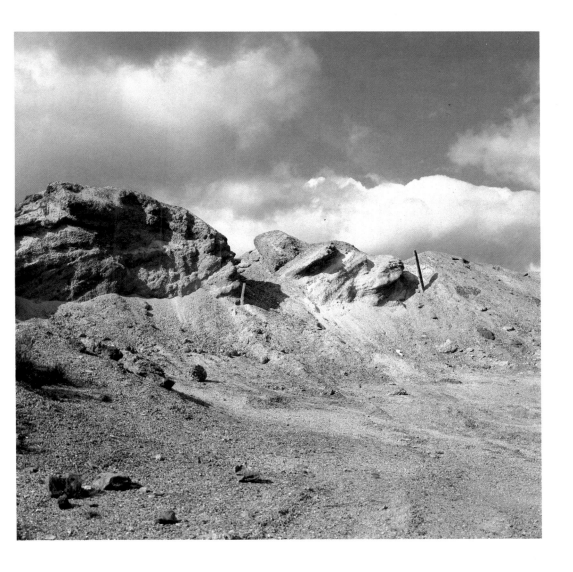

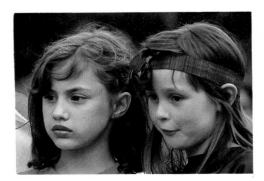

Pictures need an indication of scale; a rugged landscape (left) suddenly shrinks to a small excavation when you see the posts. The two girls (above) watching someone are unaware of the camera which records their concentration. The sun throws a highlight on to a brook (below), transforming a murky subject into one with movement and sparkle.

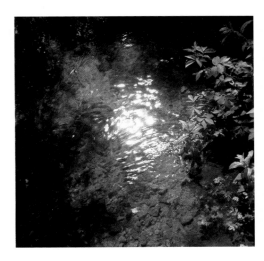

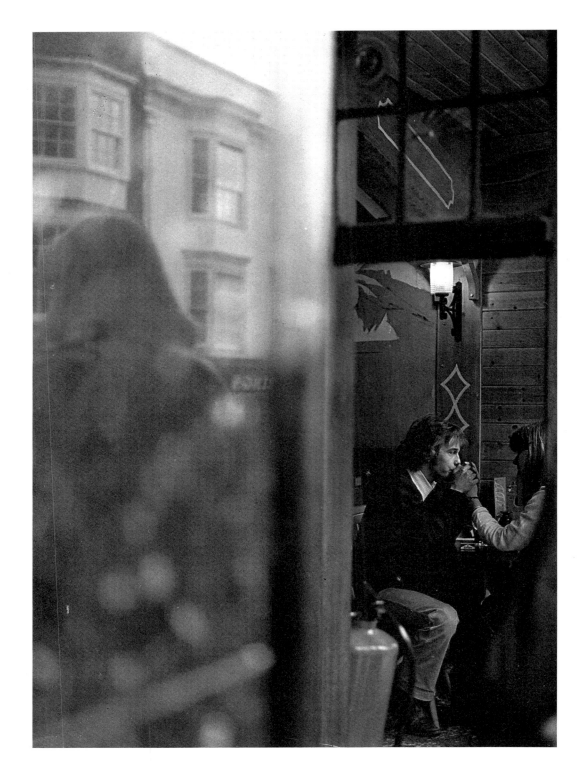

Keep to a method

You suddenly see a picture you want – just the right facial expression. You raise your camera, press the button and – nothing happens. Why? You forgot to wind on the film. You wind on, but you've missed the moment. The picture has escaped forever because you were unprepared. In photography, one or two well formed habits can save you a lot of trouble. One worth cultivating is winding on the film *immediately after every shot*. Some people say that if you do this you may fire the shutter by accident. Well, you may. But wouldn't you rather occasionally lose a frame of film than miss a picture you really wanted?

Before setting out check that your camera really is loaded with film. Of course you can't open the camera, but you may be able to see the cartridge through the window on the back. On 35 mm cameras there is often no obvious sign unless you have developed the habit of tucking the carton end into the case as a reminder. The frame counter may show you a frame number but this is not reliable if you are in the habit of playing with an empty camera, because in most cases the counter works whether the camera is loaded or not.

To test for a loaded camera turn the rewind handle (without pressing the rewind button underneath) and see if it moves freely or if there is some resistance.

If you are the kind of person who takes a lot of pictures when you find a particularly interesting subject, keep a spare roll of film handy.

If your camera uses batteries and has a device to allow you to check their condition, press this before you go out to take a picture. Ensure it is the right battery and that it works by putting it in the camera and trying the tester or the meter needle to see if it reads exactly as it did with the battery you just took out. If the meter gives strange readings suspect the battery first. Sometimes on an automatic camera the first reading may be correct and all the subsequent ones wrong if the battery is at the

Have your camera always at the ready. The couple in the cafe and, reflected in the window, the girl waiting outside were only like this for a few moments. The exposure was guesswork, and focus, pre-set for medium range subjects, needed little adjustment.

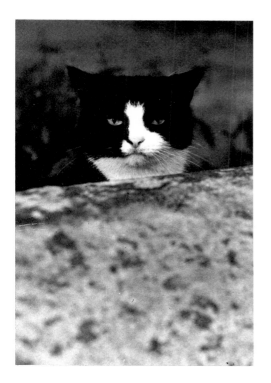

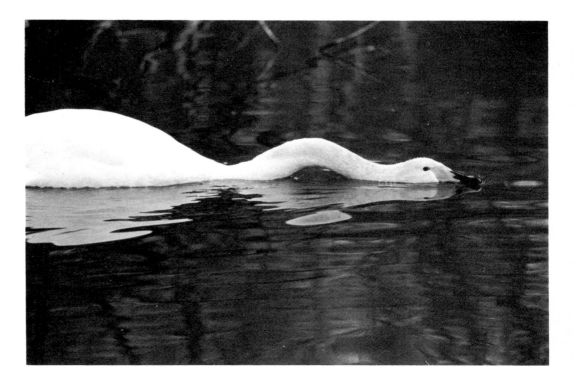

The cat was not angry with the photographer but had just run behind a low wall to avoid a dog. The exposure was pre-set for the general surroundings and the focus had been pre-set for medium range. There was no time to focus so the camera was just moved closer until the cat looked sharp — a typical situation where pictures have to be grabbed rather than composed and set up. In this kind of work you must expect a much higher failure rate than normal. If you wait to check exposure or try to adjust the focus you may very easily miss the moment — and the whole object of the picture. Even a slow-moving subject calls for quick reactions. The swan (above) left enough time for focusing and careful composition but the one below passed so quickly that the necessary quick grab was too late. But an enjoyable picture, nevertheless.

end of its useful life. If it is really old (say, over a year) change it anyway.

Your camera, when loaded, needs the ASA speed of the film to be set so that the exposure meter knows what film you have loaded. This is very easy to forget. Check that you know the speed and type (colour or black and white); if colour, print, slide or (daylight or artificial light) film. You can't count on remembering such things. Some cameras have a film type reminder disc for the purpose.

When the film ends

Sooner or later the camera runs out of film and you have to take it out and replace it with another. But you must be sure that the film has actually finished.

How do you know?

With a cartridge loading camera each exposure is numbered and you see these numbers in a window at the back of the camera. After you reach the final exposure (e.g., no. 20) the camera stops and no more numbers appear.

With a 35 mm camera the frames cannot be seen but the frame counter on the camera reaches the final frame number according to the load: 12, 20, 24 or 36. (On half-frame cameras you get twice as many exposures half the size so it can be 24 40, 48 or 72 according to the cassette length loaded.) Most frame counters count upwards to the last frame which is the total loading i.e. 12, 20, etc. The advantage of a counter that counts *down* from the total is that you can tell immediately how many shots you have remaining, provided that when you loaded the camera you remembered to set the figure to count down from the number of frames on the film pack.

Watch for the end

With 35 mm film, it is an advantage to keep an eye on the total number of shots taken, otherwise your first indication of the end of the film may be a sudden tightening of the transport lever just when you wanted to take another picture. If you reach the end unexpectedly, and pull the lever too hard, you could tear the film perforations, possibly shedding small pieces of film in the camera which may be difficult to remove. They can get into the mechanism and spoil future pictures. Torn film may also refuse to wind back into the cassette. In that case the camera would have to be unloaded in a darkroom. Also, laboratories do not like to handle damaged film which could cause problems in processing.

If you have forgotten whether you loaded, say, either a 20 or a 36 exposure cassette, wind carefully when you arrive at shot 20, and if the film continues for three or four frames beyond this then it is safe to assume that it is a 36.

In cases where the film continues to wind and allows further exposures beyond the number marked on the pack, you should not depend on actually getting these extra pictures unless you are processing the film yourself. In some cases the processor automatically cuts off the film after the normal number of exposures; in others the extra frames survive. With colour slides extra shots might be returned to you mounted or simply as a short strip of uncut film which you will have to mount yourself.

Unloading cartridge film

With cartridge film, after the last picture has been taken you must *wind off the film* before opening the camera to remove the cartridge.

A 35 mm film, when used up, must be wound back into its light-tight cassette before it is removed from the camera for processing. An exposed film which has not been rewound is only safe as long as the camera is not opened. So make it a habit, after each film is finished, to wind it immediately back into the cassette.

To rewind, press the transport disengage button (usually in the base of the camera) and turn the rewind crank or knob (at the opposite end from the transport lever or knob), usually clockwise, until, after a time, the winding suddenly becomes loose. Give a few more turns. If the film has definitely disengaged when you operate the transport lever it should now have no effect on the rewind knob, even though the disengaged button may pop up again. Now, open the camera and remove the cassette.

Never leave a tongue of film protruding from the cassette which can cause you accidentally to reload the old film in mistake for a fresh one. It may also tempt the processor to remove the film from the cassette simply by pulling out the tongue, instead of opening the cassette as

Unloading the camera (35 mm). With the camera still closed, press the rewind button, **1**, underneath and turn the crank handle at the top, **2**, clockwise until resistance slackens and it revolves freely. Slip catch, **3**, to open back, **4**, and remove cassette, **5**.

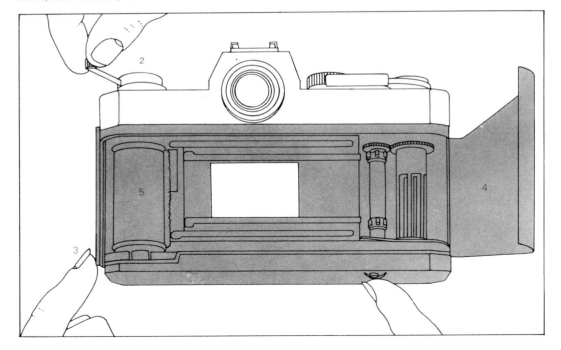

he should. This increases the risk of scratches from particles of grit that may have become lodged in the cassette's lined light-trap when the film was rewound.

Opening the camera on many models automatically returns the frame counter to a start position marked, e.g., 'S' or 'O', ready for the new cassette. On some older cameras the counter must be re-set manually with each new loading.

It is possible, though fortunately not common, for the film end to become detached from the spool inside the cassette – a fault mainly associated with self-loaded cassettes. The most obvious warning is that the transport lever continues to work past the last frame. Yet the rewind crank does not turn with it. You can check this by turning the rewind crank knob without pressing the transport release button. If you do not feel the crank tighten but continue to revolve freely, then the film end is detached. The camera must now only be opened in total darkness, the film end re-attached to the cassette spool and the film wound back into the cassette. If you do not feel confident to do this yourself, you must ask the laboratory or someone with a darkroom to do it for you, otherwise the film will be fogged or totally spoiled.

Unloading roll film

After the last picture has been taken on a roll film, the film, like a cartridge, must be run off before the camera is opened. On most cameras you simply keep on winding until you feel the resistance slacken, and the red window (if there is one) darkens. Open the camera, remove the roll, and immediately lick the gummed tab and stick down the paper end, ensuring that the roll is tightly wound. Transfer the empty reel to the other (take-up) spindle leaving the feed spindle ready to take the new roll.

Get it processed – now

Your film should be processed as soon as possible after exposure. The image actually begins to deteriorate as soon as you have taken the picture. This can affect the density and colour. Although the loss is not noticeable straight away, much depends on the temperature and storage conditions.

Print finish and presentation

You can order prints in various sizes, the most common being en-prints ($3\frac{1}{2}$ × 5 in.) or square equivalents, made from e.g. 6 × 6 cm square negatives ($3\frac{1}{2}$ in. sq.). These are the most economical and the most popular size for mounting in a photo album. Any printing from colour negatives demands a certain amount of adjustment in the process. The service normally offered, with colour, is for 'machine' prints. These are economical prints made in a machine which automatically applies the approximately correct controls for printing each negative, but is especially effective with negatives that are of subjects taken under average conditions and correctly exposed and processed. Most people find the results from machine-made prints perfectly acceptable for most of their pictures. Where particular care is required in achieving the best colour quality in printing from 'difficult' negatives, more expensive colour 'hand' prints can be ordered – a service mainly provided for pictures of larger than en-print size. Hand prints do not differ greatly from those made by machine when the original negative is satisfactory. Done by an expert printer, however, a hand-made print provides the best colour that a particular negative can give, and for occasional special pictures is worth the extra money.

Pictures may be supplied in a pocket 'frame' mount. For an album they may be fixed by photo corners (preferably transparent), double sided adhesive tape, adhesive, or by a plastic overlay which allows prints to be interchanged or moved about without difficulty.

For more general display, prints may be framed behind glass or mounted on card or a block. Dry mounting tissue, a shellac-coated sheet, placed between print and mounting surfaces provides a permanent bond when heat and pressure are applied.

Mounting with non-photographic adhesives can cause discoloration with time, especially when used with prints made on ordinary fibre-based papers (non resin-coated). For long term use, choose an adhesive designed for the job.

The printing paper may have a plain, glossy or textured surface. Choice is largely a matter of personal taste, selecting, say, textured prints for portraits and glossy for travel pictures.

You may have your prints made with a narrow white border or, with handprinting, a very broad one or, more commonly, with no border at all.

Process-paid colour transparencies (slide film) may be returned ready-mounted in frames as part of the processing service – for which you pay in the price of the film. Other films you may have to mount yourself, for which purpose slide frames can be bought. Most ready-mounted slides are provided with card frames, only occasionally the more rugged plastic type. If you mount your own (page 28) you need mount only the best pictures and avoid wasting money on those you do not want. Projector heat can make slides curl. Some plastic frames incorporate glass which holds the slide completely flat during projection and so ensures all-over sharpness on the screen.

Pictures containing fine details are best printed on glossy or plain-surfaced paper. Textured surfaces confuse the image.

Storage

Whereas some pictures may serve their purpose if they last only a few weeks, others you may wish to preserve for a lifetime. The main enemies of slides, prints and negatives are light, damp and excessive heat.

Slide preservation and storage

Colour slides, which should normally be stored in the dark, deteriorate less rapidly if they are infrequently projected, although the shift in colour balance caused by actual chemical change cannot be prevented.

If transparencies are taken deliberately for frequent projection,e.g., illustrated talks, it is advisable either to have duplicates made, or to shoot the subject more than once, which is cheaper.

The arch enemy of slides, and also prints, is damp. This can cause a fungus or mould to grow on the surface of the image, which is very diffcult, or impossible, to remove. This spoils the image particularly with slides because the effect is greatly magnified in projection. Slides should never be completely sealed from the atmosphere by air-tight binding. The ideal storage conditions are a dry, well-ventilated place with a fairly constant moderate temperature.

The normal way to store slides is either in plastic boxes or in loaded magazines when a magazine type projector is used. The magazines ensure that the slides are always immediately ready for projection in the correct order. But the cost of a magazine adds, in effect, to the cost of each slide. Slides for single-slide projectors can be kept in the plastic boxes supplied by the processor and then loaded in sequence. It is important to write the necessary details: date, location, etc on each slide as a large collection can soon become confused.

A Slides with diagonal key mark. B References for slides. C Slide marked with data. D Card mount. E Two-part plastic slide. F Plastic slide with separate cover glasses. G Slide sleeves in binder. H Slide sleeves in file. I Individual slides in cabinet. J Individual slides in carrying box.

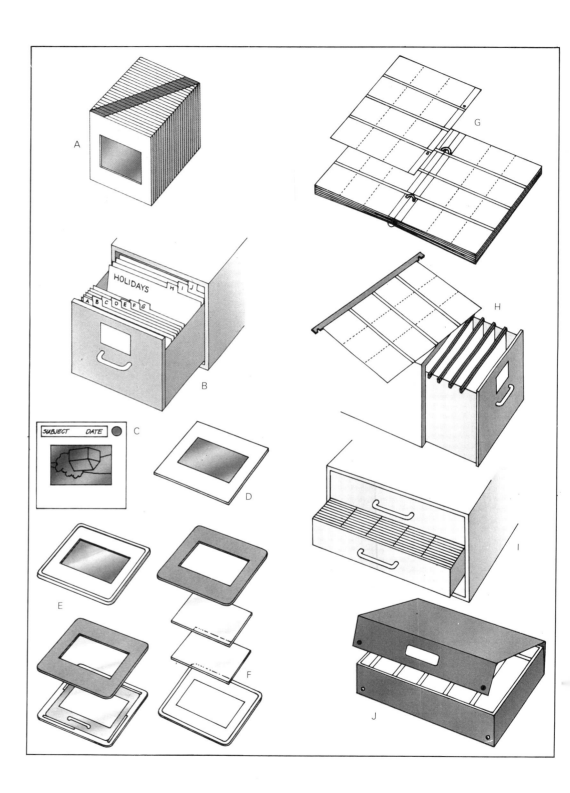

Print preservation and storage

Light makes photographs. It also destroys them. Colour prints especially are vulnerable, and although various claims are made for one kind of print compared with another, the fact is that none of the dyes used make the process as permanent as a black and white image. You can extend the life of a framed colour print that is on permanent display by placing or hanging it in a position well away from strong light, especially sunlight. Glass covers or varnish do not affect the lasting qualities of the dyes, however. But to ensure the longest life the prints should be stored in the dark, in an album or box, and they will then only be exposed to the light when you actually look at them.

Black and white prints made on fibre-based (i.e., non resin-coated) paper that has been *properly fixed and washed* can last almost indefinitely, even in daylight. Resin-coated papers, however, though popular, have not been in use long enough for their lasting properties to be definitely known. A black and white paper specially designed for archival permanence is Ilford Galerie.

A spring-binder album, **A**, has transparent sleeves which can accept small prints; each individual wallet can of course take two prints back to back to utilise fully the storage capacity of these albums. Photoframes and card mounts, **B**, are ideal for displaying prized pictures.

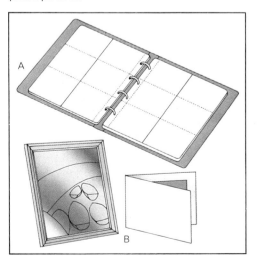

Negative storage

Because negatives are the masters from which any future prints of a picture are to be made, it is essential to take care of them and preserve them in a way that avoids as much handling as possible.

In some cases when looking at a negative it is hard to see clearly what the subject is, particularly with colour negatives where the masking dye confuses the outlines of objects in the picture. Black and white negatives are easier to 'read' in this way though, even here, it can be tricky when you want to find one particular negative from among many similar subjects. Faces are difficult to differentiate and expressions cannot be judged from the negative at all. You must establish an effective filing system for your negatives if you expect to use them again in the future.

If you do much photography it is surprising how soon the stock of negatives builds up. Failure to organise them properly will eventually render them useless through being so hard to find. The best way to arrange them is to make a reference print of each one. With colour you may wish to order contact strips for each roll. You can cut the film into short lengths and lay them side by side on a sheet of bromide paper, put a sheet of glass over them and then make a contact print under the enlarger light or with an ordinary domestic lamp.

The quality of this contact reference sheet does not need to be perfect – it serves only to identify the individual frames of a film. It is better not to cut up negatives into shorter strips than groups of three frames – preferably four or six, or whatever fits the contact sheet you wish to use. Individual frames or negatives can be fiddly to handle. Special contact printing frames are made which allow convenient handling of groups of negatives when making these reference prints.

Negatives can be stored in special pockets or sleeves holding several strips at a time. They should be at least semi-transparent and allow somewhere to write references. Individual frame numbers can be identified using the numerals printed alongside each frame. These sleeves can be be stored with each reference print or the reference prints may be more conveniently stored in used bromide-paper boxes.

Handle negatives as little as possible and keep them away from extremes of light, heat and damp. They can deteriorate just as easily as slides or prints but, unlike prints, they are irreplaceable.

Prints may be kept in boxes but are more easily looked at in albums. You can buy a special album containing several plastic packets per page and small prints may be inserted in each, back to back, so that it is possible to view perhaps a dozen at a time. The sheets are held in a spring binder and can be moved around at will. Another kind of album has boards with a layer of clear plastic film on each side. You put the print under this and lay the film over the top. The natural adhesion effect of static electricity holds the prints flat and prevents them from moving around. The plastic sheet may be peeled up and the prints moved or replaced without any tearing or unsticking being necessary. The traditional type of album has prints held by adhesive photo corners. The disadvantage of these is that the prints tend to pop out when the pages are bent. A more permanent arrangement is to put the prints in with adhesive, but be sure that it works with plastic based prints.

Slides that are not stored in a projector magazine should be held together in a box. If a diagonal line is drawn across the top while they are held tightly together, it is possible to see immediately if one is missing, back to front, inverted or out of order. Where very large numbers of slides are involved a filing system must be established, especially where a selection is to be made from slides that are stored in separate boxes.

Very few people these days bind their own slides with tape between pairs of plain cover glass, although that method is desirable where the slides are subject to heavy use, as in slide lectures. Cardboard self-adhesive slide mounts are available which, although inexpensive and quick to use, have the same disadvantages as those sometimes supplied with protective transparencies. They tend to wear quickly and may eventually come apart. Also they are more likely to jam in a temperamental projector than more rigid forms of slide. The most convenient slide is the type that uses a plastic mount. For general handling of individual slides, especially those which will only be examined in a hand viewer, a simple press-together plastic mount will do. Other kinds combine the plastic frame with cover glasses. The glass may be incorporated in each side of the slide mount or be supplied as a separate unit.

Creative photography made easy

The eye and the camera

You can think of a camera as resembling an eye – with its focusing lens, iris to control the light and sensitive recepter to register the image. But the comparison is confined to those mechanical features. The eye and the camera do not see things in quite the same way. The eye is linked to the brain, which qualifies the impression it receives while the camera is coupled to a chemical process which exerts its own influence. Thus, when you photograph the things you see the results can sometimes turn out looking very different from what you had expected.

Photography has limitations, but with a little understanding you can quickly find ways round them, avoid the pitfalls and even make some of the shortcomings work to your advantage.

Once you have mastered the basics, you will really feel in control and the camera will do just what you want because you will begin to see things the way the camera does, which is so different from normal vision. In this way you can use photography to create pictures often from the simplest 'raw materials' you see around you.

You will begin to see pictures where before you saw nothing in particular. (Photography sharpens the eyes and generally makes you much more aware of your surroundings.) You will be able to take pictures of people that say much more about them than just the shape of their face.

Creative photography offers immense scope to the imagination yet the basics of it are very easy to follow. The essentials are often made to sound far more complicated than they really are – especially by people who are more interested in cameras themselves than in what they can do with them.

For successful creative photography you must understand three things: firstly, the way the camera (and its film) differs from ourselves in how it sees things so that you can learn to see in *its* way; secondly, how the camera actually takes a picture, so that you know how to get things right from the start or correct them out if they go wrong; and, thirdly, details of the ways and means of cameras and film so that you can control and influence everything that happens. Then you can let your imagination work through the camera rather than just let *it* boss *you* around or refuse to do what you want.

How do the eye and the camera differ in the way they see things?

Eye and brain. Although they apparently take in a wide view, the eye and brain actually concentrate on only a single part of it at a time before moving quickly on to the next. The camera is selective only if you make it so, by suitable framing, focus or exposure – otherwise the subject you want to isolate is lost in the confusion of the surroundings. You may still want a *hint* of the surroundings, however, and the right technique gives you this without swamping the subject.

Sharp or soft. The healthy eye always shows everything sharp because it focuses automatically as you look at things. The camera must be focused on things by you. But, unlike the eye, it can make one thing sharp and another out of focus and so separate them, which can be an advantage.

Pictures in a frame. There are no defined limits to the eye's vision, but the margin of a photograph can affect what is shown within it. The shape of the frame and the position of the subject within it can alter the appearance of that subject, e.g., it can make the subject appear larger by suggesting that parts continue beyond it; it can also increase the attractiveness of a scene by visually balancing the relative sizes or importance of different parts.

A flat world. The eye sees in three dimensions but a picture is a flat image. It has no real depth, only that suggested by perspective (the relative sizes of objects, particularly where one partially conceals another), the modelling effect of light and differences in density due to distance and haze.

Time freezer. The eye sees movement as a continuous event, but a photograph can only record it either as an action frozen in time or by allowing the subject to blur across the film, as a trace or smear of what has happened – neither effect resembles anything you would ever see with the eye.

Light and dark. The eye can see into very bright areas and shadows at the same time but film cannot span these differences, and must favour one or the other.

Colour, true and false. We are much less aware of the colour of light than is a film, to which indoor lights and daylight are so different that each needs a separate film or filter.

Black and white. Black and white film represents the colours we see as a series of grey tones. You must try to imagine your pictures as built of tone even though they are full of colour. You can soon learn to 'see' in black and white and observe how it enhances certain subjects.

False views. Compared with the natural view, some lenses may give a false impression of the subject, flattening or distending it in one way or another.

Final touch. The usual aim in making prints is to get a realistic result. But prints can be manipulated to give an image so false that it hardly resembles the original scene in any way.

Shapes, patterns or colours that echo one another unify the theme of a picture, as with this symbolic nativity canopy hung from a cathedral vault.

What is a photograph?

We press the button and a picture is taken. It's so easy we tend to take the whole process for granted. But if we don't know what is happening, or how, or what we have produced, then how can this process be made to do what we want? So what is a photograph?

An image made with light

Light is a form of energy which, reflected from the world around us, enables us to see. This same energy allows us to take photographs.

Virtually all our usable light comes from the sun. Light moves in a wave form along an axis and travels in a straight line. Light rays from the sun strike an object and bounce off in various directions. Those which come in our direction and enter our eyes make that object visible. The better it is at reflecting light, the brighter the object appears to be; the most efficient reflectors can dazzle us when we look at them: glass, water, polished metal, or a mirror at the appropriate angle. The light which enters the eye comes at different brightnesses from different objects enabling us to distinguish between them and, in effect, add up to a picture of our world.

The eye

Light enters the eye through the lens and focuses an upside-down image on the retina at the back of the eye. The image sensations are then conveyed by the optic nerve to the brain which turns the image the right way up.

The eye is focused on objects at different distances by means of muscles that control the lens shape and its ability to bend light. The amount of light entering the eye is varied by the size of the pupil, a small hole between the lens and the cornea (the front lens of the eye). In bright light the pupil becomes smaller to protect the retina from receiving too much light. In dark conditions the pupil dilates to admit as much light as possible to the retina.

The camera lens forms the image

The camera is a light-tight box that resembles the eye in the way it works but which is less refined in its mechanics. At one end is a lens which is the only means by which light may enter the box. The lens forms an image of objects in the outside world on to the back wall. As in the eye, this image is upside-down. The lens is focused on images at different distances by moving backwards or forwards, closer or further away from the back wall, as required. In the case of the camera the back wall is occupied not by the retina but by another light-sensitive element – the film. The lens is designed to spread the image over an area to cover the whole of the film surface for each picture and to ensure that it is sharp from the centre to the corners.

Because the image from the lens is inverted it too is recorded upside-down on the film. But when we view slides or make enlargements from this film the picture is simply turned the other way up to match the original scene.

How much light?

To control the amount of light entering the lens the iris, or aperture diaphragm, is opened or closed as needed. On very simple cameras the aperture is simply a hole, or series of inter-

The human eye. **1** Muscles which focus the eye. **2** Iris which regulates the amount of light passing through the lens and reaching the retina. **3** Lens. **4** Retina, on which the lens focuses its image. **5** Optic nerve which conveys the sensations caused by the image to the brain.

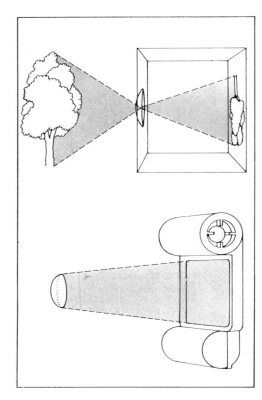

The camera is a light-tight box with a lens at one end. The lens makes an image of the subject on the far side of the box where the film is positioned.

Aperture stops on simple cameras may be holes perforated in a thin metal sheet, otherwise an iris diaphragm of overlapping leaves opens or closes according to the setting made.

changeable holes, perforated in a thin metal plate and pushed into the light path in the lens. Most cameras use a diaphragm consisting of several overlapping metal leaves with a central opening that varies according to the setting made on a control ring around the lens. On a simple camera the aperture settings may be indicated with symbols for different brightnesses of scene. On more advanced cameras the diaphragm ring is marked in *f* stops, *f2*, *f2·8*, *f4* etc.

... And for how long?

The other means to control the light entering the lens is the shutter. Whereas the aperture diaphragm governs the brightness of the image, the shutter determines for *how long* that image should enter — usually for a small fraction of a second, and set out in a series: 1/2, 1/4, 1/8, 1/15, 1/30, 1/60, 1/125, 1/250, 1/500, 1/1000.

These two controls then work together to govern the light and thus the exposure.

For convenience, the various openings of the diaphragm are arranged in steps, known as *f* numbers. These are usually in sequence: 1·4, 2, 2·8, 4, 5·6, 8, 11, 16, 22. Each of these openings has twice the light-passing ability of the next higher number, and half the light-passing ability of its lower neighbour. These relative apertures are, in fact, approximately the ratio of the diameter of the aperture to the focal length of the lens. The larger figures therefore denote the smaller openings and the smaller figures the larger.

The intervals between the *f* numbers correspond with the steps between each shutter speed on its scale in terms of the total light passed. For example, the combination 1/125 sec. at *f8* comes to the same total as 1/60 sec. at *f11*. But the effect on the image itself may be different in other ways. The smaller the aperture (higher *f* numbers) the greater the sharpness *in depth* (i.e., range of distances) in the picture. The wider the aperture the more shallow the depth. The faster the shutter speed, the more able is the camera to make a sharp picture of a moving subject. Because the faster shutter speed gives a briefer exposure you have to select a wider lens aperture to make sure that the film still receives sufficient light to register an image. You therefore select your speed and aperture combination according to the particular subject you are taking, fast moving or stationary,

and whether you want sharpness over a distance or only at a certain range. The combination of speed and aperture you set is determined by the brightness of the scene you are photographing and the sensitivity of the film.

The shutter

Most cameras have one of two kinds of shutter. A *leaf* shutter consists of a number of very thin overlapping metal leaves. When the shutter opens, the leaves part and withdraw to the sides leaving an open space through which the light passes. They then close again to cover the space and cut off the light. This type of shutter is normally built into the lens, and is positioned very close to the diaphragm. Because a leaf shutter always opens to reveal the whole picture area, for however short a period, it is suitable for use with electronic flash units at any shutter speed.

The main disadvantages of the leaf shutter are that its top speed may only be 1/500 sec. or less and, because it is actually in the lens and not in the camera body, with a camera that has interchangeable lenses every lens has to have a shutter built into it. This is quite an expensive arrangement. However, this is no drawback on the fixed lens optical viewfinder or rangefinder cameras to which they are usually fitted. They are also fitted to all twin lens and some single lens reflex roll film cameras.

The other type of shutter is the focal plane. This is built into the camera body immediately in front of the surface of the film. The shutter consists of two roller blinds which pass across the light path. In the closed position the lens is completely blocked. When the shutter fires, the first blind is moved away, uncovering the film. The second blind then crosses and covers it over again. At slow shutter-speeds the whole area of the picture is momentarily revealed, but at higher ones the second blind follows the first so quickly that the film frame may only be scanned by the narrow gap or slit between them.

The advantages of a focal plane shutter are that it can be built into the camera body, that it can give very fast shutter-speeds (of 1/1000 or 1/2000 sec.) and that the lenses themselves do not need to contain a shutter and are therefore of simpler mechanical construction. The main disadvantage with focal plane shutters is that they cannot be used with electronic flash at shutter speeds faster than 1/30, 1/60, 1/100 sec., or in some cases, 1/125 sec.

A focal plane shutter consists of two blinds positioned immediately in front of the film. As they move across the film the open section between them makes the exposure.

A Leaf shutter in the lens positioned close to the diaphragm. **B** Focal plane shutter operates across the front of the film; the lens contains only the diaphragm.

A

B

What the camera must do

More advanced cameras

In a single lens reflex (SLR) camera, the lens that takes the picture provides the means of viewing as well as forming an image on the film. Light that enters the lens is reflected by a mirror on to a frosted screen immediately above it, and so provides an image by which the subject may be viewed and focused. When the shutter is released to make an exposure the mirror moves out of the light path and allows the light to pass via the shutter to the film at the back of the camera. After the shutter has exposed the film the mirror returns to the first position and the subject may again be seen on the viewing screen. The actual moment of exposure therefore causes a brief blanking out of the screen image. But when you use the camera you are normally only aware of a brief blink when you fire the shutter. If you make long exposures the view-ing system is blanked out for that period of time.

The screen image on an SLR is viewed through an eyepiece in the back of the camera where it is seen in a natural unreversed state as if you were looking directly at the subject. To achieve this however, the image must go through a pentaprism or five-sided glass block by which it is 'turned over' and realigned. The viewfinder eyepiece magnifies the screen image and allows you to view it in comfort so that with the standard lens fitted, you are seeing an image only a fraction smaller than life size.

A special advantage of an SLR camera is that the framing of the image and the focus on the viewing screen are identical to that recorded on the film. A difference in position between the viewfinder window and the actual taking lens is a drawback in many applications, and

Single lens reflex. For these cameras there is a wide range of interchangeable lenses and other accessories for specialised types of photography.

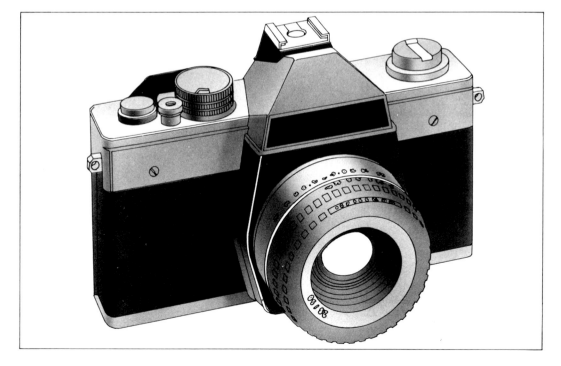

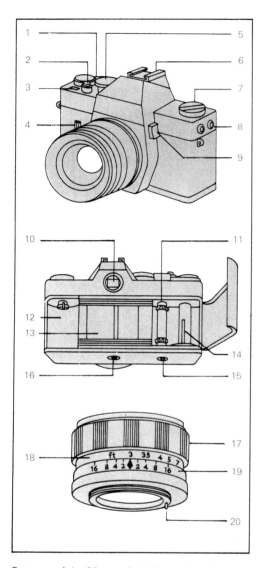

Features of the 35 mm single lens reflex. The pentaprism housing gives most models a distinctive appearance. **1** Film transport lever. **2** Shutter release. **3** Exposure counter. **4** Self timer. **5** Shutter speed dial. **6** Accessory shoe. **7** Rewind crank. **8** Flash sockets. **9** Mirror lock. **10** Viewfinder eyepiece. **11** Sprocket wheel. **12** Cassette compartment. **13** Shutter blind. **14** Take-up spool. **15** Rewind button. **16** Tripod socket. **17** Focusing ring. **18** Distance scale. **19** Depth of field scale. **20** Auto diaphragm pin.

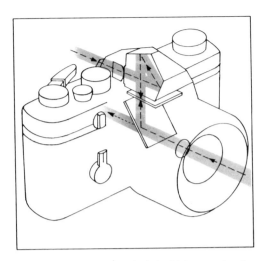

The single lens reflex principle. Light entering the lens is reflected up into the viewfinder. At the moment of exposure the mirror flips up and the light passes through via the shutter to the film.

ing). The readout for this meter is visible in the viewfinder (see page 44).

The 35 mm single lens reflex camera has been the subject of constant development and design improvements over the last two decades or so and its advantages and ease of use make it an obvious choice for many people wanting to take the first steps away from a simple camera. They range in price from moderate to expensive but of all cameras on the market they are certainly the best value for money. Advanced cameras of this type have a huge range or 'system' of lenses and accessories available for them. On one or two models the pentaprism is removable to allow waist-level viewing and to accept special attachments.

for such things as close-up work the SLR, with its common viewing and taking system, is an ideal camera. On some SLR cameras the image on the film covers a slightly larger area than that seen in the viewfinder. This is to allow for an all round margin on the image that would be masked by a slide mount or in the enlarger carrier when making prints.

The viewing system of the SLR gives it a particular advantage when changing from one lens to another as you see the image exactly as given by each lens. The same applies to diffusers and special attachments that can be fitted for trick photography. If you fit a close-up diopter lens there is no need to consult focusing tables; simply focus visually through the viewfinder as you would with any other lens.

The screen image is normally seen with the lens at maximum aperture to give the brightest possible viewing. But if the SLR camera you use has a depth of field stop-down preview facility you can check the relative sharpness of different parts of the picture as they will actually appear in the photograph.

On most 35 mm SLR cameras the shutter speeds are set with a rotating dial on the top plate. Aperture adjustment is on a dial around the lens. However, many models have some degree of automatic exposure control, usually via a meter that reads the subject brightness through the taking lens (TTL meter-

The single lens reflex viewfinder has special advantages in close-up subjects. It is possible to arrange the subject positively in the picture area and in many cases check the relative sharpness of foreground and background subject matter at the shooting aperture before taking the picture.

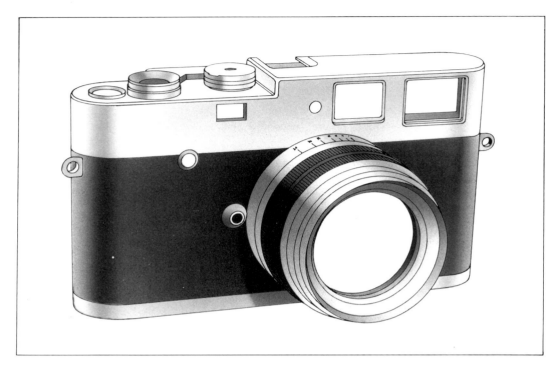

Sophisticated 'system' rangefinder camera with automatic viewfinder masking that shows the area of subject covered by the lenses which are fitted to it.

Rangefinder cameras

The rangefinder camera is still the most popular type with people who want a lower price or a compact camera. It has many adherents among professional and more advanced amateur photographers who prefer the direct or optical viewfinder but also want the convenience of interchangeable lenses.

The main advantages of the rangefinder camera are the ease of focusing and the small size of the lenses and camera body compared with the SLR. This makes them extremely quick to use and they are a special favourite among photographers who do candid photography. There are very few 'system' models to choose from and they vary widely in price.

All rangefinder or direct vision-optical viewfinder cameras suffer from problems with parallax. Additionally the system rangefinder camera needs some means to show the framing obtained with different lenses. On the best model this is an automatic facility and changes of its own accord as each lens is fitted. It also allows you to check the framing with different

lenses without actually having them mounted. The optical viewfinder, however, only shows the framing; it does not magnify the image

seen with any particular lens in the way of the SLR camera. But a special magnifying viewfinder can be purchased and attached.

Large formats

Several SLR cameras are available that take roll film. These cameras are generally more expensive than equivalent 35 mm models. They share many of the features of the modern 35 mm SLR but are not really designed for the kind of photography where quick reactions and rapid operation are needed.

The advantage of the larger format films, such as 6 × 6, 6 × 7 or 6 × 4·5 cm, is the superb sharpness and clarity of the pictures they produce. This is especially noticeable in large prints made from colour or black and white negatives.

All roll film SLR cameras may be used with their normal waist-level viewfinder or with a pentaprism attached for photography at eye level. With those taking pictures in the 6 × 4·5 cm format however it is practicable to take only horizontally composed pictures at waist level. Because the camera needs to be turned on its side for vertical pictures, and even when the screen is viewed at eye level the image is then upside down, they are normally used with the pentaprism attached. Some SLR roll film cameras have TTL exposure meters and with some the film is loaded into a detachable magazine back which may be interchanged with another if you wish to

A 'system' rangefinder camera has a complete range of lenses of various focal lengths from wide angle to telephoto.

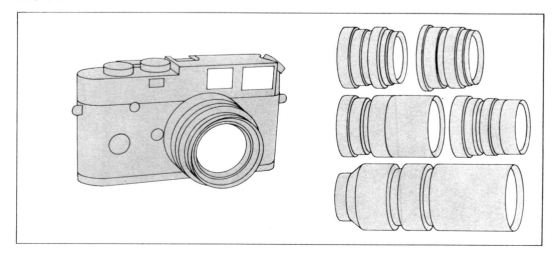

Twin lens reflex. As the two lenses on the front panel are moved forward or back in unison, the upper lens focuses an image on a viewing screen, seen by looking down through the open hood at the top. The lower lens focuses an image on the film. This model has a built-in exposure meter and crank film-wind.

alternate between films of different kinds (e.g., colour or black and white) or speeds. Cameras taking pre-loaded inserts, speed up the reloading procedure for a busy photographer.

The main disadvantage of SLR roll film cameras is their size and weight, especially when you also have to carry several additional lenses.

Another type of roll film camera is the twin lens reflex. In this camera there is a separate viewing lens, with a fixed mirror and viewing screen arrangement, above the lens that takes the picture. A rugged though bulky camera, it

Roll film single lens reflex giving 4·5 × 6 cm pictures on 120 film. The removable pentaprism viewfinder with exposure meter built-in may be replaced with a waist-level finder for landscape photography. Crank film-wind and interchangeable lenses.

is less expensive than a single lens reflex and not quite so versatile. One model takes interchangeable lenses. Wide angle and tele converters are available for another, but the traditional lens reflex design is intended for photography with only the standard lens. Lacking some of the refinements of a 35 mm SLR, and though sharing with direct vision and rangefinder cameras the problem of parallax, they are still an economical way of producing high-quality roll film format pictures; which helps to explain why this rather old-fashioned design still has a considerable following among photographers everywhere.

Small formats

The 110 cartridge loading film is normally associated with simple cameras, but one or two fairly sophisticated models also exist which accept film of this size. One has a built-in zoom lens, rather like a movie camera, and another has a set of interchangeable lenses of wide-angle standard and tele focal lengths. Both of these types use the single lens reflex principle. These cameras are light in weight and compact to carry around and have some of the advantages of the sophisticated 35 mm SLR. Their drawback is the film size and the

With a 110 pocket camera the sharpest-looking results are obtained where there is high contrast and hard edges in the subject.

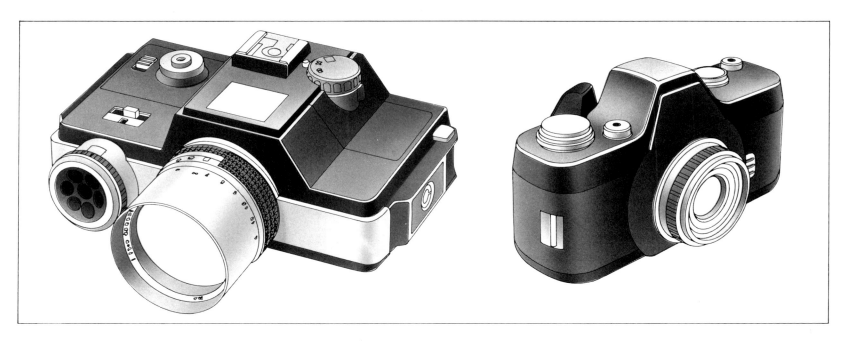

Zoom reflex camera (*left*) for 110 cartridge loading film. The camera has a built-in exposure meter. Reflex 110 type camera (*right*) with interchangeable lenses.

limitations in technical quality that may be achieved when making prints from so small a negative.

Interchangeable lenses

All cameras with lenses that may be interchanged with others of different focal length have either a bayonet or screw fitting mount. There have been screw fitting lenses of various kinds. At one time quite a number of cameras used a standard 42 mm screw mount, but with increasing automation in cameras, and the consequent need for extra linkages between lens and camera, this type of fitting became rather impractical. Nevertheless, some cameras still use screw fitting lenses and many lenses are still made for them.

With the growing popularity of bayonet mounts has come a loss of standardisation. Most camera systems nowadays use a bayonet mount exclusive to their own lenses which means that except in one or two cases you cannot interchange lenses between one make of camera and another. In a few

instances adaptor rings are available that enable you to interchange the lenses but this usually means that the camera exposure meter cannot be used in the fully automatic mode. At best the meter works by the stop-down metering method (page 127).

Independent lenses

Independent lens manufacturers make lenses to fit current models of most of the best-known cameras. These lenses are generally less expensive than camera brand-name lenses and, in a few cases, offer some feature that is not available for that camera – particularly zoom lenses. The optical quality of independently made lenses can vary widely. Some, generally the more expensive makes, are excellent. Independent lenses too, are often made for one particular brand of camera, but the maker usually offers the same basic design in different versions to fit other cameras. Some offer their lenses in their own mount to which another unit is attached and the same lens may then be used on several different cameras for the price of an adaptor

Lens mounts. **A** Locking bayonet type. The lens is inserted and turned to secure, or is secured by a locking ring on the camera body. **B** Screw mount requires several turns of the lens to secure.

for each. So, if you change your camera for one of another make or use two camera bodies of different makes you do not need to buy another set of lenses, only change the adaptor.

Extra lenses

All interchangeable-lens cameras offer at least several, and sometimes as many as twenty or thirty, alternative lenses. They may be roughly grouped as wide angle, standard and telephoto (long focal-length). After buying a camera which comes with a standard lens most people buy a wide angle (e.g., 28 mm), a medium telephoto lens (e.g., 135 mm) and occasionally a long telephoto (200 mm). (These focal lengths are for 35 mm cameras.) The full range of focal lengths offered by a camera manufacturer might run as follows: Fisheye 15 mm; wide angle 21, 24, 28,

Lenses. **A** Wide angle, 20-35 mm; **B** medium-long focus 85-135 mm; **C** long focus, 180+ mm.

35 mm; standard 40, 50, 57 mm; telephoto 85, 100, 135, 200, 300, 400, 800, 1000 mm. Obviously many of these lenses are very close to one another in focal length and the difference between images would be marginal. But the range does offer the scope for choosing different 'spreads' of lenses. See page 65.

A 75-205 mm zoom lens with single control ring for zoom and focus. **A** At longest setting; **B** at setting for shortest focal length.

Zooms

A zoom lens offers continuously adjustable focal length between two fixed limits. You may adjust the framing to fit the pictures exactly instead of changing the camera position. This is especially useful with slides which cannot be subsequently adjusted like a print. There is no need to change lenses so you save time by simply adjusting from one focal length

Macro zoom lens. **A** Macro mode; **B** normal focus range.

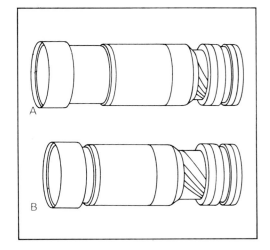

to another. The creative advantages of zooms are discussed later (page 66).

Zoom lenses are available in wide to medium and medium to long focal-lengths. With most newer models the change in focal length is operated by the same control ring as that used for focusing (with push-pull to zoom and twist to focus). On others these are controlled by two separate rings.

A macro zoom lens is a special type that has an extra close focusing range for close-up photography. It is normally operated by slipping a catch to move the whole lens forward.

Lens converters

It is possible to extend the focal length of a lens by adding a special afocal converter or lens extender between the body of the camera and the lens. These converters are available in versions that give 2 × or 3 × increase in focal length whatever the lens fitted. A 2 × converter fitted behind a 50 mm lens gives a 100 mm combination; fitted with a 200 mm lens, a 400 mm combined effect and so on. Though much less expensive than an extra lens the drawback of these converters is that in increasing the focal length they reduce the working aperture. For example, with a 2 × converter an *f*4 lens becomes *f*8. Moreover, you generally need to stop the lens down further to obtain a good standard of sharpness over the whole picture area.

A tele converter lens is fitted between the camera lens and the body to extend the focal length. **1** Camera body. **2** Tele converter. **3** Camera lens.

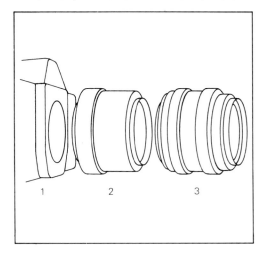

Choice of film

As explained earlier, some films are more sensitive to light than others and require very little exposure to get an image while others, which are less sensitive, require greater exposure. If any film is wrongly exposed the result will be an inferior or spoiled picture. To ensure that each film gets the exposure it needs, its sensitivity or film speed is given an ASA rating.

With this system a film of 125 ASA has twice the speed of one rated at 64 ASA. The range of films widely available generally extends from 25 ASA to 400 ASA and in the case of special film, such as some of those used in instant photography, the rating may be as high as 3000 ASA. The other speed rating system, DIN, was described earlier and a con-

version table for the ASA and DIN equivalents is given on page 11.

Except in the case of certain cartridge loading cameras, where the ASA speed is set by a notch or key in the cartridge, the film speed must be set on the ASA or DIN dial on every camera with a built-in exposure meter. With a fast film (400 ASA) you can use a fast shutter-speed and small aperture, stopping subject movement and giving great depth of field (see page 45). You can take pictures on dull days and even indoors if you give a long enough exposure. Why not, then, use only fast film? On very bright days and in bright conditions, such as when taking pictures on the beach, too much speed can be a problem. If you cannot set a small enough aperture and sufficiently fast shutter-speed your film will be over-exposed.

Also, the actual quality of the image you get with the slower films is usually better. It is sharper, gives more detail and the colours on colour film are generally stronger. With fast film the grain structure of the film becomes apparent with enlargement, particularly if small areas of the picture are selected for enlargement. Fast film has lower contrast.

The best all-round compromise is a medium-speed film, say 64 to 125 ASA. This gives sharp images, little grain, good contrast and the colour rendering is excellent. It has sufficient speed to be used in average conditions. It can also cope with the brightest days without resulting in over-exposure.

Slow films are ideal where the finest possible sharpness and resolution of detail is wanted. They can stand great degrees of enlargement without any grain becoming evident, even from a selected area. Colour slides, too, look extra sharp when projected on a screen. The contrast on slow films is generally greater than with medium-speed films. Their main problem is that you need good light to gain the advantages of which the film is capable.

If, because the light is not good enough, you have to use a slow shutter-speed or extra wide aperture with the camera held in the hand, then you will probably not be getting the sharpest of images, in which case you would do better with a medium-speed material that allowed you to obtain the best from the cam-

era. If, on the other hand, the subject is stationary, the camera can be firmly mounted and you can use a medium aperture, then a slow film will give you the best quality images. Slow films are generally used in copying work because there is little difficulty in supplying enough light or in giving long enough exposures with the stationary subject matter.

Colour slide film: daylight and tungsten

The colour film you use for all outdoor daytime photography is known as daylight film. It is designed to give accurate colour when exposed with daylight as the source, outdoors or indoors, or when used with flash.

You can also buy a 'Type A' or 'tungsten' film which is intended for indoor photography by photolamps and can also be used when taking pictures of street scenes and illuminations at night. It also works with most ordinary indoor home lighting, and although it is not ideal for this it is a better choice than other materials. Tungsten Type A film is mainly available for 35 mm and roll film cameras.

On the face of it there is little difference between daylight and indoor lighting; both are 'white' light. But the quality of white can vary according to its constituent colours. White light consists, literally, of the colours of the rainbow. But the whiteness of white light depends on the exact mixture of these colours. Daylight for instance, contains much more blue than indoor light, which is why lamps look more yellowish-pink than the light coming in through the window.

Film is much more aware of the exact differences in quality of light than we are and the 'warmth' or 'coldness' (redishness or bluishness) of the light is calibrated for convenience on a scale of colour temperature units known as Kelvins (K). The whiter or more bluish-white the light, the higher the 'K'. Daylight, for instance, has a colour temperature of 5000 – 6000 K, whereas photolamps are 3200 – 3400 K and ordinary home lighting about 2800 K. The differences between these light sources are particularly noticeable when more than one appears in the same picture and it is usually a good idea to avoid such a mixture if possible. There is a useful combination available with flash (electronic and blue bulbs) and daylight because flash may be used outdoors in strong sunlight to reduce the contrast of light and shade and put a little detail

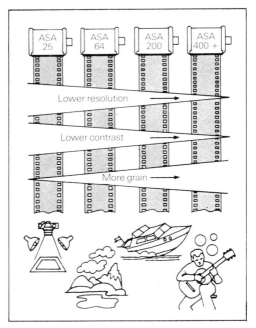

Choose a film to suit the situation, according to its speed and other characteristics. Slow films (ASA 25) give the sharpest image and finest detail. Medium speed films (ASA 64) are best for general work and the fastest (ASA 200, 400 +) for low light. Slow colour films (ASA 25–64) give the brightest colour rendering.

into the shadow areas of the subject. This technique is known as fill-in flash.

If you use a film in the wrong light source you will get a very heavy colour cast over the whole picture. Daylight film used with photolamps or home lighting has a strong orangey-red cast, whereas Type A films used in daylight have a heavy blue bias.

Colour print film

Colour print film is normally only available in one type. This is because it is possible to control the colour rendering in making the print so that any bias in the negative can be compensated by filters when a print is made. With slides this is impossible because the film you expose in the camera is the actual film that becomes a slide; no printing is involved, only processing.

You should not expect the same quality from colour print films as you get from black and white materials of the same speed. Whereas all fast films give coarser grain than other films the grain in colour pictures is usually worse because the structure of the film is more complex.

Instant picture film

There are two basic sorts of instant picture film; the type you peel apart and the type consisting of a single sheet. The single film sheet produces a print on which the image begins to appear after a few seconds and is fully revealed in a couple of minutes. With the peel-apart system the picture is pulled out of the camera after each exposure, so beginning a chemical process. After a minute or two you peel apart the two sheets and you have a print and negative. In some cases it is possible to wash the negative and use it for making subsequent prints but normally the negative is thrown away. Colour instant film is of slow to medium speed, black and white is often a very fast material.

With fast film you can shoot in dull weather or evening light. If you can get up close enough to the subject the moderate degree of enlargement needed will not reveal the graininess of the film.

Light and exposure

It is possible to expose film according to the recommendations in the leaflet supplied with the film. These are rule-of-thumb exposure settings and depend to some degree on the interpretation you give them. A more accurate and reliable method, provided you handle it correctly, is to use an exposure meter, especially when shooting colour slides. You can get away with marginal exposure errors with black and white film and colour film negative is also reasonably tolerant of inaccuracies, but colour slide film must be exposed correctly or you will get very poor results. In any case, unless you expose a colour or black and white film properly you are not going to get the best out of it and you could very well end up with inferior prints.

Simple cameras often have an exposure control using symbols for various weather conditions. A scale of several symbols would be sufficient for reasonably accurately exposed snapshots, taking for granted the occasional failure. Exposure, the photographer's traditional nightmare, has become much less of a problem since the appearance of automatic cameras, but even these are not foolproof. People often assume that the meter

On simple cameras the exposure is sometimes set by a symbol indicating such conditions as bright sunshine and open aspect, bright sun, hazy sun, cloudy bright and cloudy dull.

does more than it can, with a resulting failure rate of ten to fifteen per cent of pictures taken.

What to expose for

Exposure meters are designed with the assumption that the subject they are measuring consists of a mixture of light and dark areas which, taken together, add up to a mid-tone, or that the mid-tone forms the greater part of the picture. The reading they give will always be correct where these conditions are found. So, on automatic cameras the meter reading given is, for about ninety per cent of the time, correct, or at least satisfactory. Even if the light is fluctuating it takes account of that. What then happens in the other ten per cent of cases? If a subject consists of large areas that are extremely bright but also some small dark areas, or the other way around, the meter can get quite the wrong impression. If it is a fully automatic camera it will set the wrong exposure, unless you can intervene and put matters right.

For example, if you have a subject standing in a shaft of sunlight and the large surrounding areas are dark, the meter will take an average of all areas added together (i.e., mostly shadow) and indicate, or set, an exposure which will result in the light area being overexposed. On colour slide film this would probably make the subject almost vanish.

The reverse creates a similar pattern. When someone is photographed with the sky as background the meter reads the average of the light it sees (which is mostly sky) and indicates or sets a reading that results in the person being grossly under-exposed, possibly appearing in silhouette.

The way to overcome this problem is to go up to the subject and take a reading of the light reflected and set that, overriding the automatic control. If it is not possible to approach the subject, take a substitute reading from any other subject nearby that appears to be of a similar tone.

The largest problem is in identifying the cases where your meter is going to be misled, and making the necessary corrections. Watch out for all situations where the subject has an exceptionally light or dark background, where part is in direct sunlight and part in deep

A reading of the subject may be unduly influenced by the background. For consistent exposure for the subject, with very bright backgrounds open up the aperture diaphragm by one stop; with medium-tone backgrounds set the reading indicated, and with dark backgrounds close down the diaphragm by one stop.

shadow, where the sun comes from behind the subject and may influence the meter directly, or where you are dealing with excessive contrast in the picture.

It is usually only necessary to give an extra stop, or one stop less, to put matters right. You may have to base your correction on the wrong estimation given by the meter. So, where the predominant tone is light and the subject itself dark, you need to increase exposure by about a stop (one f number); where the predominant area is dark and the subject itself light you need to decrease the exposure by a stop. In doubtful cases you should 'bracket' your exposure reading. By this is meant taking three exposures, the one indicated by the meter, and one either side i.e., one stop more and one stop less.

Bracketed exposure readings are especially advisable when taking pictures against the light. The amount of detail you show in the shadow side, which faces you, depends on the exposure you give. If you want full detail in the shadows take a close-up meter reading from the shady side. If you cannot get close enough, take the general reading (shielding the meter from direct sunlight) and then add

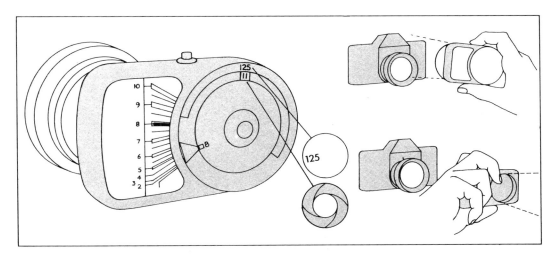

With a hand meter first set the ASA film speed (125) on the dial. Take a reading and transfer the indicated light value to the calculator dial. Read off the shutter and aperture combination from this (11). Indirect readings with the baffle in position are taken with the meter pointing at the camera; direct reflected readings with the meter directed at the subject.

one stop to the exposure, i.e., f5·6 instead of f8. If you do not want any detail in the shadows take the general reading or read from the bright areas of the subject and set that exposure without alteration.

Using the meter

With a separate or hand exposure meter you have to determine the exposure first and then transfer the figures to settings on the camera. With a meter built into the camera this is usually done semi- or fully automatically and, consequently, is much quicker to use.

The best hand-meters are super-sensitive and can take readings at very low levels of light indeed, well beyond the range of any meter built into the camera. A modest hand-meter is useful to have for checking exposure without moving the camera. For serious photography with a camera that does not have a meter built in but allows a full range of speeds and apertures to be set, a meter is essential. A hand-meter is also invaluable for taking readings close to the subject when the camera is on a tripod.

Hand meters

Set the film speed on the ASA or DIN calculator dial. To take direct readings of the light reflected from the subject be sure that the

Exposure as a creative control. By under-exposure only the bright highlights are fully registered on the film; surrounding details are suppressed and so lost in blackness.

white incident-reading baffle is not in position over the meter window. Point the meter at the subject and note the figure at which the needle comes to rest on the light value dial. (On some meters you turn the calculator dial to move a pointer which must be aligned with the needle.) Set the light value on the dial which then tells you all the speed and aperture combinations you can use. Select a combination and set these on the speed and aperture controls on the camera.

Some hand-meters can be used to measure the light falling on the subject rather than that reflected from it. These so-called 'incident' light readings are convenient when you cannot get close enough to the subject for a reliable reading of the light reflected from it, or where other conditions would interfere with such readings. The meter has a white baffle which fits over the cell window. With this in position go up to the subject and take a reading with the meter pointing straight at the camera. In many cases where the conditions are the same you can take this reading from the camera position but turning round and holding the meter as if you were standing by the subject and reading it as before. This reading, like the reflected type, represents the

integration of all subject tones to a mid-grey. It is not, however, affected by light or dark backgrounds as a reflected light reading may be. This is a reliable method of determining exposure but unfortunately cannot be built-in with an automatic camera metering system of the modern kind.

Another way to read exposures is to take a reflected-light reading from a special (18 per cent reflecting) grey card. This method is akin to the incident light system in that readings are not affected by extraneous subject matter, bright areas or freak lighting conditions. Simply hold up the card against the subject and use the reflected-light meter in the normal way, taking care not to cast a shadow on the card, the meter itself or your hand.

With ordinary reflected readings taken from an outdoor source it is advisable to point the meter slightly downwards to avoid including too much bright sky which could influence the results.

Camera meters

There are various types of camera exposure meter. Some, virtually separate meters built in to the camera body, necessitate transferring

Exposure meters can be misled by over-bright subjects. With a snow scene for example, a meter may indicate such a short exposure that little detail can be obtained in mid-tone subjects. Therefore you must increase the exposure by one stop over that indicated in a direct reading if you want such detail. If not, a near silhouette will result.

Through the lens (TTL) metering, using needle alignment. With the ASA film speed dial set for the film loaded in the camera (64), the shutter speed is selected (1/125 sec.) and the diaphragm ring turned until the needle seen in the viewfinder is centred, giving the correct aperture for the brightness of the scene. The aperture may be set first and the shutter speed determined by centering the needle.

Shutter priority method: set the shutter speed required, then turn the aperture ring until the needle is aligned. This is the correct aperture setting for the brightness of the scene.

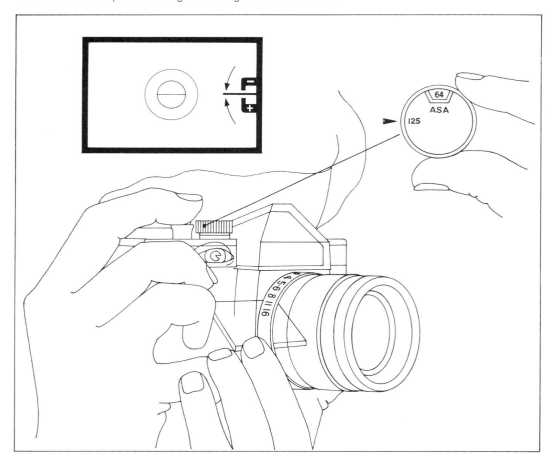

figures from one dial to another for the correct exposure. On others, a follow pointer is coupled to the aperture dial. As you align the pointer with the meter needle the correct aperture is set. On many semi-automatic cameras which have an exposure meter that reads the light level through the lens, the correct exposure is set when a needle aligns with a fixed point visible in the viewfinder. Some cameras indicate the aperture in the viewfinder once you have set the shutter speed (shutter speed priority); others set and display the correct shutter speed once you have chosen the aperture (aperture priority). Whether exposure is indicated by a needle or lights the principle is basically the same: a tie-up between shutter, aperture, the film speed (previously set) and the brightness of the subject as seen by the meter. Automatic meters are easy to use but they must be handled with care as they are as likely to be misled as any whose readings are of reflected light. The camera normally sets or indicates a reading for what

Exposure reading methods with a built-in TTL meter. **1** General view. Point the camera slightly downwards to avoid sky. **2** Take a reading from the highlight and shadow side of the subject and set an intermediate aperture or speed. **3** Against the light subjects. Read the shadow-side close up to show shadow details. **4** Take a flesh tone reading off your hand. **5** A grey card reading. **6** Fit a long focal-length lens to confine the reading to a small area of the subject or to take a long-distance reflected-light reading.

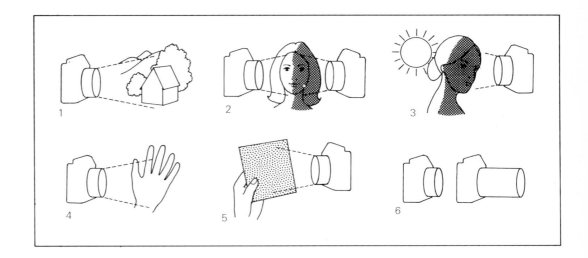

the meter sees through the lens. But many cameras have an exposure 'memory' device by which you may take a reading in one place, hold it, and then give that exposure when you point the camera elsewhere.

With a subject in surroundings that might fool the meter, you could point the camera at a nearby area of similar brightness, hold the reading, and then point the camera at the subject and give that exposure.

A fully automatic camera that does not allow exposure adjustment can be made to give either one stop under or over the reading by moving the ASA dial to either double or half the film speed.

Through the lens (TTL) meters measure from certain parts of the picture area depending on the make of camera; the instruction booklet for individual models should take account of this.

Aperture and depth of field. *Left*: depth of field scale. A small aperture ensures sharpness over a greater range of distances than a large aperture. Aperture numbers either side of the focusing index are opposite figures on the distance scale, indicating the near and far limits of the depth of field. *Right*: zone focusing. The standard lens (left) can provide two or more useful focusing zones according to the setting of the distance scale. A wide-angle lens (right) covers a deeper zone at the same aperture.

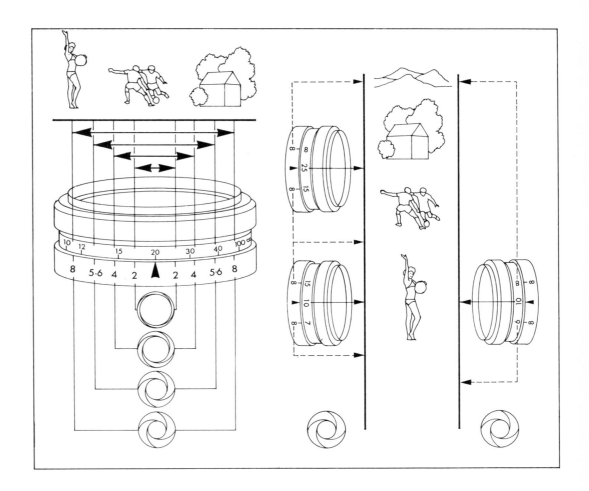

Things that move

Many, if not most, of the subjects that you are likely to photograph contain some movement, however small. You must be able to control subject movement otherwise you will have blur where you do not want it. Conversely, if you have been *too* careful to avoid it all your pictures may seem static and lacking in life.

Advantages of subject movement

Your human subjects may stand stock-still for you to take a picture though it might sometimes be better if they did not, but the trees beyond may move or someone's clothes or hair might be blowing about. And if it is really windy you could be having trouble trying to hold the camera steady while you are being buffeted by the strongest gusts. One way or another there is constant movement and much of the time things would be a lot easier without it.

Animals may not be so obliging as humans, and often you have to be very quick to take them while they are still. Even then, the stationary poses may not be the best ones. You need activity to put life into your pictures, and it seems a little pointless to photograph immobile subjects that are normally on the move. Even the people you photograph lined up against a background of rocks would probably feel much more relaxed if they were playing with a beach ball or a Frisbee, while the close-up of a face is enlivened by catching a sudden turn of the head. A formal grouping of people can look very pleasant but for a change, especially when the same group must be photographed many times, you could try making them all walk towards the camera as you walk backwards, and take the pictures on the move.

The same considerations apply to mechanical subjects. There is much more excitement in a motorcycle at speed with the rider taking the bend or accelerating out of the mud than a polished but riderless machine on its stand with only a brick wall beyond. For variety in your pictures, after you have taken the standard arranged pictures, try to find some movement, or if it is not there, induce it.

Cameras for many subjects

There are some subjects in which movement is endemic. (Techniques for action subjects are discussed on page 90.) For these you generally need high shutter-speeds (unless you want the subject to appear blurred), fast film and, in some cases, long focus lenses. Also, a quick eye, quick reactions and a good deal of practice. You would be making life unnecessarily hard for yourself if you did not also use the right camera. This, especially for sport, is one area of photography that really does demand the right equipment.

Although there are sometimes opportunities to pre-focus on a partucular spot (see page 87), for most action photography you need to focus while you shoot. So the ideal camera is one with either screen focusing, i.e. reflex, or a rangefinder, coupled to the focusing mechanism. The rangefinder must be visible in the normal viewfinder and on modern cameras it always is. Unfortunately, most modern rangefinder (non-reflex) cameras do not have interchangeable lenses and that facility is essential for much of the action shooting you are likely to do, and virtually all outdoor sport.

Indoors you may need to use a wide angle lens, though the semi-wide angle standard (e.g. 35 or 38 mm) lens permanently fixed to some compact rangefinder cameras may be very suitable indeed because you get a large image without distortion (see page 65).

The single lens reflex (SLR) with interchangeable lenses is the best all-round camera for action. But it must have a pentaprism viewfinder, as do all current 35 mm models, although on a few this is a removable item and there is an alternative waist-level finder. All roll-film single lens reflex cameras can be fitted with a pentaprism. Without a pentaprism finder the reflex viewfinder screen image is seen the right way up but laterally reversed.

Movement and distance with deliberate blur. The dodgems nearest to the camera blur more than those in the distance even though they are all moving at the same speed. While the shutter is open nearby subjects move further across the film than those at a greater range.

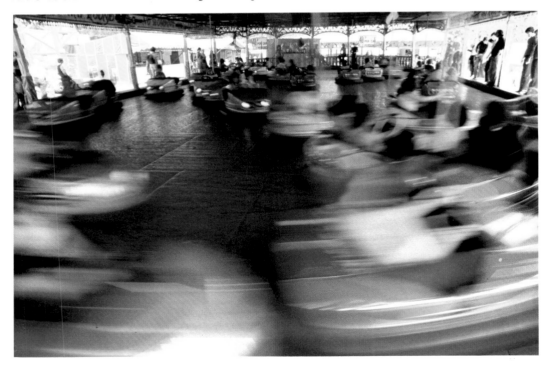

So, when an object moves across your view to your right, it moves towards the *left* of the viewfinder screen.

It is virtually impossible to follow a moving subject with a finder in which the subject appears to move in the opposite direction from the way the camera must move to keep it in view. Twin lens reflex cameras also suffer unless used with a pentaprism (or the sports finder) and, except for one model, do not accept interchangeable lenses. Most photographers would find these cameras very inconvenient, if not completely unsuitable, for action photography and would almost certainly choose a 35 mm SLR instead.

The 35 mm format has the advantage of offering the widest choice of lenses at reasonable cost, including some of very long focal-length that are either unavailable or extremely expensive for cameras of other formats. Another point in its favour is that the focal lengths normally used for a good-sized image on 35 mm film allow sufficient depth of field to give you a reasonable chance of getting a moving subject in sharp focus. Those for the larger roll film cameras, however, must be of greater length to get the proportionally larger image needed to fill the big negative or slide. This, consequently, allows less depth of field. Loss of sharpness through slightly inaccurate focusing, is noticeable, even though the big negative or slide requires far less enlargement to make a print or fill a projection screen compared with those on 35 mm. In other words, you do not necessarily gain, and you might possibly lose advantages by selecting the larger camera. If, however, you select a lens of the same focal length as that on a 35 mm camera, although the subject appears the same size on the negative or slide, there is more space around it and you would therefore have less difficulty in keeping a fast-moving

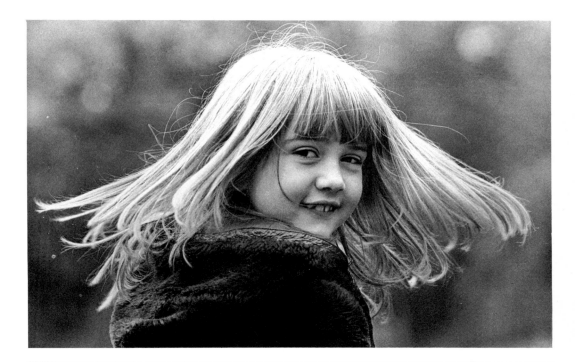

Deliberately induced movement (*above*) to impart life to a picture. The subject suddenly turned towards the camera and her hair flew out in separate strands, caught by a high shutter-speed. Moving subject, stationary camera (*right*). The waterfall was photographed through a 200 mm lens. A slow shutter-speed was needed to show movement in the water and a small aperture to give sufficient depth of field. A camera held in the hand with this combination of lens and shutter speed would have blurred the whole image, so a tripod was used.

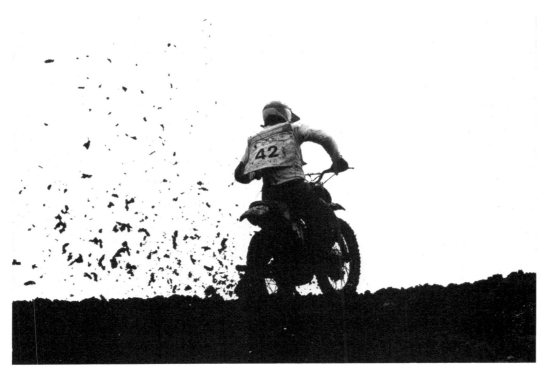

High shutter-speed. The flying mud is suspended in mid-air by the use of a high shutter-speed. For this you need a camera with a speed of 1/1000 or 1/2000 sec.

subject within the picture area. You can enlarge selectively from your negative or slide and so reposition the subject if it is not quite right. With 35 mm, your framing would have to be correct, and the subject should fill the picture adequately. However, selective enlargement from small areas would probably reveal grain to an objectionable degree if the fastest film had been used. For the same reason the tiny image on the 110 film makes cameras of this size unsuitable, even if their focal length can be varied.

Power winders or motor drives are a great advantage with action work, so a camera that can accept one of these is a good choice for action photography. You need not take the camera from your eye while you follow a moving subject and it is always ready for the next shot. If you hold the release down you can take several pictures in rapid succession.

Moving and static camera

Action photography almost inevitably requires the use of long focal-length lenses. Lenses of greater than 200 mm focal length are difficult to hold steadily for sharp pictures. Some lenses are simply too cumbersome to use without support and the longest focal lengths can only be handled with a tripod. Except with these lenses, the moving subject may be best tackled with a hand-held camera. This gives you freedom to follow the scene and a fast shutter-speed may cancel out the effects of unsteadiness.

There are various aids to improve your chances of holding the camera steadily without actually setting it up on the ground. Some people find that a pistol grip gives them good control. It screws into the bush at the base of the camera and a cable release from the trigger is fitted into the cable release socket in the camera. You hold the grip and squeeze the

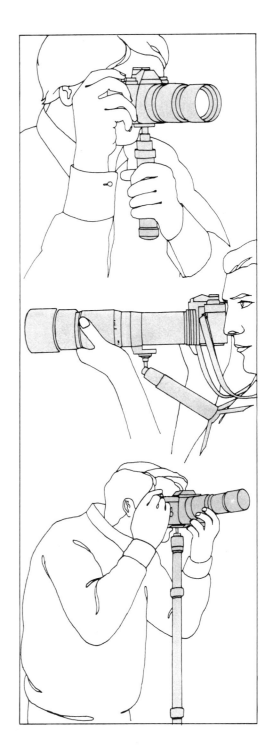

Camera steadiness with freedom to follow movement. Miniature tripod in the folded position can serve as a pistol grip (*top*); when extended it becomes a chest pod. A monopod (*bottom*) is a one-legged tripod that gives vertical rigidity.

This is what can happen if you use a slow shutter-speed with a long focal-length lens where the camera is used in the hand without any special support.

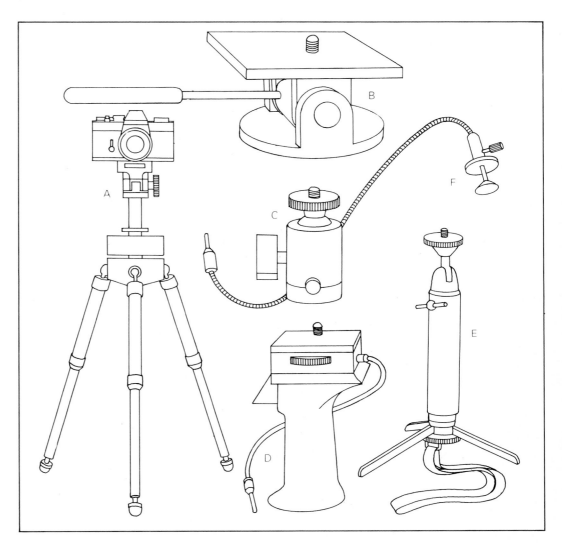

A tripod is the most solid support, **A**, for a camera. The pan-around tilt head, **B**, allows controlled movements in both horizontal or vertical planes. The ball and socket head **C**, can lock the camera at any angle. The pistol grip, **D**, is a one-hand camera-holding device. The table tripod, **E**, is seen in its normal open and upright position. A locking cable release, **F**, is used with any of these supports except the pistol grip which has its own connected to the the trigger.

trigger while focusing or steadying it further with the left hand.

A small table tripod, when collapsed and in the folded position with the camera mounted on top, serves much the same purpose. But with this arrangement you use the right hand to release the shutter in the normal way. When the tripod is opened and the legs are extended it can be placed on the chest to serve as a support for use with long focal-length lenses.

Ground support

Another device to support the camera is the monopod. More compact than a tripod it stands on the ground and gives support in the vertical plane only. But it allows you freedom to pan the camera or tilt, according to the type of head fitted.

A tripod gives the firmest support of all. Ideally, it should be very heavy. But this is often impractical and most people settle for a lighter type that folds up in many telescopic

sections. When open it should allow sufficient spread to form a steady mounting. The feet often have interchangeable rubber and spiked ends to grip different types of surface. More elaborate tripods have a central pillar that may be raised or lowered to the required camera height. The central section should only be used when the legs are fully extended and give no more height. Very long and heavy

lenses should be positioned immediately above one of the legs for maximum stability (though many lenses have fixing screws positioned at their centre of gravity) with the other two legs arranged to leave a clear space for the photographer's feet when standing behind the camera.

The table tripod provides a level or adjustable stand a few inches above a flat surface.

First, catch your subject . . .

The camera has the ability to snatch a moment from time and make it permanent. If it can catch the *right* moment, the picture can do a lot more than just record the scene. Press photography has shown how a single picture can tell a whole story. Your own pictures, if given thought, can do the same.

The elusive subject

When you photograph people you can often see their expressions change. One moment someone's face may look a bit blank – especially if they know you are going to take a picture. The next, a characteristic expression appears that tells you much about their personality. If two people are taking pictures and one catches that special moment, then however excellent, technically speaking, the other person's pictures, most people will prefer the first – even if the picture is poorly composed and not quite sharp. In photography, spontaneity wins every time.

Sometimes you may be about to take a picture when something happens – someone gets in the way and spoils it. Try to think of that not as a lost opportunity but a new one presenting itself. You have to be flexible in your thinking to take advantage of situations as they develop. By being patient and keeping alert things will seem to happen for you. When they do, keep calm, focus and shoot.

Staged pictures

It is possible to set up a picture and get a reasonably impromptu-looking result. More often staged pictures look just what they are, prearranged for the camera. The most suc-

cessful ones are usually of something you have actually seen. You could ask someone to continue what they are doing but to move back a little where the light catches them at a particular angle, making a much more interesting picture.

Subjects that repeat

Where some activity involves predetermined movements or repeatedly covers the same ground, you can train your camera on that spot and simply wait for the subject to reappear. Although recommended in connection with sports and athletics (page 90) this technique can be applied to many more general subjects. The advantages are that you can preset exposure and focus and select just the camera position and focal-length of lens (if you use different lenses), all at your leisure. You have time to look for a rigid support, if needed, on which to rest the camera. So although your subject may be moving you can be certain to get first-class technical quality.

Techniques for the unsuspecting

To be always at the ready you can preset your exposure and focus (page 87) to cover most likely eventualities. But one quite important factor when photographing people is not to be seen – if you can manage it. You can use tricks like taking a picture and then looking the other way, or pre-focusing on an object at the same range but in another direction and then swinging round at the last moment to get the picture you want. You can use a right-angle mirror on the lens. But the thing that will help you more than anything is speed – to see the subject, choose the moment, point and shoot. Pictures can come and go in seconds.

The autumn scene (*far left*) was not pre-arranged. The girls just walked into the scene at the right moment. It was only necessary to press the button when they reached the best place in the composition. The man at the street festival (*above left*) was dancing and momentarily turned towards the camera. The goat (*left*) inquisitively pushed his nose into the lens. These pictures all required a quick response. The musician's face (*right*) was lit by reflections from his instrument every time he started to play. To get this picture, it was only necessary to wait for him to play again, meanwhile he crossed his feet (*above right*).

Black and white

Why take black and white pictures today when colour is so generally available? Some people feel that black and white pictures are somehow more 'photographic' than colour ones, and it is undeniable that in the company of a mass of colour pictures a few examples in black and white certainly draw the eye. In an age when we are surrounded by colour — magazines, television, advertisement hoardings and packaging — black and white images have a stark quality that demands attention.

From the photographer's viewpoint, black and white technique offers several challenges that colour does not. In all except 3D photography, the three dimensional reality of our world is reduced to the two dimensions of a flat print. Normally, different colours define objects sufficiently to allow a clear separation between various parts of the scene. In black and white, however, this advantage is missing and subjects tend to merge unless they are sufficiently differentiated in *tone*.

This can be achieved by several means — by knowing how various colours will reproduce when turned into the tones of black and white film and making sure that these tones are sufficiently far apart for the different features of the subject to separate when viewed in a print. The realism of the picture depends considerably on the control of tone. In a landscape the illusion of distance, due to objects reducing in scale, is enhanced by an equivalent weakening in tone, especially if several 'planes' of tone are visible in diminishing order, one behind the other. The strongest impression of depth and solidity in objects is achieved by the effect of light 'moulding' or 'modelling' the subject and revealing its volume and texture.

To achieve all this you have only light and shade. But an advantage of black and white photography is that you can control this tone, and sometimes by falsification achieve a result that is actually more, or less, realistic.

Black and white allows you to imagine an effect and then bring it into being by juggling with the tones. (If you do your own processing and printing, this is not at all difficult.) One way to do this is by fitting filters over the camera lens. A full range of filters enables you to 'correct' or rebalance the tones in relation to one another at will. The most useful and popular filters are the ones that lighten foliage or make the clouds stand out against a blue sky (yellow and yellow-green).

The mechanical side of black and white photography is much easier to handle than colour. You are far less likely to make mistakes and, even if you do, you may still be able to get a reasonable final print. It is possible to shoot black and white slides, but most people use negative film from which they subsequently make prints.

Black and white film is generally more tolerant of exposure errors than colour. It gives you a much sharper image (because the film is of simpler construction) and you do not have to worry about mixing light sources such as daylight through a window and ordinary home

Tone. In black and white photography colours are reproduced as tones. You can control these tones by exposure and the use of filters, and care in making the prints. A realistic differentiation is made here between the white woodwork and the pale blue-green walls.

then go on to colour printing when you feel you have enough experience.

Black and white photography is much cheaper than colour and can be a lot more fun unless you are expert at colour printing. The scope for creative photography is immense and many serious photographers consider that only black and white pictures can give the ultimate precision and quality of which their equipment is capable. The creative potential of black and white is so great that most of the world's famous photographs are in this form. It means a different way of seeing but its images are full of power and drama.

Filters and their effect

Medium yellow	2	Darkens blue slightly
Deep yellow	2½	Darkens blue moderately
Pale green	3	Lightens green, darkens red, orange
Medium green	4	Lightens green, darkens red, orange further
Green	5	Whitens green, darkens red, orange, blue slightly
Blue	5	Brightens blue, darkens red, orange, yellow
Orange	5	Brightens orange, red, darkens blue, green
Light red	7	Lightens orange, red, darkens blue, green
Deep red	10	Lightens orange, red, darkens blue, green

lighting. Neither are colour casts reflected from objects or the reddening effect of morning or evening light of any consequence.

If you intend to do your own printing, you should start with black and white and learn to control the process in its basic form. You could

Composition (*above left*). You can manipulate the tones of a black and white photograph to strengthen the composition. Here the contrast was slightly forced so the dark areas are more than normally assertive. Modelling (*below left*). The shape and volume of subjects is shown in black and white pictures mainly by the way the light falls on them. The deep curve of this dead leaf is moulded by light from the side. Texture (*below*) becomes most apparent when light strikes the surface of the subject from a very oblique angle.

Colour

In some ways taking pictures in colour is easier than in black and white. You do not have to be so concerned that the shape of the subject is modelled with light, or make sure that it differs sufficiently in brightness from the background in case they merge. Nor do you have to arrange or falsify tones to suggest depth in a scene. The actual volume of subjects may or may not be apparent, but their colour is paramount.

In a colour photograph you often determine the shape of the subject by the outline of its colour against those of the surroundings. It will not be confused with the background because, even if it is of the same brightness, it is virtually certain to be at least slightly different in hue. Depth is indicated by the clear differentiation of objects beyond other objects and the colours themselves may even help to reinforce this feeling.

The truthful film

Colour photography does have its own problems however. With our eyes we tend to look at the colour of subjects in a selective way. The brain makes sure we do this. But colour film cannot make any such choice. It records exactly what it sees, so that if a snowscene is lit by a blue sky, the snow, too, will be tinged with blue and be especially noticeable in the shadow areas.

Colour casts

In colour photographs objects are frequently tinged with reflected colour from nearby objects as in the children's game of holding a buttercup under the chin and making a yellow cast to see if the person likes butter. In many situations the colour reflected from surrounding objects may be acceptable, even attractive. But there are some cases where it is not, most commonly in the reflection of grass on a person's face and clothes, which thereby becomes tinged with green. A brick wall may throw red reflections onto one side of a subject's face and we have already mentioned the problem with blue skies.

Sometimes you can do very little to avoid these difficulties. But it is still worth keeping a sharp lookout for them because it may be possible to avoid the more unpleasant colour casts by moving the subject a few feet or changing the camera angle.

When it works best

By isolating a subject from its surroundings, great emphasis is placed on the colours in a picture. Also because of what we can call the film's over-responsiveness to colours (particularly colour slide film), they seem to be brighter in pictures than they are in real life. Consequently we should be discriminating in the way we use colour film and try to take advantage of the freedom to combine pleasing colours, while avoiding disharmony and habitually crowding too many colours together. Colour photography offers many good examples

One approach to colour photography (*left*) is to seek out the most colourful subjects you can find. But a mass of colour does not always make a good picture. If they are too discordant they may devalue each other and weaken the whole picture.

of the truth of the adage 'less is more' — less colour is more effective. Some of the most potent pictures use extremely limited ranges of colour or tone. A powerful effect is achieved by a single bright spot of colour seen in surroundings of very restrained hue.

The strongest colours grasp our attention so firmly that to place a subject against a vivid area of background may well shift the interest from the subject to that of its background. People sometimes ask to be photographed against a bed of flowers, when in many cases they would be seen better standing in front of

something containing colours that are less competitive.

Another contradiction can arise here because of the apparent behaviour of colours — again, more significant in pictures than in life. The so-called warm colours, yellow, orange, red, appear to come forward, whereas the cold colours, blue, green and violet, recede. Certain juxtapositions of these colours create an odd effect. A blue dress seen against a red background appears as a section cut out of it, while a bright red jersey can come forward in such a way that it seems to detach itself from

A picture may have only a single colour for its theme. In this case (*above*) the blue painted door and sky above are an exact match, separated only by a neutral tone. Complementary colours (*below*) or those that just pleasantly harmonise or interact with one another (*right*) are a good basis for colour design in pictures.

the wearer. When colours are arranged according to their behaviour pattern, (e.g., red foreground, green mid-distance, blue beyond) the picture gains in apparent depth. Nature, with which we associate the behaviour of colours, arranges these patterns for us in this way. The strong associations we make with colours are important. Colour is suggestive of conditions — dull weather with cold colours and warm with bright colours.

How to choose colour

It may seem a little odd to suggest that anyone taking pictures of what they happen to find should actually 'choose' or 'use' colour to gain a particular effect in photographs. However it is more a question of noticing when colour works best so that observation of potential colour subjects becomes a habit. Some people have an instinctive sense of colour, but they are a minority; most people have to make mistakes, see the results and so learn something about the medium.

Colour theories describe the behaviour of colours according to physical laws rather than individual preference, but what matters to the photographer is the practical effect of placing certain colours together and varying them in quantity, strength, and distribution.

Hue, brightness, saturation

Hue is the name we give a colour, such as red, yellow and green. *Brightness* denotes its strength in relation to other colours, orange for instance being brighter than blue. *Saturation* stands for the purity of colour; less saturated colours contain more white, more saturated colours are stronger. Despite many theories over the centuries it is not definitely known how we perceive colour. Some physical effects, however, do remain valid whatever their cause or logic. Certain colours interact with one another as pairs, by both complementing and opposing one another. Red and green for example, cannot be merged by blending, yet when placed alongside seem to reinforce one another, and increase in apparent brightness. This 'simultaneous contrast' is

Artificial light does not have the same colour quality as daylight and you must use a special film designed for tungsten illumination. Even with this, many non-photographic lights give a rather warm colour rendering.

related to the behaviour of the eye whereby if it sees one colour for long enough it tends to produce the complementary colour as an after-image. Stare at a green object for a length of time and then look at a white sheet of paper. You will see a magenta image of that object. The same happens with yellow and violet, blue and orange, and even black and white.

Interactions also occur between areas of pure tone. Grey appears darker when surrounded by white and lighter when surrounded by black. The neutral grey area will also alter towards the complementary of any colour surrounding it, e.g., surrounded by red it will appear tinged with cyan and vice versa.

Colour interactions are broadly categorised in terms of their actual or imagined character and the feelings we associate with them, the ways in which they contrast with one another, and the ways in which they may harmonise.

Colour character

Blue is associated with cold, shows apparent depth or distance in pictures and mixes easily with red or yellow to give violet or green. *Yellow*, the brightest colour, is associated with warmth yet, like blue, also with depth and distance. It does not advance. *Red*, the warmest colour, advances and gains warmth when placed alongside darker colours, but it is weakened by adjacent light areas. *Green* is a quiet colour which, in pure form, is associated with coolness but is sensitive to influences in either direction according to the mixture with blue or yellow hues.

Colour contrast

Principal colour contrasts are those of:

 1 *Warmth*, the colours, as above, being set against one another.

 2 *Complementary contrast*, where the colours reinforce one another, e.g., red-green, yellow-violet, and blue-orange.

 3 *Brightness*, where the brightness (i.e. according to white or black content) of the colour is varied in the picture to contrast one area with another.

 4 *Quality*, i.e. purity of saturation according to the influence and admixture of other colours.

Colour contrasts are all influenced by the rela-

White foxgloves, a monochromatic subject for colour photography. Subjects containing any pale colour should not be overlooked, as colour pictures give quite a different representation of them.

tive size of areas that each colour occupies in the picture.

Colour contrasts are most effectively exploited where the number of colours in the picture is kept to a minimum and the composition itself is simple. Many colours placed together create confusion and discord and they tend to weaken each other, whereas some of the most effective pictures use only a single colour contrasted with its complimentary.

Colour harmony

Colour harmony is the pleasing sensation of balance that occurs when certain colours are placed alongside one another, regardless of the actual qualities of the component colours or whether they seem, to the viewer, pleasant in themselves. There are no rules about which colours harmonise; recognition of harmony is largely a matter of individual response, where opinion may vary with cultural differences, fashion, etc. Generally, however, closely related and closely blended colours harmonise, and those combinations in which complimentary areas are either singly or both desaturated (diluted with white) are more likely to harmonise than those in which these colours appear at high saturation. Pictures containing large areas of desaturated colour balanced with small bright areas of intense colour are far more likely to produce harmonious effects than those containing the reverse arrangement.

The world in close-up

A close-up photograph allows us to study in detail many objects which we could normally not see in this way with comfort. It reveals detail which is too small for unaided human vision to perceive. And, at even quite modest degrees of enlargement, it turns familiar objects into a form that makes them unrecognisable.

How close can you go?

The normal camera lens cannot focus on subjects closer than about 3 ft. The simplest way to overcome this is to use a diopter supplementary lens, a simple positive attachment which fits over the camera lens. Such lenses are available in different strengths indicated in diopters. A 1 diopter lens allows you to focus on a subject at 1 metre (approx 3⅓ ft) from the camera and a 2 diopter lens at ½ metre (just over 1½ ft) *when the camera is focused on infinity*. If, however, you focus the camera lens at its closest point, say 3 ft, then with the 2 diopter close-up lens fitted, you can render subjects sharp at about ⅓ metre. You can get lenses of 3 and 4 diopters (as well as weaker ones, 0·5 and 1·5) but these strengths can also be made up by adding lenses (1 + 2 = 3; 2 + 2 = 4) always arranged with the strongest lens nearest to the camera lens to minimise image aberration. You can add more than two, but more than three is inadvisable as image quality begins to deteriorate noticeably. You would get better quality by using fewer close-up lenses and enlarging the negative further. With a reflex camera you can fit the close-up lens and focus visually. Users of rangefinder models must position the camera at the distance required and focus the lens according to a chart supplied with the diopter lens. The use of diopter lenses does not affect exposure but does slightly reduce image contrast.

Macro lenses

A special lens designed for close-up work is available for interchangeable-lens reflex cameras. Known as a macro lens, it has a greatly extended focus travel which allows you to photograph objects at anything up to life-size. Because the lens is specially computed for work at this range, the technical quality of pictures is exceptionally good, provided it is used correctly. The lens may be fitted to a camera mounted on a miniature or

Medium range. Gaily coloured wrapping seen reflected in a scalloped silver dish. In close-up pictures you can concentrate on certain features and exclude all the surrounding evidence – ideal conditions for abstract photography. (Standard lens and extension tube.)

Despite the very close camera position the horse's head is not distorted because a side, parallel view was chosen (standard lens).

table tripod (perhaps with a focus slide) for taking small movable objects at close range or, where a handy surface is available, for immobile subject matter. It may also be used on a camera held in the hand. You can set the distance for the desired reproduction size and then just move the camera forward until the subject appears sharp.

The maximum aperture of these lenses is not as great as a standard lens but you do not generally need wide apertures for close-up work.

Extra close, tubes and bellows

Standard camera lenses or macro lenses in interchangeable mounts can be fitted with extension tubes (rings) which increase the distance from lens to film and thereby allow the lens to be focused on objects at closer than normal range. A set of tubes consist of several rings of varying depths which may be assembled in useful combinations to give different amounts of lens extension with a special ring for each end to fit the camera mount and lens. The available extensions, combined with the focus adjustment of the camera lens, provide various degrees of magnification at close range. Separation of lens and camera in this way disconnects the automatic diaphragm and other controls unless the tubes are designed to take care of this (automatic tubes).

A continuously adjustable lens extension is available with a bellows unit which, like the tubes, is fitted between the camera and its lens. By turning a focus control the lens may be moved forward from the normal close-up range to give images that are larger than the actual size of the subject (i.e., into the *macro* range).

When the lens is separated from the camera by tubes or bellows the light it passes is spread over a wider area and is therefore not so bright when it reaches the film. You have then to give longer exposures than normal. The built-in through-the-lens meter in a reflex camera takes account of this change automatically. *Without* TTL metering, you have to add to the exposure (approximately) as follows: magnification $0.25 = \frac{1}{2}$ stop; $0.5 = 1$ stop; $0.75 = 1\frac{1}{2}$ stops; 1.0 (life size) $= 2$ stops larger.

Extension tubes and bellows can be used with the standard camera lens or with a macro

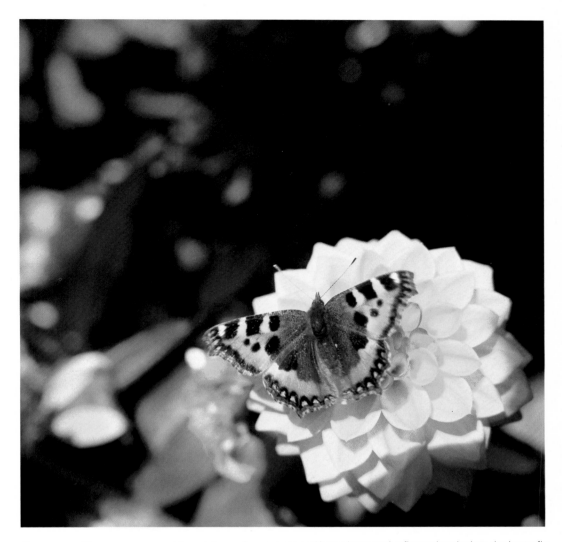

Close range. The camera was set for minimum focus range and brought up to the flower head when the butterfly suddenly settled on it and spread its wings in the sun. The standard lens was fitted with 2 supplementary close-up diopter lenses giving a total of 4 diopters.

lens fitted. Sometimes the standard lens gives better image quality if used in the reversed mode, i.e., attached to the front of the bellows or tubes by its front (filter) thread instead of the normal mount. A special reversing ring is available which enables you to mount your lens in reverse. Generally, however, you would expect to get slightly sharper pictures with tubes than with diopter lenses. Other lenses can be used on bellows; the shorter the focal length the greater the degree of magnification. Tubes can also be used to permit very long focal length lenses, which have limited minimum range, to focus closer than normal when, for example, photographing small birds nearby.

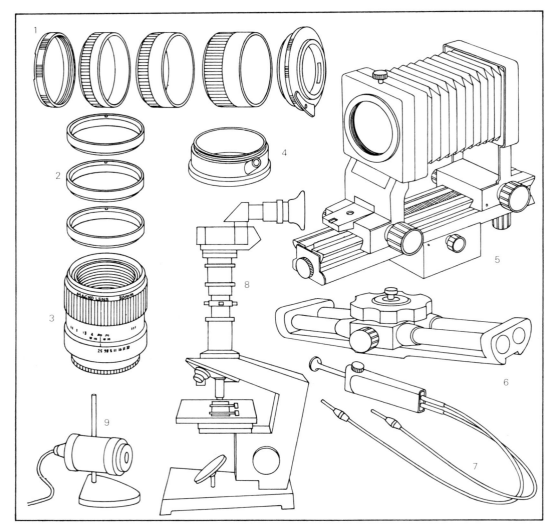

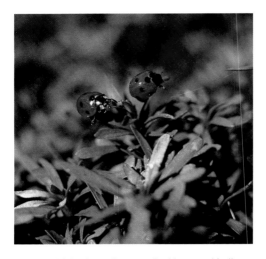

Two ladybirds through a standard lens and bellows unit fully extended to give a life-size image. The exposure needed was four times (two stops) greater than that indicated by a meter reading.
Rhododendron leaves and buds photographed with a standard lens and electronic flash. Flash provides an easy way of obtaining great depth of field at close range because there is enough light to allow selection of a small aperture. Also, the flash is so short that you can hand-hold the camera without any fear of blur from camera shake. But the flash must overpower the daylight completely. Any residual daylight in the picture might register as a ghost image and spoil the result.

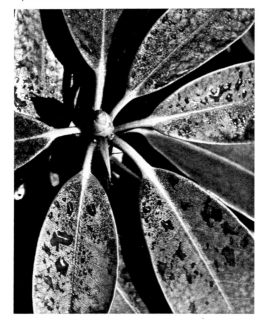

The hardware of close-up photography. **1** Extension rings (tubes). **2** Close-up diopter lenses. **3** Macro lens. **4** Lens reversing ring. **5** Bellows unit. **6** Focusing rail. **7** Double-cable release. **8** Microscope with camera fitted. **9** Microscope lamp.

Through the microscope

You can fit your camera onto a microscope and take pictures in colour or black and white of any subject you could normally view through the eyepiece. Ideally you would use a single lens reflex camera with TTL metering, but rangefinder cameras are also practical on microscopes that have more than one eyepiece. Except for high magnifications (more than 75×), use a microscope without a substage condenser or with its condenser removed, directing the light onto the slide with the concave mirror. Remove the camera lens and fit the body to the microscope with an adapter. Looking through the camera viewfinder, focus with the microscope and adjust the microscope lamp to give even illumination with its iris fully open, then stop down the substage iris (or fit a smaller stop) until the image begins

A piece of driftwood end-on. This log had been afloat for so long that the end was eroded away in a radiating pattern. Standard lens plus one 2 diopter close-up lens.

to lose brightness. Open the lamp iris sufficiently wide to avoid vignetting. Use the TTL meter to read exposures, giving the needle or readout half a minute or so to settle on a reading (it may be sluggish), and adjust exposures using the shutter control. A camera that requires its lens for the TTL meter to function can be used with the lens in place set at its widest aperture and focused on infinity. Use a fine-grain artificial light colour film suited to long exposures, such as Agfa 50L, and take a set of test exposures, noting the lamp distance, etc., on which to base your final exposures.

Spider by daylight (*above right*) using combined bellows and extension tubes and the standard lens in the reverse position. The camera was on a very solid tripod for this time exposure. The body of the spider was a little over ¹/₈ inch in length.

Through the microscope. Section (*right*) of a human lung magnified twenty-five times. The red area is mucin and the blue is background tissue. A section (*far right*) of decalcified bone magnified forty times. In each case the colour film used was specially designed to give correct colour rendering with long exposures where needed.

Lenses: wide and long views

The normal or 'standard' lens fitted to a camera gives an image size and angle of view that is considered convenient for all general purposes. This is the type of lens used on cameras where the lens is a permanent fixture and cannot be interchanged with another.

Interchangeable lenses

Changing the lens for others with different image sizes and angles of view greatly widens the scope of your picture taking and also influences the appearance of the image itself.

The image size and angle of view of lenses varies according to their focal length (which, in simple terms, is the distance behind the lens at which the image is brought to a sharp focus on the film). A 'long focus' lens forms an image at a greater distance behind it than a 'short focus' lens, and that image is larger than the one formed by the lens of shorter focal length.

'Short' and 'long' lenses

Lenses are considered either long or short in focal length according to the accepted norm or 'standard' for the particular format of film in use. This is usually about equal to the diagonal of the picture size on the negative. A 35 mm camera takes pictures that measure 24 × 36 mm and the diagonal of this image is approximately 43 mm. Standard focal length lenses for this format vary between 40 and 50 mm. Some standard lenses for 35 mm are longer than this, e.g., 55 mm or 58 mm but this is due to particular physical and optical limitations and is not a preferred choice (and it

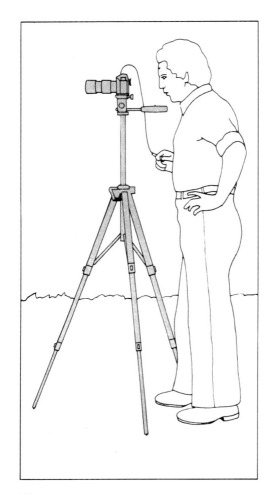

When the camera is on a tripod and more height is needed, only raise the centre pillar when the legs have been fully extended. Do not touch the camera and expose with a cable release.

is mostly confined nowadays to reflex camera lenses of exceptionally wide aperture). The nominal diagonal of 6 × 6 cm (2¼ × 2¼ in.) pictures (120 roll film) is 81 mm. 'Standard' lenses for cameras taking this picture size are normally 75 or 80 mm in focal length. Long focal-length lenses are normally called 'long focus', 'tele', or 'telephoto' lenses (these terms, strictly, mean different things) and these lenses all give a larger image of the subject within a narrower angle of view than a standard lens used from the same distance. Lenses of short focal length, called 'wide angle' lenses, give a smaller image of the sub-

The shallow depth of field of a long focal-length lens allows a clear separation between subject and background when a wide aperture is used. In this case the background is defocused.

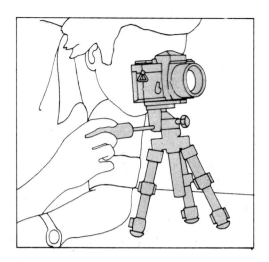

A miniature tripod allows steady pictures with slow shutter-speeds where the available surface is high enough, but uneven or unsuitable or where the camera angle must be precisely adjusted.

ject but cover a wider viewing angle than a standard lens. On a 35 mm camera a typical long focal length lens might be 135 or 200 mm compared with, say, 50 mm for the standard and 28 mm for the wide angle lenses. The actual angles of view for these cameras are 12° (200 mm), 18° (135 mm), 46° (50 mm), 75° (28 mm). On the 6 × 6 cm (2¼ × 2¼ in.) format a long focal length lens might be 150 mm compared with, say, 80 mm for the standard and 50 mm for a typical wide angle lens.

Many reflex cameras offer a wide choice of lenses with focal lengths varying from about 15 mm to 1000 mm. The most popular focal lengths are the ones stated above but there are other intermediate lenses which have become popular for particular purposes.

A few fixed-lens cameras can be fitted with special afocal attachments which change the focal length to either wide angle or long focus. But the image quality from this arrangement is inferior to that obtained when the whole lens is removed and interchanged with another.

The shallow depth in this use of long focal-length lens is differently applied. The background windows in an office are sharp, and the foreground, the last few autumn leaves, out of focus.

With lenses of different focal lengths you can achieve variation in composition from virtually the same viewpoint. The wide angle (top) includes foreground subject matter, the standard (centre) places the subject itself in the foreground and the long focal length (bottom) is highly selective.

The automatic TTL exposure meter gave less exposure to the wider angle pictures because it was partly reading from the light sky and water areas. As the angle of view narrowed so the reading included a smaller amount of sky and water and more of the dark subjects. Consequently the tele lens picture is the lightest.

Portrait lenses

Lenses of 80 mm (or 85 or 90 mm) on 35 mm cameras are popular for portrait photography because they create a pleasing perspective at a working range that gives a good head-and-shoulders view. Lenses of 100, 105 mm and slightly longer focal lengths are also used in head-and-shoulder portraits. But 80-90 mm lenses are often available with a very wide maximum aperture that gives all-round versatility in low light or indoor shooting and in the candid picture taking for which this 'short telephoto' lens is often the preferred focal length.

Lens sets

If you want to take advantage of the versatility offered by an interchangeable-lens camera and, for outdoor photography, are prepared to carry more than one lens with you, then your best choice for all-round work with a wide angle lens is, perhaps, a 28 mm. With this lens you can take pictures in confined spaces, take in wide landscapes and quite high buildings, and take pictures in the street with pre-set aperture settings (see p88) – all giving an image of reasonable size without too noticeable distortion. Most camera makers supply this focal length in economical and more expensive (wider aperture) forms and every independent lens manufacturer includes one in his available range

For a medium-long focal length (medium tele) lens, again for general purposes, the wisest choice is the 135 mm. Its popularity ensures that it is available from most manufacturers at reasonable cost (for lenses of modest maximum aperture). The lens gives considerable image magnification (about three times greater than that of the standard lens) yet, used with care, does not invite the typical problems of camera unsteadiness, critical focusing and small working aperture

With wide-angle lenses you can include a very wide view (*left*) without shooting from far away. This also results in large sky and foreground areas that may be usefully filled with other subject matter. With a wide angle lens the depth of field is very great; the wider the angle the greater the depth. It is sometimes possible (*right*) to have the immediate subject and distant details sharp at the same time.

Fisheye lens picture from a church tower (*above right*). If the horizon does not cross the centre of the picture it develops a deep curve.

Fisheye and red filter. The widest angle fisheye lenses give a circular image within the picture frame. Fisheyes usually have built-in filters because you cannot fit accessory lenses to the front mount without cutting off part of the image.

(therefore low shutter speed) associated with lenses of long focal length. For long range subjects the next most popular lens is a 200 mm, also available in economical versions.

Zoom lenses

You probably do not need to add more than the wide angle and medium tele lens to your standard lens unless you concentrate on subjects that demand special lenses, e.g., birds, sport, close-up or low light.

If you take mainly colour slides, which do not allow later adjustment of image size as prints do, then you may prefer the precise control offered by a zoom lens.

A zoom lens gives continuous change of focal length, and therefore image size, between two set limits. There are three main types: those ranging between medium and long focal lengths, 80-200 mm; those spanning the medium range such as a 35-70 mm or 45-100 mm; and those covering true wide angle to standard focal lengths, e.g., 28-50 mm.

With these lenses it is possible to fit the framing exactly as you please around the subject without necessarily changing your shoot-

Whole-frame fisheye without filter. The fisheye lens or attachment bends all vertical and horizontal lines in the subject except those bisecting the image.

ing distance. Optically, even the best are not quite as good as equivalent fixed focal length 'prime' lenses, but you probably would not notice this unless you wanted to make high quality black and white enlargements of 10 × 8 in. or larger. Most of these lenses perform best at mid focal-length settings and medium apertures. Some do give a slightly distorted image at the extreme focal length settings but this would only be noticeable in photographs of buildings or other subjects having many straight edges.

Fisheye lenses

Fisheye lenses are of extremely short focal length. Their 'uncorrected' wide angle vision gives a peculiar spherical distortion to subjects that increases towards the edges of the picture area. Some fisheye lenses fill the whole picture frame with a distorted image but the wider angle type (more than 200° vision) give a small circular image in the centre of the picture frame.

Optical tricks

Optical tricks are achieved by fitting a special lens to the camera, or an attachment screen or prism to the front of any ordinary camera lens. Distant subjects shown in depth through a long focus lens can appear foreshortened. Suitable subjects ranged one behind the other (e.g., cars on a main road) appear unnaturally compressed. Wide angle lenses tend to expand the subject towards the picture edges and if used very close to the subject record an exaggerated perspective.

Other trick attachments include simple prism lenses with two or more facets which give multiple images of the subject geometrically arranged within the picture frame, and diffraction gratings which give pointed 'star burst' patterns to light sources and strong specular reflections in the picture; also diffusion discs (optionally with a clear central area) which soften the image all over or around the edges only – a 'romantic' device often used when photographing women or children.

Some special films used in trick photography require particular handling and processing conditions. These materials are available through very few outlets and instructions for their use are normally enclosed with the film.

Lens care

Dirty lenses result in pictures with low contrast and inferior definition, so it is essential to look after them. Always keep a lens cap in place when not in use, keep lenses dry and never touch the glass surfaces with your fingers. To clean them, dust first with a soft-haired rubber blower brush to remove the larger dust particles or grit, then wipe away any remaining dirt or finger marks with a special lens-cleaning tissue. Do not use liquid lens-cleaners because fluids can penetrate the lens assembly. Never rub the lens hard and never use a tissue without first dusting the lens with a blower brush, as hard particles trapped between tissue and lens could scratch the surface. Lenses should only be cleaned when really necessary. Never take the lens apart; if there is dust inside, take it to an optical specialist or the manufacturer's agent for attention. Do not store them in a damp place because fungus can damage the glass surfaces which would then require re-polishing by an optical engineer.

The zoom adjustment was operated during this exposure, using a medium shutter-speed. This effect is much easier to manage with lenses having a single push-pull zoom control than the two-ring type (one for focusing and the other for adjusting focal length).

Bad weather and low light

The onset of bad weather is not the time to put your camera away but to go out and find a new range of effects in a transformed world.

How much light is enough?

With modern films and camera lenses you are not prevented from taking pictures in bad weather because of insufficient light. You may have to change to a faster film than you normally use and the technical quality might not be as good as usual, but in bad weather work it is really the atmosphere that counts more than anything else.

Rainy conditions are characterised by dull, low contrast lighting which, however, gives a pleasant pastel shade to many colours. There is an overall coldness in colour quality and the blue or blue-green bias may be accepted as part of the natural conditions or 'corrected' to some degree with an 81A filter over the camera lens. (The 81A requires an exposure increase of half a stop which can be a problem when the dull conditions already require relatively full exposure.) The low contrast of an overcast day gives an even colour reading with

no loss of detail in shadow areas nor over-bright highlights (except for wet surfaces).

Rain itself is very difficult to show in photographs except when sharply backlit against a dark background or when seen falling on a surface. But it is easy enough to show the effects of rain with people running for cover, umbrellas, glistening surfaces, water runs or droplets forming on overhanging edges.

With black and white photographs you should increase exposure if you want more detail in the picture generally. A lengthened developing time will increase the contrast and counteract the dull effect. With wet surfaces the opposite technique, under-exposure, can give quite dramatic results. With the sky reflected, and so plenty of reserve in brightness, the highlight areas become isolated from the shadowy surroundings that make up the remainder of the picture. Try under-exposing by one or two stops.

Direct reflected light exposure readings, e.g., with a TTL meter, should give accurate results for normal exposures. When photographing rainbows, select the end rather than the middle because the colours intensify the closer they get to the pot of gold. The end of the rainbow can also be more easily fitted into an interesting composition. Take a general meter reading and expose one picture at that setting. Then take two more; one with half a stop and another with one stop under-exposure. You have to work quickly because a rainbow can fade in a minute or less.

Pictures taken in falling snow also lack contrast and direct readings of snow-scenes will indicate too short an exposure to show the snow as white, so open by one stop. Snow is very effectively outlined by morning or evening light which moulds the shape of snow-drifts and causes the crystals to glisten.

Mist reflects the blue end of the spectrum and colour pictures take on a blue-white cast unless corrected (as with rain). Lights seen through the mist, however, appear more red-orange than normal as the vapour disperses the blue but allows the red rays to penetrate more directly.

In heavy mist nearby objects are reduced to bold shapes with little or no detail visible. With

Before the storm (*left*). Direct sunlight and darkening sky. Exposure readings should be taken from the sunlit area rather than the dark sky (which would over-expose the picture in the highlights).

A blue sky inevitably causes the shadow areas of snow scenes to assume a blue cast. Although this can be filtered out, it is generally accepted as a natural effect, perhaps because it emphasizes the coldness of the conditions.

distance the shapes progressively lighten until they disappear altogether. The mist therefore stresses the effect of depth-with-distance. Be careful not to over-expose, preferably give a little less than the direct reading indicated, and take care to preserve the low contrast in making prints.

Storms provide the most dramatic lighting effects in daylight and you may even take pictures of the clouds alone. Sky effects can be exaggerated by under-exposing one or two

stops less than indicated by a direct reading. To photograph lightning at night set up your camera on a rigid support and open the shutter with the lens cap in place. Uncap the lens immediately before the next expected flash and cap again afterwards. This technique gives you a chance to make more than one attempt. By repeated exposures several flashes can be recorded on a single film frame. Stop down to f16 with a medium speed film. Do not uncap for too long or the sky will show

Evening light is even redder in colour pictures than it is in real life. A special morning and evening light-filter can be used to reduce this effect.

too much detail. Negatives of separate lightning flashes can be sandwiched for printing.

Sunset and evening light

No photographer can resist taking pictures of an exceptional sunset, especially if he hap-pens to be in a place that offers an interesting foreground or knows where to find one. Sun-sets seem stationary but actually develop, change and then disappear in an amazingly short space of time. You must have your cam-era handy and react very quickly to get them at their best.

Against a sunset, most features appear as silhouettes, but the sky is beautiful when reflected in water which breaks up the colours into its own pattern. You need to photograph a sunset in colour; it really only works in black and white if the clouds or foreground subject matter are particularly interesting. Colour film is very responsive to these colours, and sub-jects photographed by evening light are tinged with its red-gold hue. If the sun itself is obs-cured by cloud take your exposure reading directly from the sky. If the sun is visible, take the reading from a bright part of the sky, but be careful to exclude the sun itself. Bracket all exposures.

To compensate for the reddening effect of morning and evening light you can fit an 82A

Teasel (*above*) with frost, photographed against the light. With the sun behind the subject frost appears especially translucent. Sunset (*right*): take the exposure reading from the bright part of the sky but not directly from the sun if it is visible. Under-exposure on slides deepens the colours.

filter over the lens (add half a stop). Often, however, it is better to have the full, exaggerated colour in the picture.

Twilight is one of the best times of day for taking pictures in urban areas as the street-lights and shop lights contrast strongly with the deep blue or after-sunset colours of the fading sky. Again this period does not last long, and as you have to work quickly it helps if you have a pre-planned location where you know of promising foreground matter. Typical exposures with medium speed film could vary between 1/15 and 1/60 sec. at f4, according to the effect you want; whether lights only or greater shadow detail.

Low light

With low light photography, indoors or out, you are forced to seek whatever sources of

Flooded fields in evening light. The presence of water enlivens the lower part of the picture with a broad reflection. Evening and night scenes are nearly always better when the ground is wet enough to reflect sky or lights.

light or strong reflections happen to be available. A subject itself may be adequately lit by a 'light pool' when the surroundings are too dim to register an image on the film. Exposures must be based on readings taken from the

area of main interest. Even at maximum aperture and with fast film, exposures may not allow really sharp pictures unless the subject is stationary. Occasionally, your only hope for any image at all is to set a time exposure with the camera rigidly mounted. When photographing people in very dim conditions it helps in some cases to pre-focus on a particular spot and wait until the subject moves to that position.

When there are large areas of shadow quite frequently an exposure meter does not move at all, or if it does it gives an unreliable reading.

If you cannot find a mid-tone in the subject from which to take a reading then take your reading from a sheet of white paper and open up the lens three stops to gain sufficient shadow detail. Bracket your exposures. Exposures taken in existing low light have far more 'atmosphere' than you can get by working with lamps or flash, if you want pictorial effects shot by the light that is there.

An exception to this is in night photography where the light you add is actually included in the picture. This can be done by setting the camera up on a solid support facing an unlit

Puddles after heavy rainfall (*above*) reflect the sky and the surroundings. You can play with the alignment of reflections and experiment with different exposures. Such pictures depend on exact camera positioning and the effect you get is far easier to determine on a single lens reflex with a stop-down preview control that enables you to see the depth of field at the taking aperture.

Mist (*right*) is a very subtle effect which is easily lost in photographs. The main danger is over-exposure of the film. It is best to take one picture at the exposure level indicated by the meter and a second, giving half to one full stop less than that. It is a very effective subject for black and white photography but the general lightness of tone, and even the mist itself, can disappear in a print made on too hard a grade of paper (see Black and white printing). One way to guarantee good results is to take a set of test pictures on different grades and select the best.

scene, selecting a small aperture and opening the shutter on a time exposure (i.e. with a locking cable-release). You can then walk into the scene and fire a flashgun at various places around it, most effectively behind objects (though not your own body). Occasionally from a distance you can fire it directly at the camera. These flashes build up as a series of 'lamps' in the picture.

If you are not seeking atmosphere in low light pictures but only need a record of facts or faces you should always carry a small flash-gun, as it can help you out of many difficulties.

The camera indoors

Daylight through the window is a wonderful source of light for photography whether used on its own or combined with other sources such as lamps or flash. You can use the window to light a portrait, take a still life, shoot an animal, or take a picture of the interior itself. You may even photograph the shafts of light picked up in a dusty atmosphere as they enter a building.

You do not have to take window-lit pictures on a sunny day. Some subjects need more light than others, however. For a still life you can make do with very little because you can give time exposures. But a portrait subject may move during the exposure so you need more light for him or her. The direction and strength of window light varies from one window to another. The diagram opposite gives some idea of how light enters the room, and by playing with shadows you can achieve many effects that would be difficult to arrange with lamps.

Light through a window is nearly always of high contrast. This has several advantages. It can model the subject in strong light and shade, allowing you to stress certain features and play down others. The large shadow areas from window light can hide objects in the room in blackness if the subject has been positioned close enough to the window. The film's inability to register the whole range of high-light and shadow – even though you can see it yourself – is, in this case, turned to good account. Much also depends, of course, on the size and arrangement of the windows, the colour and lightness of the room. You can control window light with curtains. Heavy fabric will block sufficiently to give you a controllable light source. Thin fabrics, if the sun falls on them, or even in bright daylight, may act as a diffuser and cast a soft glow over the subject; this is particularly suitable for pictures of children and women.

The main means of controlling window light is in the positioning of the subject in relation to the window and the camera. If you turn the subject round it is almost as if you were moving a light around him. The starting point may be with the camera shooting across the window from one side with the subject looking out. Except in the brightest room, or those in which there are large windows in more than one wall, this produces a half-light half-shadow effect that gives very strong modelling on the face. A completely different kind of lighting is available when shooting a portrait of the subject facing the window but with the camera between the window and the subject. This is generally a full flat lighting arrangement which, like diffused light, tends to broaden the appearance of the face and minimise skin texture and lines.

You can 'fill' the shadow side of the subject with light either by adding a lamp or using a

The light that already exists (*above*) can pinpoint your subject in dim surroundings. This boy having lunch with his father was sitting in the light 'pool' from a large window almost overhead.

Lighting provided for stage shows and on dance floors (*right*) is of much higher contrast than it seems to the eye. Unless the light comes from a frontal position, stage pictures are likely to lose some detail but gain starkness, which can be an attractive alternative.

74

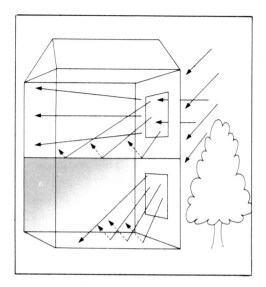

How window light may be distributed in a room. The top storey: light from the floor is weaker and more widely distributed but light is strong deeper into the room. On the ground floor light is strongest under the window; there is little light deeper into the room and most of the light is reflected from the walls and floor only.

reflector. A reflector is best because the colour of the reflected light is identical to the source (if the reflector itself is a neutral tone). For diffused light hang a newspaper, white sheet or similar reflector over the back of a door or chair. For more direct reflection you could use the dull or shiny side of cooking foil. The most directional reflected light comes from a mirror. But you will need a large one to have much effect, except to highlight a detail.

Other existing light sources

When working away from home, you could encounter virtually any kind of light source. In some interiors light is reflected from surroundings which may be highly coloured – resulting in a colour cast. Moreover, since lighting is normally arranged to see by rather than for photography, it may be too high in contrast for ordinary images, full of shadow and highlight detail, to be recorded on the film. Typical of this is stage and dance-floor lighting, it is also true of lighting in the average home. You can of course always carry a flash with you, but flash alters the atmosphere of a picture almost completely even when used only to put a little illumination into shadows.

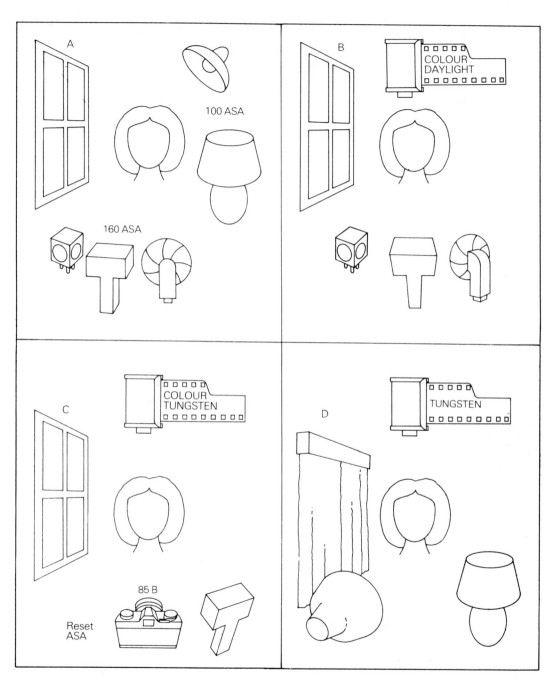

Mixing light sources. **A** There is a marginal difference in the rated speed of equivalent colour films designed for exposure by different light sources (tungsten versions are slower). **B** Colour daylight film; blue bulb, cube or electronic flash may be mixed with daylight. **C** When used in daylight or with flash added colour type B tungsten film requires an 85 B filter on the camera lens. **D** Tungsten film indoors without a filter: draw the curtains. A combination of photo lamps and home lighting gives a mixture of warmth in lighting.

Making your own light – flash

Flash gives you a great quantity of light for a brief moment and enables you to take photographs in conditions which would otherwise be impossible. People often comment that the quality of flash is rather harsh and uneven. It is an excellent emergency light source, but it is also capable of producing good lighting effects. Given more than one flash unit and the necessary connecting cords it is possible to arrange flash for pleasant lighting in most situations. The main disadvantage is that (with portable flash units) you cannot arrange the lighting by eye; you have to guess the effect you are going to get, by working out what *should* happen with one or more flash units placed at different angles and distances.

Auto flash

The automatic flashgun has taken most of the

The 'freezing' effect of flash. A comical moment caught by the exceptionally fast speed of flash.

Flash technique. **A** Soft-frontal lighting by bouncing flash off the photographer's body and onto the subject. **B** Two unit set-up with shadow 'fill-in' flash twice the distance of the 'modelling' flash, and two lamps at equal distance from the subject but with one diffused with two folds of handkerchief.

mysteries out of exposure with flash. You simply set the ASA film speed on the calculator dial and read off the aperture that you must set on the camera. The dial tells you what range of distances the flash will cover. Some guns offer half or full-power generation to give different ranges at the same aperture.

Lighting in depth. **A** Flash bounced off the ceiling gives a general overall lighting in the room, but spill light also reaches the subject directly.
B Lighting a row of people seen from one end. With frontal flash the light level diminishes towards the rear.
C With the flash taken round to one side, the subjects all receive the same amount of light.

Some also offer auto-operation on several apertures which are set according to the distances you are shooting at and the depth of field you want (determined by the aperture). On firing, a sensor cuts off the flash when the film has had sufficient exposure. These and the simpler flash units also work manually.

Manual flash

On a manual flash unit a dial on the body tells you which aperture to set at a given flash distance when used with film of a particular ASA rating. To help calculate the aperture for each distance the manufacturers of electric flash units issue a guide number of the unit's relative power when used with film of each ASA speeds. The guide number is the product of the lens aperture and the distance (in feet or metres) from the flash to the subject. Flash bulbs use the same system.

Having decided on the distance you want to shoot from, you divide the guide number of the flashgun or bulb by the flash-to-subject distance to find the aperture you need to set. Say that distance is 10 ft, then a flash unit with a guide number of 40 ft would require an aperture of $f4$, i.e., $^{40}/_{10} = 4$.

If you want to set a particular aperture, say $f8$, to gain sufficient depth of field, you can find the distance for the flashgun by dividing the guide number by that aperture i.e., $^{40}/_{8} = 5$ (ft).

You can vary the combination of flash distance and aperture as you wish and you will get correct exposures provided the distance and aperture, when multiplied by one another, come to approximately the same guide number. In Europe flash units are nowadays normally quoted with a guide number in metres. In this case the flash-subject distance is simply calculated in metres instead of feet.

Flash units may be used on or off the camera. Most are designed for use on the camera but may be triggered at a distance with a connector cord. With a slave unit (a light sensor that catches the flash of one gun and instantaneously triggers another to which it is attached) you may have more than one flash at a time which gives you much greater scope and variety in lighting when working with a single unit.

Flash techniques

Here are some basic lightings using one or more flash units:

One flash – on camera. Hard lighting. Shoot with the flash at least 6 in. above the camera lens set on auto or shoot manually at a constant flash-subject distance. If the flash is too close to the camera lens, people and animals will appear to have red eyes (or pearl if the photograph is in black and white).

One flash. Soft light. With a manual unit and a nearby subject, point the flash at your own body and bounce the light off it and on to the subject. Having calculated the correct exposure maintain a constant flash-body-subject distance. Do not use this method when wearing colourful clothes.

One flash – diffused. Place two layers of white handkerchief over the flash unit (but not over the sensor) as a diffuser.

Two units. Set the flash heads each at 45° to the subject but with one giving half power or full power at twice the distance. Or have the units at the same distance and power, but with one diffused with two folds of handkerchief. For soft lighting diffuse both heads with handkerchiefs or bounce light off walls or ceiling.

Two units, model and fill. Move one unit to one side modelling the subject and a second immediately above the camera but at twice the distance of the first.

Diffused flash for portraits. If the flash unit is directed into a special white or silver reflecting umbrella, which can be bought for the purpose, there is sufficient illumination for close-range head and shoulder shots in diffused light.

Making your own light – lamps

The special advantage of using lamps to light your subject instead of flash is that you can view the lighting as you arrange it and make any necessary adjustments. You can use the ordinary household tungsten bulbs if you are shooting in black and white although their light output is low compared with those designed for photography. Also their colour temperature is far too warm for colour film.

Photolamps

There are two kinds of photolamp: photofloods and photopearls. Both use a tungsten filament and both are available in either the normal household type of glass envelope or in a mushroom shape with an internal reflector; this type gives a more concentrated beam.

Photofloods contain a special filament which is designed to be over-run, giving a much greater light output for the rated wattage than with an ordinary lamp. The advantage of an over-run lamp is that a fairly small and cheap bulb gives you a lot of light, and several such lamps can run from the ordinary house power supply without overloading it.

The photofloods in common use are the no. 1 (275 W) with an effective output of

750 W and the no. 2 (500 W) with an effective output of 1600 W. Reflector versions are also available (nos 5 and 7, also a no. 6, at 375 W consumption). The working life of an over-run bulb is short, about three hours for a no. 1 and no. 5, and a little longer for the others. A no. 2 costs approximately twice the price of a no. 1. All photofloods are designed to operate at a colour temperature of 3,400 K. Some colour films are specially designed for use at this colour temperature. Photofloods are available in screw and bayonet fittings.

Photopearls, or 'studio lamps', are high-output lamps which are not over-run. They are no. 1 (500 W) and no. 2 (1000 W). There is also a reflector version, the no. 3 (500 W). Their operational life is 100 hours if used with reasonable care. Their colour temperature is 3,200 K – a little 'warmer' than photofloods – and many colour films are designed for use with them. However, if you use films designed for photofloods, the colour error (only 200 K) is unlikely to be objectionable. Photopearls come in ES and GES fittings.

Floodlights and spotlights

The typical photographic light has an open bowl-shaped reflector with a lamp fitted in its centre. The light emitted is fairly diffused; part comes from the bulb and the rest is reflected from the bowl. Some larger units have a small back-reflector or shield over the bulb.

A spotlight gives a relatively narrow concentrated beam of light that carries over long distances without losing as much in strength as a flood. The spotlight uses a mirror and condenser system rather like a slide projector (and for black and white work a slide projector can be used instead). Spotlights allow adjustment for beam width to give greater or less diffusion over a larger or smaller area. Spots are very useful but not essential. Being more complicated than floods they are much more expensive. If your use of them is only occasional it would be much cheaper to buy a mushroom reflector photoflood.

Be sure that you do not overload your power supply when you use more than one lamp. To work out how many lamps you can plug into the power supply the formula to use is watts = volts × amps. If you have a 13 amp power

socket circuit and the supply is 240 volts, then the total wattage of all lamps or other appliances you can safely run from the circuit at any one time must be: 13 × 240 = 3120 W.

If you have a 15 amp power socket (USA) and 115 volt household supply then the maximum amp rating for the circuit must be 15 × 115 = 1725 W.

In the first example (UK) six 500 W no.2 photofloods may be used and in the second (USA) three 500 W photofloods.

1 Spotlight in ventilated housing. 2. Floodlamp on a lightweight stand with adjustable reflector. 3 Extension-arm lamp fitted with shaders (barn doors) for controlling area covered. 4 Boom lighting unit with counterweight. 5 Clip-on lamp.

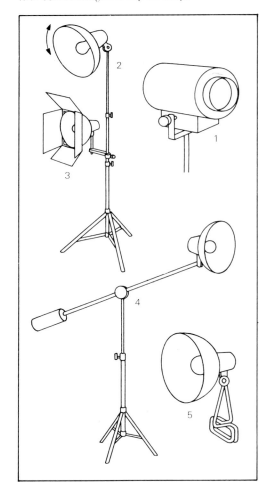

A spotlight sends out a concentrated, more or less parallel, focused beam that maintains its brightness over a distance. Most units are adjustable for their spread of light. A flood casts part direct, part diffused light over a wide area. A flood with shield gives an even wider area of totally diffused light.

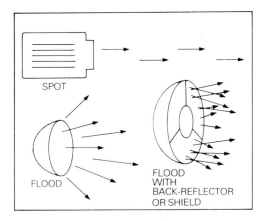

SPOT

FLOOD

FLOOD WITH BACK-REFLECTOR OR SHIELD

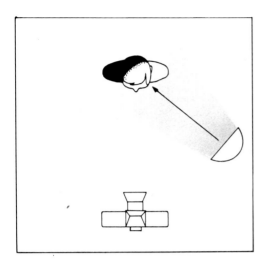

One lamp lighting (*above*). Front/side lighting gives full (hard) modelling to the subject and deep shadows. A lamp on the camera would give neither.

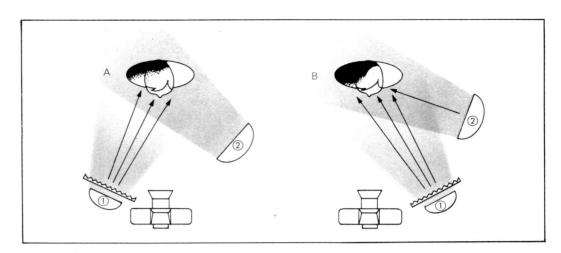

Two lamps (*above*). **A** Front/side main (key) modelling light (**2**) with a second lamp (**1**) placed frontally and diffused to give a soft, weak, fill-in illumination to the shadows. **B** Side key light (**2**) with front/side fill light (**1**) on the same side as the key and diffused to soften hard-edged shadows from the key light, and to increase apparent roundness in the subject.

Three lamps (*below*). **A** Front/side key light (**2**) with weaker diffused filler (**1**) close to the camera on the opposite side and backlight outlining the subject with rim highlight. The background is unlit and may be darker than the subject. **B** Front/side key light (**2**) with weaker diffused fill (**1**) and light on background to kill shadows from main lights. The background is lighter than the subject.

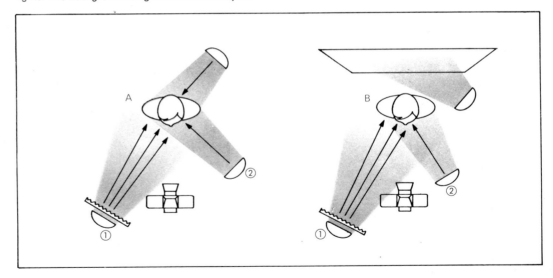

Lighting your subject

Assuming that the basic function of the light, to provide enough illumination to take a picture, is fulfilled, you can also use light to shape or model the subject, to outline it, to increase or decrease the contrast in the picture or to gain other effects with the subject and its background. You can model the subject by placing the light at an angle away from the camera viewpoint. The shape is made apparent by the way the bright area facing the lamp becomes shaded towards the far side. With the light striking an oblique angle, the surface texture of the subject is revealed.

The effect of modelling and surface texture is enhanced by a concentrated light source and diminished by a diffused one.

A light directed at the background can silhouette a subject provided no light reaches it from the front. If light creeps slightly round the edge of the subject it is said to be 'rim' lit. It is possible to position a lamp behind the subject and directed at it while keeping all light off the background and off the front. The subject then appears only in outline at the edges.

The contrast in lightness between a subject and its background can be varied with the position of the lighting. The closer the light is to the subject the greater the difference in light level between subject and background. The further away the lamp, the closer are the light levels.

The diagrams on these pages show basic one lamp, two lamp and three lamp lighting set-ups. It is best to work with only the lamps you really need, starting with one and building up the lighting scheme by adding another and, perhaps, a third. One-lamp lighting can give you the basic modelling, called the 'key' light. A second lamp from a frontal position fills the shadow area and reduces the contrast. You may need the third to lighten the background, catch the hair or 'rim' light the subject.

Tricks and effects with the camera

The camera can get up to all sorts of tricks just by the way you use it, without any special attachments or processes. For instance, you can move in so close, or choose such an odd angle, that the subject becomes unrecognisable or looks like something quite different. You may see the particular subject as an abstract shape or carefully line up two objects so that to your one-eyed camera they appear joined together.

Tricks of the light

An odd trick of the light may make the picture for you by hiding the normal surroundings in darkness or cutting a strange shape out of the subject. You can even create the effect by deliberately projecting light patterns on to the surface of the subject using a pocket lamp or a slide projector with your own specially prepared slides. One such effect that occurs naturally is the silhouette. When the light comes from behind the subject, which acts as a light barrier, then provided the exposure is suitably arranged, and that usually means under-exposed, then the subject can be made to appear as a black shape. Again this situation

can be deliberately set up in front of the camera.

Another light effect that can happen by accident, but which you can also create deliberately, is flare in the lens. If you point the camera at the sun or a bright light, you are sure to get this effect, even though modern lenses are specifically designed to prevent it!

Reflections

Objects reflected in an uneven surface appear distorted and may become abstract patterns of different shapes and colours. Unsilvered glass, such as that in shop windows and showcases, can produce ghost images as the camera sees the surface reflection combined with whatever is beyond. You can set up these situations deliberately, but remember that to render reflections sharp you must focus the camera on the reflected image itself and not on the surface in which it appears. If you want both the reflection and the surface of the subject to appear sharp, you may have to select a very small aperture to obtain sufficient depth of field, if the reflected object is very far away. The clarity of the 'ghost' can be varied in some

cases by altering the strength of light falling on it.

Another possibility of this kind is to photograph objects through semi-transparent media seen either as vague shapes or as shadows cast on the surface of this material – or both.

A rather odd trick which can yield beautiful results is the suspension of coloured dyes in clear water. The water must be absolutely still, and in a clean container, preferably with flat sides, and seen against a white background. Drop a small amount of dye, ink or similar substance on to the surface and a pattern gradually develops in the water. You wait until the right moment and then photograph it using flash directed from one side, or on to the white background. Several colours may be combined, although it is easy to overdo the effect and spoil the results.

Filter tricks

A range of coloured glass filters are available for controlling tonal rendering in black and white photography. If you take a picture through one of these with colour film loaded in the camera, the picture will assume an overall cast of that colour. The deeper dyed filters transmit only that colour, but the less intense ones allow some of the subject's own colours to show through, though biased towards the predominant colour. The effect of filtering in this way can be very strange. All-red images in particular have a sinister quality whatever the subject. You can use the whole filter or only part of it. For the 'sunset' shown here the edges of two filters have been used overlapped; the blue is natural.

Multiple exposure

Double exposure is the trick everybody used to perform inadvertently before the advent of prevention locks on cameras. Nowadays, if you want to do it deliberately you may have a special facility to cut out the lock. But this is how, on 35 mm cameras, you expose twice on the same film frame if your camera does not normally allow it.

1 Take the first exposure but don't wind on the film afterwards.
2 Turn the rewind crank to tighten the film still remaining in the cassette just as if you were rewinding it. But don't press the rewind button.

Trick sunset with filters. These were not done with graduated filters but ordinary coloured screw-in filters for black and white photography. Orange and yellow filters (*left*) were partially overlapped in front of the lens and in the second photo (*right*) a green filter was used. The blue sky was natural, and exposure was based on a reading from it, so all other details were rendered as a silhouette.

3 Holding the rewind crank firmly in place, press the rewind button or release (usually in the camera base).
4 Now advance the lever wind.
5 Take your second exposure and then wind on.

For double exposures where the bright parts of the subject are fairly broad it is best to halve the indicated reading for each exposure. Where in both exposures the highlights occupy only a small area and most of the picture is fairly dark, give the full exposure time indicated for each. More than two exposures

can be made on the same frame by repeating the above procedure, holding or taping the rewind crank in position and holding the rewind button down while advancing the transport lever. Multiple exposures, however, tend to be rather confused and less effective. Double or multiple exposures can be done with flash, but the camera must be stationary and the subject otherwise unlit, or very nearly so. With the camera on a tripod you set the shutter on 'B', keep it open by holding down or locking the plunger on a cable release, and firing the flash repeatedly by pressing the 'open flash' button.

A single motorcycle photographed through a prismatic (or faceted) lens attachment. This device screws into the filter thread of the camera lens and is available in versions giving two or more images.

Exposure and movement

You can get different effects by varying exposure away from that indicated, most noticeably by deliberately over- or under-

exposing on colour slide film. Over-exposure 'bleaches' out the image and generally softens the colours; under-exposure intensifies the colours and isolates bright highlights from their surroundings which then appear unnaturally dark. On any kind of film, over-exposure increases the detail visible in shadow areas at the expense of highlights. These, when printed, are blocked up and reproduce as large areas of white. Under-exposure has the reverse effect, deepening the shadows and causing mid-tones to invade the highlights.

Movement effects are particularly exciting in colour. In principle, you give a long enough exposure to allow either the subject or the camera to move while the shutter remains open. This smears the image across the film yet at the same time gives a vigorous pattern or sensation of activity – depending on how it is done. You can do it by finding a colourful subject and selecting a slow speed such as 1/15 sec. and making test exposures deliberately shaking or moving the camera. If the subject moves you can trace its action with a similar technique except that in this case you

Tricks with camera movement are very attractive in colour. In both cases the camera was set on a low shutter-speed and moved during the exposure. Above, lights; right, flowers.

hold the camera still or put it on a tripod. You may have to attempt this trick many times before achieving successful results. A variation is to fit a zoom lens and adjust the focal length during the exposure. The subject seems to rush to a central point in the picture and this can produce very striking results with certain subjects.

Portraits at home

There are two quite different approaches to portrait photography. You can pose the subject, together with any props you may need, against a special background and organise some appropriate lighting. Or you can photograph 'on the loose', catching a pose as it occurs with whatever light happens to exist. The first kind of photograph is normally taken in a studio where the conditions are entirely under the photographer's control. The second is, typically, taken in the subject's home or workplace often surrounded by the objects of their everyday life.

Studio portraits

The studio approach has several advantages. You can be sure of achieving a visually well-balanced effect by repositioning the subject or rearranging stray arms and legs. You have no problems with distractions or unnecessary background objects because you use either a plain white or coloured backdrop (or a plain area of wall) or a special graduated background which gives a shaded effect. The plain background can be shaded with lights or it can be totally black, and you can usually move or alter the background as necessary. You have the freedom to place the camera almost anywhere you like and so choose a viewpoint that suits the subject, and you can arrange the lighting to flatter the subject or emphasise certain features. You are unlikely to go wrong with exposures or other technical matters because you are working in a familiar situation and have the time to check everything.

Why not then, take all portraits by this method? Unfortunately, all those practical advantages do not necessarily add up to a good portrait. Too often such pictures lack spontaneity, or, sometimes, any sign of life at all. The pose, though compositionally correct, can seem forced, the expression wooden, and the picture fails to convey much impression of the subject's personality. It is difficult to enliven a subject after going through such an elaborate ritual. It is possible, but it needs some skill and practice.

The surroundings of an improvised or real studio are probably new and strange to the subject. First, you must try to make him or her feel relaxed. You may have a few ideas in mind for the pose that you think might suit that subject and be worth trying. Or you can prearrange the way a person sits or stands by choosing a chair or a position in the room that makes them fall naturally into a particular kind of composition. You may then adjust that to remove any obvious faults, confused outlines or awkward shapes. Watch the hands, especially when partly closed. Watch also for the way the nose cuts the outline of the face; its tip can form a 'pimple' on that contour. Any limb that reaches out towards the camera will appear disproportionately large; try to limit this by choosing a distant viewpoint and a long focal-length lens to increase the image size. For formal portraits you can have the camera on a tripod, as you are achieving your effects mainly by manipulating the subject and by lighting.

Indoor portraits by artificial light allow careful arrangement of lighting to suit the subject or for dramatic effect. Subjects posed and lit in a formal way do not have to appear lifeless. Exposure in this case was based on the highlights and all surrounding details were lost in darkness.

You need at least 16 ft working distance for full length and 8 ft for head-and-shoulders portraits. To avoid perspective distortion never come nearer than 5 ft. In a small room it is better not to attempt full-length pictures. However, you might succeed by taking the camera further away and shooting through an open door or window.

In formal portraits it is best that the subject looks straight into the camera, never slightly above or to one side. Alternatively, he should actually look at something well away from the camera and not just by turning his eyes away. Having the subject apparently occupied with doing something in a studio portrait does not usually work; it conflicts with the formality of the arrangement and never looks convincing. The lighting is a major part of successful studio portraits and this is discussed in detail on page 76.

Above all, work quickly and keep the subject attentive and interested throughout the session.

Informal portraits

The informal method of taking portraits has always been popular with amateur photographers partly because it does not require a studio or special lighting and also because it is relatively easy to get a good character study this way.

One advantage of going to a person's home to take a portrait is that the surroundings themselves may say quite a bit about him. Sometimes, particular interests are suggested by objects, the person's trade or profession, whether he is a bachelor or a family man; such things, even half seen, and provided they do not clutter the picture, can add an interesting dimension to the individual. One of these items may even become a main feature of the picture, e.g. someone seen through a foreground of exotic plants that are grown for a hobby. When taking the picture you may be forced to work only near a window or table lamp. If you have enough light to work by without this constraint, it is easy to ask the subject to move about the room and involve himself in the things he normally does, while you watch for picture opportunities. Often, objects seem to fall naturally into place in the composition. You might hold the camera in your hand to allow maximum flexibility in choosing your viewpoint. The same strictures on camera distance apply as in formal portrai-

84

ture, but it is often possible to avoid distortion by the way that objects around the room naturally block part of the view. If the subject is genuinely preoccupied with some activity it would be quite natural that he looks at that rather than at the camera, though that works too if, for instance, he glances up spontaneously. Extremely high or low viewpoints can be used for effect. You would expect some distortion but if it seems deliberate rather than accidental, it is acceptable.

You can use the viewpoint to emphasise or play down a person's individual facial features. Some photographers do this to achieve a characterful representation; at worst the subjects' peculiarities are (perhaps unsympathetically) exploited to produce a caricature. At the opposite extreme, the photographer flatters his subject by choosing an angle that hides the weaknesses and regularises the subject's appearance. The photographer must make his own judgements and act on them.

From a slightly lower viewpoint than normal, the jaw is more prominent, the nose is shortened, the cheeks fuller, the eyes less deep and the forehead lowered. A higher viewpoint enlarges the forehead (and a bald head), deepens the eyes, lengthens the nose, stresses the cheekbones and makes the jaw less prominent. Slight changes of viewpoint have great effect, but extreme angles do not deceive at all because the exaggeration is obvious. Sometimes the most flattering angle is a profile. It disguises a crooked nose, uneven eyes and other irregularities. People whose full-face view is undistinguished might have a striking profile; a woman who is not especially pretty may look remarkably attractive when seen from this angle.

All these factors may be manipulated and controlled with the combined effect of the viewpoint and lighting.

Formal and informal arrangements may be applied to portraiture outdoors. There is little control over lighting but the surroundings may be more pleasing and, because they are further away, easier to control with shallow focus.

Outdoor portraits are best taken either in the shade or with a slightly overcast sky. A formal grouping is fine if it occurs naturally or, at least, appears to have done.

Glamour and figure

The aim of glamour photography is to heighten the appeal of the subject to achieve an effect of refined sensuality, using whatever technical means are available – composition, lighting, diffusion or other forms of image manipulation. The best starting point is, of course, a person with suitable natural gifts and, acting under the photographer's guidance, the ability to project the right mood, often under circumstances of great physical discomfort. This is hardly achievable without some kind of personal communication between the photographer and his subject – a factor that also explains why group modelling sessions are of little practical value. Glamour is a subject in which many otherwise competent photographers have a high failure rate.

In many other situations a photographer obtains his results by observation and selection. But here he has to exercise some organisational skills through another person who may not be able to understand immediately what particular image he has in mind.

Glamour demands an element of fantasy and this cannot be achieved in a straightforward pictorial record of a woman, however attractive she may be. Moreover, there is no such thing as the perfect model; all people have strong and weak points, so you need to recognise them and then aim to emphasise the better points in favour of the weaknesses, if necessary using photographic tricks to disguise them.

Choosing a model

Everyone has their own ideas of what is desirable and if we know the person it is particularly difficult to be entirely objective about them. However, there are several points in favour of using someone you know. They may be more patient with your early experiments. They do not need to be paid and, as a non-professional, should not expect it (they should, however, be offered gratis some prints of their choice). You may find it easier to get your ideas across than when working with someone you have just met. Also, an acquaintance in front of your camera may be more willing than a stranger to try again, should the result be a failure. Through familiarity, you may have decided what lighting conditions, clothes and atmosphere brings out the best in your model.

For an amateur photographer, the main points against professional models are that they can be so expensive that you may have difficulty obtaining good people. Some who are over-familiar with modelling for amateurs fall into hackneyed poses and with any paid model you probably have less time available in which to get results.

Style

There are many approaches to glamour photography. You may aim for a fairly direct and realistic treatment or, at the other extreme, an impressionistic effect achieved by special lighting, diffusion etc. Some glamour pictures border almost on portraiture whereas others are quite emphatically sexual.

Indoor pictures (*left*) with a frilly outline are best seen against a plain background. The smoothness of the nude body (*right*) contrasts with surrounding details.

You must establish beforehand with your intended model what you have in mind. The best way is to show her some pictures (your own or from a magazine) that tell her how you would like her to look. Some women have the natural ability to flirt with the camera or behave in a playful manner that comes across well in a photograph. This is not necessarily reflected by their normal social disposition.

Glamour photography needs practice. Very good examples from 20 or 30 years ago retain the freshness and spontaneity they had when they were taken, but a poor picture taken a year ago may by now seem very dated.

Two approaches predominate: 1. You position your model as if she were a subject for drawing or sculpture and so build up the picture before the camera. 2. You set her free, let her wander about and do whatever she wants while you watch and capture the best moments or use the poses that occur naturally.

Surroundings

Choose surroundings suggestive of a romantic atmosphere or opt for a plain background and rely on a choice of clothing (perhaps picked up cheaply or borrowed for the purpose). Props can be useful especially if they seem part of a natural setting. Equally, they can clutter and cause distraction in the picture.

Use lighting that corresponds with the circumstances. In bedroom settings for instance, soft lighting is called for without deep shadows. Ordinary window lighting, on the other hand, can be quite strong and directional.

Nude

This most difficult branch of photography suffers from some of the same disadvantages as glamour, only more so. The availability of good models is a problem for many people. The body may be far from the ideal yet it may still provide the basis of a good nude photograph. Some of the world's most famous nude pictures are of women whose figures are nowhere near perfect. Success depends on what the photographer aspires to and whether a particular model has the means to fulfil it.

One way is to approach the model with a handful of ideas but without too many preconceptions. Try to develop one idea from another so that you finally arrive at a good result. Hav-

ing fully explored that theme go for a total change rather than allow the model to become bored with it.

As a beginner in either nude or glamour photography, you could do a lot worse than to start with imitations of pictures you admire, and then try your own variations. Keep the room warm, the model cheerful and the pace fairly lively (in step with her disposition if possible). Listen to her comments. She knows her body better than anyone but you don't have to accept her advice. Do not take pictures that

are more revealing than she intended – it is important that she trust you.

For full-length shots work with the camera at waist level and from a range of at least 15 ft. A high viewpoint will shorten the legs. A low one lengthens them. But it also shortens the body and emphasises the hips. Hands reaching towards the camera appear over-enlarged. Prior to a nude photography session the girl should only wear loose-fitting clothes as marks from underwear can take many hours to fade.

People, out and about

Pictures of people at work or play are only successful if the subjects are natural and unselfconscious, whether or not they are aware of being photographed.

Whereas some people find it fun, most of us feel slightly uneasy when picked out by a camera lens and nowadays the sight of a camera is so common that your subject is just as likely to be annoyed as to be uninterested when being photographed.

If you want to photograph people without their permission (but within the law) it is wise to dress inconspicuously and use what natural cover there is. A camera case is a hindrance in this type of photography.

If you are on the lookout for candid pictures of people you should pre-set the exposure for the light level and situation. Frequent checks to see that the light has not changed significantly should ensure that you are prepared. A camera with fully automatic exposure control will take care of the majority of pictures taken in *average* conditions. But an auto meter can be fooled quite easily, and if you don't have time to compensate when danger signs appear (such as an unusually bright background, strong rear lighting or high subject contrast) then you are probably better off with a pre-determined exposure estimation set manually, especially with colour slides. But you must make constant checks to be sure that the general reading remains the same.

You may have little time to focus. You should practise with stationary and moving subjects, trying to hit the sharp point while you rapidly turn the lens barrel. Rangefinder

The woman in the street (*above left*) made this face – evidently well rehearsed – especially for the photographer. The small boy (*below left*) was backlit but his face is lit by strong reflections from below. The playfulness of the model (*below*) provided an opportunity to catch a lively expression.

cameras have a slight advantage here because their coincident image focusing method is so positive.

You can make snatched shots much easier if you pre-focus and rely on having sufficient depth of field to include all subjects at, say, medium range. With a standard 50 mm lens (on a 35 mm camera) if you set the focus on 15 ft then at an aperture setting of *f*8, for example, everything between 10 and 25 ft will appear acceptably sharp. You can increase this available 'safe' depth of sharpness by using either a smaller aperture or selecting a lens with a wider angle of view, i.e., shorter focal length, such as 28 mm. With a fast film (400 ASA) you can be reasonably sure of using successfully a small aperture in any but very dull conditions. With a wide angle lens you have a smaller image at the same shooting range so you may be encouraged by this to move in closer to your subjects.

Feeding wildfowl mouth-to-mouth (*right*); the photographer was at the ready for the next helping. Boredom or fun and games (*below*) are equally promising occasions to sieze a good expression.

Action photography

There are two ways to treat action subjects in photographs. Either you 'freeze' all movement and show the subject completely sharp or you accept (or deliberately aim for) a greater or lesser degree of blur in the picture. The first type of picture may amaze the viewer by showing, in detail, something we cannot actually see in real life because often enough it happens too quickly. A splash with water droplets suspended in the air can give a beautiful effect, unique to photography. But often a greater feeling of movement in a picture is conveyed by allowing a moderate degree of blur induced by the subject. In sport particularly, as long as the important details are clear, a little blur suggests a feeling of released energy that would be absent from a totally motionless image.

To render the fast moving subject motionless, you need a camera with a very high shutter speed, preferably 1/1000 or 1/500 sec. With less vigorous activity you can make do with lower speeds and still get a satisfactory result. The simpler type of camera, with a maximum shutter speed of maybe only 1/125 sec., is limited to taking pictures in which the subject does not move much or where you do not mind getting a slight blur. A simple camera could also produce acceptably sharp pictures of moving subjects if they happen to be travelling in an appropriate direction.

Direction of movement

The direction in which a subject moves in relation to the camera position, affects the maximum shutter speed necessary to render it sharp. As a rule, if the subject travels across the field of view, you need a faster shutter speed than if it is moving obliquely, though at the same rate. A subject approaching the camera head-on can be rendered sharp with a relatively slow shutter-speed setting. This, however, ignores the effect of any rapid movement within the subject itself. The body of a running man may appear sharp at 1/250 sec. but his arms and legs, which are moving much faster, still appear blurred — sometimes a desirable effect.

One way to reduce the blur in the subject, but give the feeling of speed, is to follow the subject with the camera by panning in the direction in which it moves. With solid subjects not having rapidly moving extremities, such as arms and legs, the subject appears quite sharp while the background is smeared into a continuous blur. This can have the added advantage that the subject may be seen very clearly separated from a background which, if sharp, might have been confused with the subject's outline or colour. Panning the camera is a technique that improves with experience; hold the camera firmly against your face and swing the body from the hips. You can practise on passing traffic with an empty camera. Focus and, at the same time, try to maintain the subject's position near the centre of the picture and continue panning after releasing the shutter.

Generally, you achieve a better compositional effect if you leave a little more picture space in front of the subject (i.e., in the direction of movement) than behind.

Quick reactions

The essence of action photography is in firing the shutter at the moment that gives the most telling description of the event and the best composition. It is possible to *observe* composition at speed, though *arranging* it may consist of no more than choosing a position beforehand that gives a clear view and an interesting background where you expect the action to happen. If you have never taken action pictures before, it is wise to test the speed of your reactions beforehand with an empty camera. Make sure that you know how to release the shutter right on cue without jogging the camera and wind on the film for the next picture quickly and efficiently. Cameras with add-on, or built-in power winders do make this easier. But you are unlikely to get good pictures simply by using their rapid repeat-shot facility to cover an entire movement in the hope of getting the critical point somewhere in the middle. You are more likely to miss it altogether.

Peaks of action

With most action photography you need the fastest film you can get (loss of image quality with such films is less important with action than other subjects), especially if you are shooting in poor light, or indoors, or where the long-focus lens you need for a distant subject

To freeze or not freeze. Very fast shutter-speeds render everything super-sharp but tend to destroy any feeling of movement in the subject. They also require good light to work by. Often the best compromise is a medium high shutter-speed and the camera panning with the action. With this technique you can show movement within the subject. Here (*left*) the wheels of the motorcycle are spinning but the bike itself is sharp. The camera was following the bike during the shot and, because of the speed of it the background shows some sign of movement.

With a slower shutter speed (*right*), again with the camera panning with the action, the background becomes an indistinct blur and the vertical bouncing of the bike is evident. Only the rider is really sharp as his body maintained a fairly constant position in the picture during the exposure. He is very clearly separated from his background unlike the rider in the first picture where the spectators are far from indistinct.

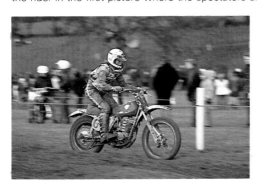
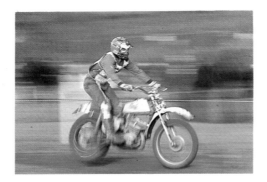

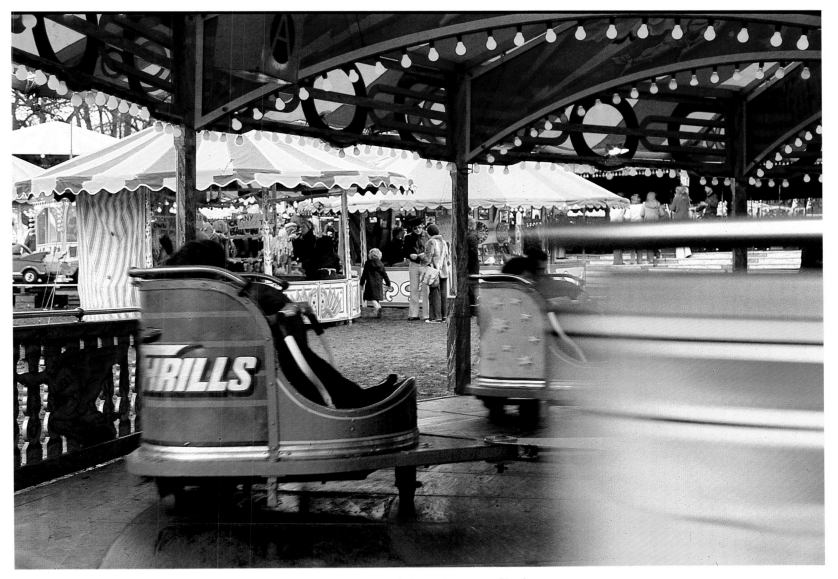

Direction of action. Movement in the picture varies according to its direction in relation to the camera. Head-on movement is least likely to blur, oblique movement is more likely and movement across the field is most likely to blur. You need the fastest shutter-speeds to arrest crossways movement.

has a rather small maximum aperture. Even where you cannot use as fast a shutter speed as you would like, or with only a simple camera, you can still get first-class results with many subjects by carefully selecting the right movement to shoot. The movement may include a peak where the subject is momentarily stationary – the dancer at the top of his leap or the child's swing about to change direction. These moments are much easier to find and capture with movements that repeat themselves and can be anticipated. The wide aperture you so often have to use when working with a high shutter speed gives little depth of field, so pre-focusing on the vital point is an advantage. Typical examples of repeat-action events are athletics and show-jumping, both fine action subjects where the critical activity always takes place in the same spot. Pre-focusing, and a well chosen viewpoint, are the keys to successful action photographs.

Animals and birds

The behaviour of most animals and birds is unpredictable so you have to use techniques that give you the freedom to respond quickly to their activity. Often the biggest problem, though, is simply one of trying to get within range. Some animals can be lured to a particular spot with food but the actual feeding may not yield interesting pictures. It is better to photograph them while they are on the look-out for food or competing for it.

For photographing domestic pets you could benefit from an owner's help – a dog can be commanded and other animals can be controlled to some extent by the owner's know-how. This may not involve feeding but simply the knowledge of how the animal will react and where it is likely to go.

It is sometimes possible to hold an animal for close-up pictures but hands, collars and leads should not be visible. Also, some animals react in ways that show they are threatened even when they are frequently handled; a rabbit, for example, may flatten its ears when picked up and a foal will seek protection on the far side of the mare when approached. Some young animals can be kept within range by their curiosity or playfulness; kittens grasp at a piece of wool, puppies scrap with each other. But the best pictures do not show the means by which the necessary containment was achieved.

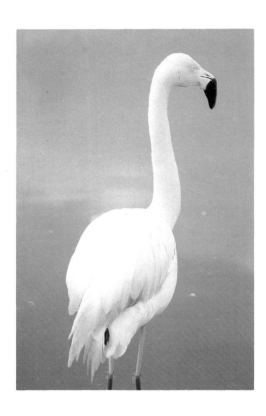

A flamingo is a large bird and if sufficiently tame can be approached without difficulty. You should be able to get a reasonable-sized image even with a standard lens, or fixed-lens camera. Look for interesting compositions.

A rabbit is too small to fill enough of the picture with a standard lens only. Here, a close-up lens was added and the camera brought to within a foot or so of the head.

Sometimes an animal or bird is prevented from moving out of range by quite natural means, for example, a cat sitting on a post or a bird on a branch. Caged animals or birds look best when apparently at liberty but there are obvious problems in planning such pictures. Sporting animals are wonderful subjects for action photography in the field or on the course.

The right angle

Animals and birds look best when photographed from about their own level. Raising the camera tends to distort the proportions of body and head and a low viewpoint may seem unnatural, particularly if the animal would normally be on the ground but has been placed on a higher level for the picture. Getting too close to the animal also spoils the perspective; typically, a horse's head appears over-large when photographed in quarter-view from nearby. Pictures of even quite small animals can suffer in this way, although from a very close viewpoint the obvious distortion can be quite amusing.

With the concentration needed for photographing animals it is easy to forget the background. But the finished print or slide can be completely spoiled if some feature beyond the subject draws the eye or disturbs the composition in some way. Altering the background, by raising or lowering the camera, also affects the subject; a background of sky is clear of obvious obstructions and may suit a bird but would be inappropriate for an animal that normally lives in the undergrowth and only operates at ground level. Your main control if the background is awkward (and you cannot move the subject) is the angle of view. Perhaps with a slight change the animal or bird may still look good but the background is greatly improved. It is better to play safe and plan pictures with a hedgerow or shrubs beyond rather than some man-made object, provided that the lighting is satisfactory and you have sufficient working space.

If you use a long focus lens and wide aperture the background may be so far out of focus that details or intrusions do not show.

In some zoos the background, and foreground, problem is particularly acute. If you are separated from the subject by a barrier of netting or bars, bring your camera right up to the barrier with the lens on a space in the

mesh or between two bars, and select a wide aperture to ensure that it is completely out of focus. (A rubber lens hood, pushed back, prevents the lens from slipping and getting scratched – watch out though, that it is not attacked by the animal.)

Photographing animals from close range may give you little chance to focus. Often the best way, especially with reflex cameras, is to set the approximate distance and then move the camera backwards or forwards, as needed, just before you shoot. The use of a tripod is impractical, except in extreme close-up work when sufficient adjustments are available on a focusing rail. (See page 60.)

Photographing birds calls for considerable specialisation. Most wild birds are far too small or shy to be photographed with a simple camera. You need long focal-length lenses (at least 300 or 400 mm on 35 mm cameras) and a bird table that is visited regularly, or careful baiting or stalking techniques (or even a hide) – and a lot of patience! However the larger captive varieties can be photographed without too much difficulty using lenses of much shorter focal length.

Timid animals that must be photographed from a distance require the use of a long focal-length lens if you want to get a large enough image to fill the picture area. Try to keep the background clear of obstructions. From a few feet away a similar lens could fill the whole picture (*below*) with a crane's head and keep the background well out of focus.

Flowers and gardens

It is not difficult to take technically excellent pictures of flowers indoors with specially arranged lighting and backgrounds. But plants and flowers are more often photographed in natural surroundings or in public or private gardens. In these places it is not possible to control the light or the background except by choosing suitable weather and a particular time of day and selecting a camera angle that excludes any distracting objects from the picture. This may not be too easy and close-ups, in particular, can take a long time to arrange in a pleasing composition as you make fractional adjustments of camera angle to avoid one obstruction or another. It is sometimes possible to push an offending branch or stem aside and temporarily hook it back with, say, a piece of bent wire carried for that purpose. If your interest in plants is scientific you will want to choose an angle that makes a good botanical study to show the exact form of bloom, bud, leaf and stem, with any other properties the plant may have, such as slight translucency or surface texture. When photographing flowers take your time; it cannot be done well if you are in a hurry.

With a simple camera you have to be content with a general view (unless you have a special close-up attachment) but focusing cameras allow you to select individual flowers, even quite nearby, and pick them out in sharp-

94

ness against the general surroundings. Even if you can focus, the most usual problem with flowers, especially at close range, is getting enough depth of field to have the whole bloom or group of blooms completely sharp in the picture. You can gain depth by using a smaller aperture but this, in turn, usually means a fairly slow shutter speed to maintain the correct exposure. It may be too slow for you to rely on hand-held pictures so you may want to put the camera on a tripod, provided you can get the tripod in the right place. But beware of slow shutter speeds. Plants may seem stationary but even in a light wind they can move enough to blur in the picture.

If you are working very close up to small blooms you are better off with the camera on a focusing rail (see page 60) and this in turn mounted on a tripod. The rail allows you to focus by moving the whole camera back and forth rather than by turning the lens.

The need for a small aperture and fast shut-ter speed would seem to call for fast film and sunny days. But very fast film is not generally the most accurate in colour rendering (and it is important to get that right with flowers).

Some people resort to electronic flash for taking flower pictures outdoors. The flowers may be sharp but the tell-tale black back-grounds, though dramatic, become rather repetitive after a while.

Gardens are notoriously difficult to do jus-tice to unless you take care to select a view-point that gives the picture a good strong shape. Often it is better to include a corner of the house or garden wall or fence to provide this. Viewpoints showing a mass of flowers or undergrowth may be impressive• when you look through the camera but are invariably dis-appointing as pictures.

Look for strong lines across the picture, provided by a path, a garden structure, the edge of a flower bed or similar feature. Or else include an ornament, garden furniture or peo-ple as part of the picture. Avoid too much empty space in the foreground and look for splashes of colour that stand out as well-defined areas in the picture.

With flowers, direct sunlight can give very heavy shadows that may not suit the delicate colours and subtle forms you hope to show. Moreover, flowers deteriorate in heat. Often, the best conditions are found in the morning, when the flowers are still fresh, and there is a bright overcast sky. With trans-parencies, differences in exposure alter the colour saturation or wash out the colour altogether so be as accurate as possible or else bracket your exposures. With blue skies (open shade) use a skylight (1A) filter and on overcast days a cloudy (81A) type to remove the likely blue cast. Use a medium speed colour film for greatest sharpness and good colour rendering.

Buildings

Buildings offer potential for many kinds of photograph. Your interest may be in the building as architecture or as a key feature in a landscape setting; you may wish to show the whole building for itself, or as a record of where you have been. Or you may concentrate on particular features that have a beauty of their own revealed by a close viewpoint. Sometimes a selected feature — particularly with modern buildings — forms the basis of an abstract picture, using the pattern or shape to draw the design' with a camera. The actual texture of the building seen in particular light conditions may be interesting enough in itself to use as picture material. A building can respond to different light conditions in a way that expresses a particular mood — a cheerful house may assume a sinister shape at dusk and even ordinary street architecture of the last century can look quite exotic against a sunset.

Any camera is suitable for photographing buildings. But to avoid sloping sides, where the vertical lines all converge towards the top of the picture (see p18) you must hold the camera so that the camera back is parallel with the verticals of the building. You may have to move further back to avoid cutting off the top, and you may now have too much foreground. Try to fill that space with an interesting subject that contributes to the picture. Failing that, you can enlarge only the upper part of the picture containing the building itself. If the surroundings do not allow you to move back far enough to include the whole building even with a wide angle lens fitted, consider going right up to the building and taking a picture looking upwards, exaggerating the convergence effect. Oddly enough, this looks quite natural. If you do your own printing you can 'correct' the sloping sides of a building to some extent by tilting the negative carrier or baseboard of the enlarger for that particular print (see page 120). Enlargement of a selected part of the negative or printing with corrective adjustment on the enlarger both tend to result in loss of quality.

Modern architecture gives you greater scope for producing abstract designs, and pictures built from patterns, than do the more traditional styles. Narrow streets require a wide angle lens, while a long focal-length can pick out details (*right*) on an ancient facade.

Landscape and seascape

The first step is to know where to find the kind of scenery that can yield the pictures you want, taking account of seasonal changes. Alternatively, travel with an open mind, see what you find and make what you can of it – but be prepared for occasional disappointment. Sometimes, and it happens to every photographer, you don't seem to be able to find a picture anywhere. Maybe it is the weather, the time of day, or just your reaction to the surroundings. If, on the other hand, you *know* what to expect you have a head-start for good picture taking.

Traditionally, every landscape photograph has a centre of interest, one main feature that is important or striking, and around which you organize the picture. Another approach is to select a part of the scene and make it occupy the whole picture area. Either way, it is a matter of selection. Looking through the camera or framing up the subject with your hands (with the thumbs out, each hand making two sides of a rectangle or square) may help you see things more clearly. With these you can see the picture frame in your imagination.

The subject of main interest may be in the foreground, mid-range, or distance but it must be emphasized in some way. In landscape photography you change the subject matter you find by choosing a suitable viewpoint. You cannot often change the view itself except perhaps by closing a gate or clearing away a piece of litter.

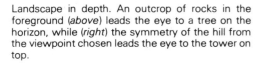

Landscape in depth. An outcrop of rocks in the foreground (*above*) leads the eye to a tree on the horizon, while (*right*) the symmetry of the hill from the viewpoint chosen leads the eye to the tower on top.

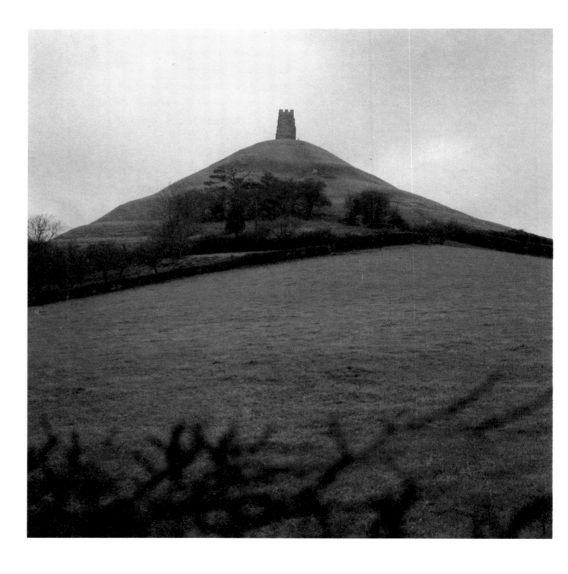

Viewpoint and relative size

Changes of camera distance affect perspective. If one subject happens to be a short distance in front of another, as you approach they will grow in apparent size, but the foreground subject grows larger more quickly than the one behind. From nearby the foreground subject may appear disproportionately large, even if it is actually quite small, e.g., a bush can look larger than the house beyond. Conversely, as you move further away, both subjects look smaller but more closely related to one another in true size. From a distance, the relative sizes of the subjects appear more natural: the bush is now much smaller than the house. You can use this fact to manipulate the emphasis you put on one subject or the other, and so organize the composition. If, from the chosen viewpoint, the features are now too far away then you can change to a lens of longer focal length and increase the image size, or, with fixed lens cameras, enlarge only that part of the picture when you make a print. If, on the other hand, the main subjects are too large to fit into the picture, you change to a wider angle lens.

The camera height too, changes the position of features in relation to one another, although with landscape photography it is often impossible to gain a higher viewpoint than eye level without altering the picture entirely. You would normally only change the view substantially by selecting a different vantage point. A high viewpoint reduces the importance of the foreground and separates out the features of the landscape into the distance. A low viewpoint conceals some of the distant elements. However, if there are important features very close to the camera, then even the smallest change in height, say between eye and waist level, becomes significant.

If you are looking for shapes and patterns in the landscape and want to fill the whole picture area with such a detail, then, unless you

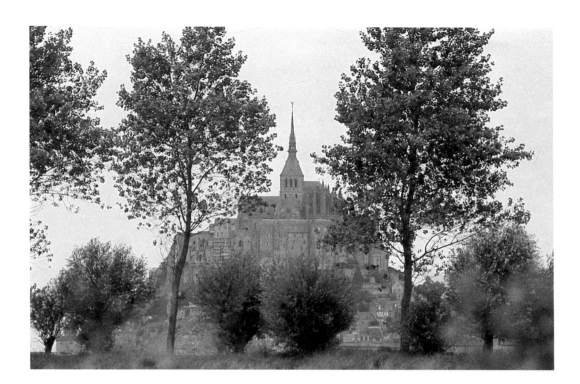

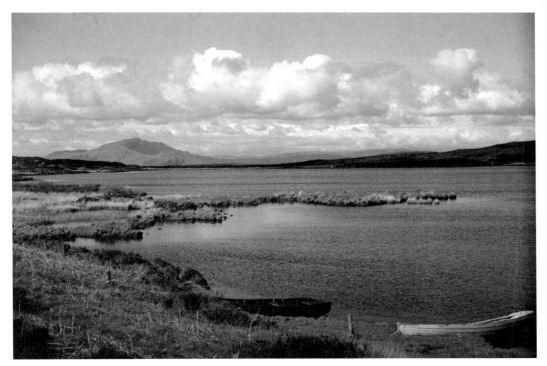

A mixture of buildings and trees (*top*) where contrast in colour and shape forms a pattern in depth. A camera position slightly above the water's edge (*right*) fills the foreground with the banks and separates the finger of land in the middle distance from the expanse of water beyond and so gives a pleasing perspective to where the distant horizon cuts the picture in the upper half.

can get close to each subject quite easily, your best ally is a long-focus lens, say 200 mm (on 35 mm cameras). Using such a lens tends to keep you at a distance that ensures that the pictures do not suffer from over-sized foregrounds because such foregrounds would be well out of focus. For deliberately exaggerated foreground details you can move in very close and choose a wide-angle lens, if necessary, to fit everything in. The successful landscape photographs are those with a fairly prominent foreground feature and a spacious but interesting view beyond.

Distance and depth

Distant views show a weakening of colours and the presence of some atmospheric haze which is even more apparent in photographs than to the naked eye. If you shoot colour slides you can reduce this effect to some extent with a skylight filter or a UV filter placed over the camera lens. With colour print film you might choose the UV, especially if you are

The headland rises out of the cove like a giant sculpture. From such a close viewpoint (with 28 mm lens on a 35 mm camera) the weeds, rocks and water movement in the foreground are greatly enlarged.

taking pictures in hills or mountains, or by the sea or wide stretches of water, where the excessive UV radiation is much more of a problem.

In black and white pictures, haze helps suggest depth as the tones lighten with distance. This effect can be reduced progressively by a yellow, orange or red filter, or may be exaggerated with a blue one (see filter table p.53). In seascapes, however, which lack such features, a yellow filter darkens the blue sky, and, by also darkening the blue reflected in the sea, gives it more tone.

Because black and white pictures depend so much on the modelling effect of light, the sidelight of morning and evening in summertime is much better for descriptive photography than high noon. In winter you would take pictures around midday and take advantage, at any time of *contre-jour* (against-the-light) effects (p.42).

Pictures that depend for their interest on both distant and foreground detailed subject matter should be perfectly sharp in depth. Use a small aperture and focus the lens so that the infinity mark ∞ comes opposite the far aperture index on the depth of field scale (p.45). Then read off the distance opposite the nearer index for that aperture to ensure that it is close enough to include the nearest significant feature in your picture. If not, move further away or choose a lens of wider angle (which has a greater depth of field).

Sky and horizon

By tilting the camera you can position the horizon exactly where you want it in the picture area and include a greater or lesser amount of sky. If you have a point of interest in the foreground, but also want to include the view beyond, you might tilt the camera down and have the horizon near the top of the picture. If you are mainly interested in the horizon and there is a sky with a beautiful cloud formation, you might tilt the camera up so that the picture consists largely of sky. Try to avoid the ugly effect of bisecting the picture with the horizon.

With seascapes, a low camera angle increases the area of sky and avoids the picture being bisected by the horizon. It also increases the apparent scale of waves or a heaving sea. Beaches and seaside locations are exceptionally light in tone and you are cer-

tain to get false exposure readings. You should take a reading and then set the exposure to give half to one stop more than is indicated. The sky must be correctly exposed in colour slides or it will lose its colour and leave only a white space. You can adjust the blue saturation of the sky and make white clouds stand out with a polarizing screen if you are photographing at right angles to the sun, (the effect decreases at greater or lesser angles). You rotate the screen to adjust the strength of the effect. The pola screen does not influence other colours, although it increases the exposure time between three and four times. With the sun overhead the sky is polarized towards the horizon and could be darkened with the filter. In seascapes, however, a pola screen may also 'deaden' the sea by reducing the surface reflections. Otherwise you may darken the sky with a graduated ND, a filter of neutral density graduated from a mid-grey at the top to a clear central area, continuing clear to the bottom. This will balance an over-bright sky with a darker landscape. You must have this filter straight so that the dividing line is arranged to cut the horizon at the right place.

Skies can be darkened and clouds made to stand out in black and white pictures by using either the pola screen, or a yellow, orange or red filter and adjusting exposure by the appropriate factor. You can photograph the clouds and sky only, but you could achieve the desired contrast in printing rather than by using a filter on the camera. You can even make separate cloud negatives to print into other pictures at a later date. In seascapes, beware of excessive glare from sand and water. Always use a lens hood to avoid flare effects or loss of contrast.

Movement

Landscapes can contain movement and this can be advantageous, or a problem. You may need a shutter speed of 1/250 sec. to prevent the effect of wind in trees showing in the photograph. A very slow speed, 1/30 or 1/15 sec., would make a deliberate blur effect possible. A shutter speed of 1/250 sec. is too fast for photographing flowing water without it appearing 'frozen'. Use 1/125 sec. or 1/60 sec. to give a slight feeling of movement and 1/15 or 1/8 sec. (with a solidly mounted camera) for blur effects. The sea breaking over rocks is particularly impressive taken at slow shutter speeds.

Landscape detail of a tree root by a canal. The late evening sun is almost horizontal with the water, giving the leaves and surrounding undergrowth an oddly theatrical appearance. For studies in detail use fine-grain film, a medium or small aperture and solid support for the camera. Shoot on larger format film if possible.

Format and film

Most landscapes and seascapes benefit from the good technical quality that results from using fine grain (slow speed) films, careful processing and the largest format camera available. Scenery photographed on cameras taking small film sizes such as 110 tends to be disappointing unless the view includes very bold subject matter and your black and white processing and printing techniques are faultless. Excellent pictures can be taken on full frame 35 mm using films such as 125 ASA or less. If you are lucky enough to have a camera of roll film format you should use this. The quality will not be in doubt and your pictures will have a smoothness of tone and detail that smaller formats cannot match.

The seaside, however, is often amply provided with picture-making subject matter – sand dunes, rough grass, seaweed, rocks, pebbles and various man-made objects of different vintages. You may even consider adding people to the picture (p.50). With seascapes certain views are only possible from a boat. This calls for a calm day and in many cases a long-focus lens – and luck. Photographing ships from the shore with a standard lens is often impractical. They appear too small in the picture unless you use a very long focal-length lens (see p.62).

Holidays

Unfamiliar landmarks and places can inspire the most jaded photographer. The visitor's fresh eye and observations can amaze the local inhabitant who is so accustomed to his surroundings that he does not notice that some of its most characteristic features are the raw material of good photographs. There is, on the other hand, a risk that novelty might cause the visitor to take very ordinary pictures of the most obvious scenery.

The landmarks in towns often do not convey much of the atmosphere of a place. This is more likely to be found in the less monumental places and among the people in their day to day activities. But it really depends on the reasons why you are taking pictures. For some people pictures of the actual place may be incidental to the holiday – simply memory joggers for the unseasonal evenings when the holidays are long over but not quite forgotten.

Creative photography while travelling

For imaginative work requiring patience and concentration you should be on your own or with an understanding companion. You cannot do your best if you are being hurried on to the next location and not noticing or bothering to attempt some of the less obvious things. A helpful person, on the other hand, might point out matters that had escaped your notice.

Take only the equipment you need; it is better to have one camera and travel far than to be so weighed down with gear that you never venture very far on foot. (There are customs restrictions in some countries for people carrying more than one camera without sufficient documentation or carnets. However you should not experience trouble if you have one camera with two or three lenses.) Too much equipment can restrict your reactions and the

constant need to change lenses will damp your enthusiasm and occasionally lose you pictures. On 35 mm, you can use a 24 mm and an 80-200 mm zoom for travel but the standard lens with its wide aperture is useful for low light work. An alternative group might be 28, 85 and 200 mm. This gives a good spread and the 85 mm is often of quite wide aperture (e.g., $f1\cdot9$). Also take a couple of diopter supplementary (attachment) close-up lenses for occasional close range pictures. When working with $2\frac{1}{4}$ sq in. roll film, you could take 50, 80 and 150 mm lenses and two extension tubes for close ups. If you can take only one lens other than a standard, make it a wide angle rather than a long focus. You can enlarge the centre of a picture but you can't retrieve parts that would not fit in to the negative area.

If you want to shoot in colour and black and white it is convenient to carry two camera bodies that can share the same lenses. Failing this, use short film lengths so that you can change without having to wait too long. Obviously you cannot then alternate between

colour and black and white for a succession of pictures. This is less of a disadvantage than it seems because they are such different ways of seeing that at any particular time you would tend to be more aware of one than the other.

There are certain restrictions on photography in most countries. Never take pictures of military installations or wherever there are notices expressly forbidding photography. Often such restrictions apply inside private and public buildings or else permission is granted on payment of a small fee.

On beach holidays beware of the camera's arch-enemy, sand. Keep all equipment in a polythene bag until you need it, then put it away again immediately afterwards. If you drop your camera in salt water, it will help if you plunge it immediately into fresh water.

Feeding the birds; a little patience brings an unusual result (*far left*). A general view might be the best reminder of a holiday (*left*) or a particular object (*below*) might bring back a memory. In the excitement the photographer himself is left out of the fun (*bottom right*). For less tricky pictures you may use the self-timer and join in yourself. Looking for shells (*right*) was sufficiently absorbing for the photographer to be unnoticed.

Ships and harbours

Ships at sea are best photographed from a small but fast motor boat hired for the purpose; you need the speed if you are to follow a yachting race and the manoeuvrability to get different angles of larger ships — and stay safely out of harm's way.

If you cannot follow a race, find a predetermined spot, such as a buoy, that the contestants will certainly pass and wait for them to appear.

Taking pictures from a boat, or any other moving platform, requires a fast shutter speed, preferably 1/500 sec., to ensure that the pictures are free from camera movement. This does not usually cause too much problem with exposure because the sea is an exceptionally bright environment and exposures are generally short anyway. The camera should be hand-held as the vibration on a motor boat

would certainly spoil pictures taken with the camera in direct contact with the boat itself. This also gives you a better chance to select angles, good groupings of boats, and keep the horizon reasonably level in your pictures. Racing yachts look very impressive from nearby but it is not always possible to approach them. Ideally, you could use the standard lens but you may have to be content to use a short telephoto (increasing the problem of camera movement).

However close you get, or if you use a long focus lens, always leave plenty of space around the subject. It is often impossible to avoid sloping horizons and to correct them in printing you have to crop the picture on all sides, so you need a sufficient area to avoid cropping the subject itself or making the composition too tight in the final print (see page 120).

An appropriate lens hood is useful to protect the lens from spray and sunlight reflected from the water. In stormy conditions a UV or skylight filter helps to protect your lens. But pictures taken of heavy seas tend to look less dramatic in photographs. You generally need a

A high viewpoint (*right*) separates masts and rigging from the building beyond and fills equally foreground and background with interest. Shooting from one moving boat to another calls for a fairly high shutter-speed. But the light at sea is brighter than on land so there should not be too much of a problem with exposure.

The training ship *Royalist* running under reduced sail (*below*). The misty conditions mask the background so that the outlines — hull, masts, sails and rigging — are seen distinctly without interference.

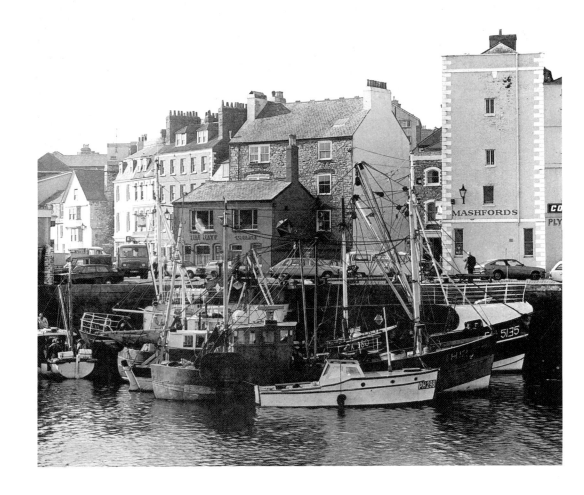

UV filter in any case to help reduce excessive blueness in colour pictures taken at sea. (In black and white you can improve the tones with a medium yellow.)

Often you have to be content with taking pictures from the shore. You usually have to use a long-focus lens, but on solid ground and with a brightly lit subject there are not many technical problems. Be careful with exposures when shooting maritime subjects. Exposure readings obtained with a meter should be reduced slightly (say half to one stop less) to allow for the generally light-toned subjects and surroundings.

Harbours

The wealth of interesting subject matter in harbours tends to be reduced to a meaningless muddle in pictures unless the photographer is selective in what he takes. The maze of masts and rigging can be minimized by selecting a high viewpoint or choosing a viewpoint leaving the foreground reasonably clear. The flavour of nautical life is reflected in even the smallest harbour details and it is often more profitable to concentrate on them than attempt to get a general view. A ship is of such a characteristic shape that even a small part suggests the whole.

Harbour buildings may form a sufficiently solid or unified backdrop to pull the fussy details together in a picture, but quite often they merely add to the confusion. Always watch for awkward background or foreground details, especially ropes or overhead cables that cut the picture at an awkward angle. You may be able to throw some of these out of focus if you use a long-focus lens. Pictures gain life if the sun or other harbour objects are seen reflected in the water, and atmosphere is created when, early or late in the day, the sun fills the harbour, coming from a low angle across the sea.

These flat-bottomed vessels were sitting on the mud at low tide and their main appeal was their ungainliness and sheer bulk. It seemed that the best way to show this was not to attempt to include the whole hull but instead fill the picture space with the great bows and, by under-exposure, accentuate their massive outline by concealing their detail in shadow.

Mood photography

'Mood' is a personal experience that we feel rather than a tangible quality that can be isolated from its causes or surroundings. Nevertheless it is expressed in certain photographs and in more than one way. It can be conveyed in a photograph by the expression on a person's face, by a situation, by ideas suggested by people's behaviour or the way things are arranged. It may depend on the smallest detail – the gesture of a hand or the glint of the sun catching a moist surface. It may also be caught by accident.

The mood of a photograph tends to be broadly associated with particular techniques, such as diffused or shady images. Attempts to make the connection more formal than this almost invariably end in failure; either the treatment does not quite suit the subject, or it is exaggerated or so subtle that it is ineffectual. If the mood is dreamy and the picture belongs to the realm of the imagination, then it is basically the subject matter and the way it is seen that gives the picture its quality, rather than the use of a trick filter or diffusing disc over the lens. However these devices can serve to reinforce a given situation, along with the natural properties of photography itself, such as the tendency to increase contrast over the natural scene as observed by the eye, or light leaking into the picture and causing a flare.

Evening light creates its own mood.

Radio telescope and trees (*above*) in a late evening fog reflected in the windscreen of a car. The combined images give a dense warm effect exaggerated by the film's over-sensitivity to the redness of evening light. In the sunset in the river (*below*) the existing mood is reinforced by the stillness of the water.

A photograph can have a dreamy quality without being melodramatic or slushy. It is a question of degree and control of the image and being able to anticipate the result. The pictures that catch the right spirit, such as many of the professional pictures seen in magazines, have a degree of polish and restraint about them that makes them thoroughly convincing. It is better to miss the mood by being too puritanical than try to cure it of dullness with a handful of cheap tricks.

Technical aids

You cannot create a mood convincingly by technical means alone, but there are physical aids that can encourage the effect without making their own presence too obvious. It is better to attempt to get what you need without any artificial aids than to produce results where the effect is imposed on a picture that does not itself suggest any mood.

Diffusion discs fit over the front element of the camera and slightly reduce the contrast by spreading the highlights into the shadow areas of the picture and producing a light haze over the entire picture. They also reduce the resolving power of the lens so that lines are softened and details are less easily defined. Discs give various degrees of diffusion for mood photography and it is nearly always best to work with the weakest.

An alternative is to smear petroleum jelly on to a sheet of glass or UV filter and place it in front of the lens. Another device is a neutral-coloured nylon stocking, with a cigarette burn in the centre, held close to the lens. But results from these tricks are usually so pronounced that they are obviously additions.

Some people get a softening effect by using an old camera lens whose contrast and definition are not up to modern standards. You can get an engineering workshop to make an adapter to fit the lens on to your reflex camera or a bellows unit. You might keep an old screw-mount camera body for this purpose or buy a low priced one. The old lens may have its own shutter; if not, you must use it on a camera that has its own shutter built in (i.e., focal plane) or be prepared to make (long) exposures by uncapping and capping the lens by hand with the camera mounted on a tripod. Photographers often have their own favourite devices to fit on to their usual camera for such occasions.

Nature usually creates the mood itself and nothing need be added to reinforce it. But in some cases it may be necessary to add something in order to *preserve* what you can see — in other words, to compensate for the failings of photography to record the scene as it strikes the eye.

When shooting colour slides some of the correction filters designed for daylight work (1A, 81A) may influence the mood by a slight shift in overall colour balance. Where the brightness range outdoors is too great for detail, in both highlight and shadow areas, you may need a little extra light in the shadow areas to preserve the mood of the picture. This is best done with a flash on the camera set for a film of three or four times the speed of that actually in use. Alternatively, cover the flash head (but not the sensor) with several folds of clean white handkerchief or paper tissue. But watch for over-exposure of the foreground, which destroys the naturalness of the picture. It only works well where all the shadow areas are at roughly the same distance from the camera. Several exposures should be made with different amounts of 'fill-in' flash.

Deliberate flare effect in the lens induced by having the sun on the extreme edge of the picture.

Still life

Few types of photography offer as much control over the subject and the way that it is presented as still life. There is more than one approach however. The theme may already exist in the imagination (and even be roughly sketched out) before it is set up in front of the camera. Possibly, only the basic idea may be there, and the picture is then gradually built up by a series of experiments to find a satisfying result. The subject might be something you just happen to see, just waiting to be photographed in the best way possible. Of course your approach may be a mixture of these. But a great attraction of still life is the scope for varied composition, lighting, backgrounds and any colour combinations that are at your disposal.

It is safest to begin with a fairly simple theme, not involving too many variables in the subject itself. Later, you can develop your skills for arrangement. Initially at least, there are probably enough things to cope with outside the subject, particularly with the lighting which can completely alter its appearance.

You do not need elaborate equipment to get good pictures. A 35 mm camera is satisfactory although if you have the choice of a larger format, that is generally preferable. An SLR camera is ideal and it should be loaded with slow-speed film to give you the best technical quality, whether you work in black and white or colour.

If you use a non-reflex camera you will have to take care of parallax problems as most of your pictures will probably be taken from close range. You will almost certainly need to use the smallest apertures to get the greatest possible depth of field as this can be very limited when shooting from nearby. That often means setting time exposures of several seconds, so you will need a cable release or a camera with a self timer. With very long exposures any vibration from the mirror will die down quickly enough not to matter, provided that the camera support is sufficiently solid. A tripod allows you the greatest choice of camera position, and this is vital where you have restricted control over the height of the subject or the angle or direction of the light.

For backgrounds, you can use a large sheet of stiff white or coloured card or thick paper that can curve gradually up behind the subject without leaving a hard edge or sharp corner. This will ensure that your foreground blends smoothly into the background and does not have any abrupt joins or other features that draw attention from the subject itself.

Lighting

Daylight through the window can provide a very attractive source of illumination if you want soft, even lighting. You can concentrate it by partially drawing the curtains, leaving only a narrow slit of light to fall across the subject.

Ordinary small flash units do not allow you sufficient means to pre-judge the actual effect of their light. As this is so critical for still life, you would be better off using photolamps (and, with slides, tungsten type colour film). With black and white film you could use any lamps that happen to be available around the house.

Shadowless lighting can be achieved in two ways. As the subject is motionless, exposures can be more than just a few seconds in length. You may even lengthen them deliberately. If so, you can use a single photolamp pointed at the subject, and move it back and forth, making one almost complete circle round the lens during the exposure (but without spilling light into the lens).

Another method, suitable for short exposures, is to arrange the subjects on a glass-topped table or a sheet of glass supported at the sides, out of view. Under this you position

Still life from flashbulbs. Lit from behind, these bulbs assume a sculptural form.

a large sheet of paper far enough below the glass for the shadows to fall out of sight. If shadows do fall on the sheet of paper then it should itself be lit separately, to kill them. The subject can also be lit from below through the glass. If you could obtain a large opal sheet of thick plastic curved upwards behind the subject area, that would probably be ideal. This, too, could be lit from below.

A more homely approach to still life photography is just to look around and photograph things as you find them. This yields pictures with a more natural flavour, although you may still have to make a few minor adjustments to them for the picture to work. A large card, black on one side and white on the other, is very handy. With this you could drop a black background behind the subject to exclude an

Abstract pattern of cocktail sticks and curtain hook — ordinary household objects, with appropriate lighting, are the tools for an imaginative idea.

unwanted feature, or use the white side to reflect a little light into the shadows and so reduce the contrast where the existing lighting is too harsh.

Successful still life work demands an unhurried and critical approach to the smallest details and as much perseverance as with many living subjects.

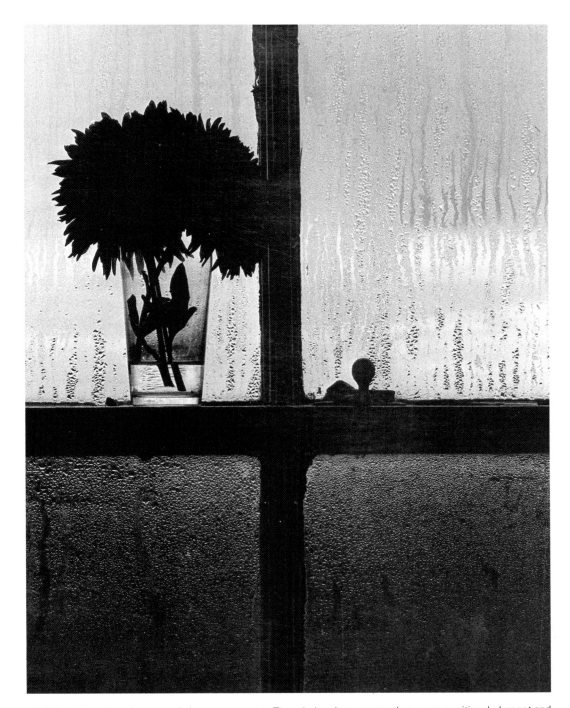

Still life using objects in a pre-existing arrangement. The window bars are used as a compositional element and the rear lighting gives a silhouette effect. Such pictures can be improved by making minor adjustments to the subject but take care not to overdo it and so lose the feeling of naturalness in the picture.

Do it all yourself

It's so easy

You may want to devote all your available time to using your camera and leave the business of making prints and slides to others. You can send your film off to a processing laboratory or take it to a shop and ask for whatever you need. Your photography in that case virtually ends when you press the button. It is exciting to see prints when they come back from the processor but it is even more exciting when you have done them yourself. Having others to do the job is certainly convenient but you may not always get exactly what you want, even from the best service available. Whatever the results, unless they are unacceptably poor, you normally have to pay for them. If you take great care to explain things and you are still not satisfied, then either you were going about it in the wrong way or you are expecting too much of a service which is clearly not equipped to do the kind of fine-tuned work that you demand. Many people are happy with the results of a commercial developing and printing service but, if you are not, in the long run it may be better to set about doing it yourself.

Cost

You gain a number of things by doing it yourself, and basically the only thing you lose is time. But that time is well spent and these later stages of photography can be fun. If you take a lot of pictures, then doing your own processing undoubtedly costs less. If you do very little you may not save much money and you may even end up paying more.

First you have to buy the equipment. The equipment needed for developing films is fairly simple and inexpensive. There is not an enormous cost saving in processing yourself, although it is often more handy to do it. Much depends on how much photography you do. The people who gain most are those who

would otherwise spend most. The occasional film is hardly worth the trouble on cost grounds alone. However, there are other advantages set out below

The equipment needed for making your own enlargements need not be very expen-

If you keep your subject to the centre of the picture and leave a generous space around it, you have an infinite choice of picture shapes when printing from the negative or slide.

sive but with certain items extra investment saves you time and improves the quality of your work. If you were to choose your equipment on the basis of what your camera cost you it might provide you with a very well equipped darkroom. It seems absurd to buy an expensive camera with an excellent lens and then lose the quality it can give by making prints or showing slides through a cheap lens that takes all that excellence away. Within limits, it is a good idea to spread your expenditure equally — though most people buy their camera first and only think about enlarging or slide projecting equipment later on.

The economics of making prints are determined largely by your own ambitions. Photographic materials and chemicals (in the quantities you are likely to need) are fairly standard in price. You pay more for the larger paper sizes just as you pay more for larger prints when they are done for you. Most other items are quite serviceable, even in low-priced versions. By paying more you gain in convenience of operation but the results that you get when using expensive equipment are not necessarily different from those you would achieve with cheap accessories. Even the enlarger itself, the king-pin of the darkroom, can be a fairly modest price of equipment provided it does its job adequately. An expensive model would be more positive in its operation and perhaps easier and quicker to use. With most darkroom items the tangible results of expenditure become less as the cost rises.

The enlarging lens, however, is an exception and with that it really does pay to buy the best you can afford, for the quality it can produce is stamped on every print. As most camera lenses deliver very good results when used in average conditions, it pays to preserve the quality that you get on the negatives when you come to make prints from them. It is true that the difference may be less noticeable

when enlarging from colour negatives but it is still there. If you are printing black and white you need the best. It is, in a way, unfortunate that some manufacturers offer adaptors to allow a camera lens to be fitted to an enlarger. Most camera lenses are not suitable for this purpose and, as a good enlarging lens is not unduly expensive to buy, this is a false economy. When well looked after, enlarging lenses last almost indefinitely and to buy a good one is a sound long-term investment.

Advantages

If you choose to process your own films you have some control over the kind of negative you produce, and if you want to obtain the finest quality of which a black and white film is capable you undoubtedly have to do that yourself. If you wish to increase the effective sensitivity of the film to allow you to take pictures in very poor light or alter the contrast range recorded on the negatives, you can do this quite easily by handling all the processing yourself. If you want a slide film processed in a hurry you can do it yourself quite reliably within an hour or so of taking it out of the camera.

When you do your own enlarging you have all sorts of controls at your disposal many of which are not normally available or convenient to order. You may want to print from only a certain area of the negative, selecting one part and excluding another. You can completely alter the composition and meaning of the picture this way. You might want a dark or a light print, or a certain feature shaded out, the colour changed, or even two pictures combined in a single print. By enlarging the picture yourself, a whole range of tricks and effects is made possible.

Black and white printing is a control process that really needs the eye of the person who took the picture to see it through to a satisfactory conclusion. You sometimes need to give separate exposures to different parts of a print in order to give it a good overall appearance. The effect you saw when you originally took the picture may only be brought out by careful printing using a suitable technique. There are special printing papers available with which to make unusual-looking prints. Occasionally you may want to do something out of the ordinary such as print a black and white picture from a colour negative film. You can even make col-

our prints (of a kind) from black and white negatives. You have full control over the type of paper you use for each print, the warmth of its image tone or the actual surface texture and finish of the print itself.

A truly fine black and white print seems to glow with a life of its own. This partly depends on the quality of the negative produced, but also has much to do with the skill, practice and patience of the person who makes the print.

Three pictures from one. By selective enlargement it is possible to produce more than one picture from the same negative, provided that the quality of the negative is good.

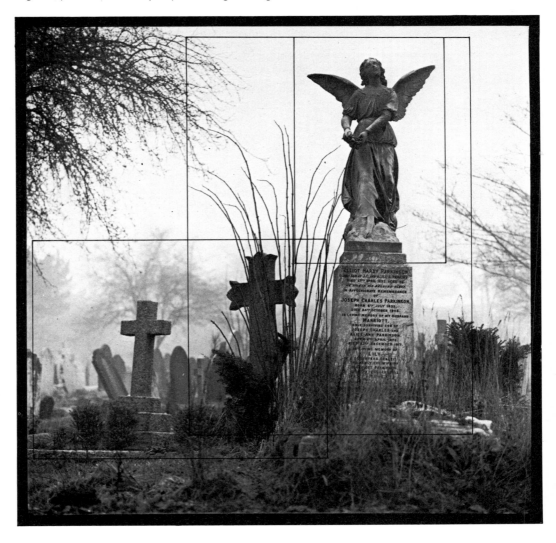

Darkrooms

You do not need a darkroom if you are only going to process films to make negatives or slides. But for making prints a darkroom of some kind is essential. Some fortunate photographers have sufficient space in their houses to fit up an unwanted room or cupboard as a permanent darkroom. More often though, some other room, such as the kitchen or bathroom, must serve the purpose without inconveniencing the rest of the household.

The bathroom is widely used as a temporary darkroom because it provides running water, but it can be a drawback for this particular room to be in continuous use by one person. The bathroom is often slightly damp and metal fittings in contact with the water pipes are a potential hazard in the event of any electrical appliance in use becoming live; for that reason, all electrical equipment used in the darkroom should be soundly earthed. The only safe method is to operate the enlarger from a shaver socket with an isolated circuit and a fuse of very low amperage. The safelight (see below) should be fitted to, or run from the light socket and this, and any other electrical items operated only via a pull-cord switch. On no account should electricity be brought into the bathroom by an extension lead from elsewhere in the house.

Running water is not essential for a darkroom. It is quite feasible to store in a bucket or plastic container a sufficient quantity to handle all the stages of developing films or making prints, except the final work, which can be done by taking the finished films or prints to another room. So in fact any convenient room in the house can function as a darkroom.

Whichever room you use, some form of effective blackout is necessary for the windows and doors. A convenient temporary blackout can be made by securing soft composition-board around the window frame with swing catches. The edges can then be lined at the point of contact with black velvet tape. Alternatively, heavy guage black polythene sheeting can be fastened to the window with masking or draughting tape, which can be easily removed without damaging the paintwork.

More permanent forms of blackout should incorporate some means of ventilation. You can prevent light entering the darkroom through a ventilator in the blackout sheet by placing a large black board a little way in front of the vent.

Light leaks around doors can be blocked by placing strips of black card across the gap in the frame and taping them to the side of the door.

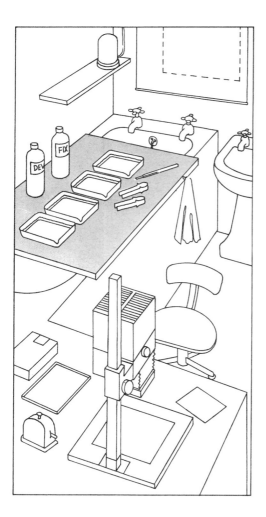

The bathroom as a darkroom. It is divided into wet and dry working areas and the equipment is set out in the order in which it is used. In the dry area is the enlarger, paper, timer, shading card and glass sheet for contact printing. The wet bench — a board laid across the bath — has processing dishes for developer, stop/rinse, fix and wash. Prints get a final wash under running water in the hand basin. Also on the wet bench are tongs, for handling prints, a thermometer and stock solutions. The safelight is on a shelf above the dishes.

Darkroom layout. Dry bench: enlarger with exposure timer, paper strip contact printing frame (35 mm). Wet bench: developing, stop/rinse and fixing baths with developing timer, stock solutions and tongs. Centre bench: final wash with running water flowing through dish into basin, also film developing tank, measuring flask and thermometer.

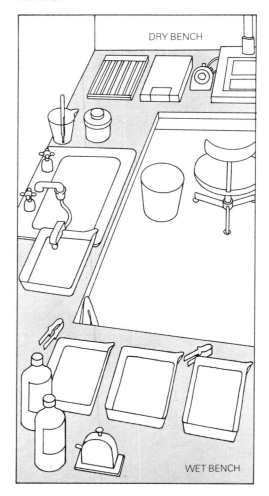

Layout for working

A darkroom, permanent or improvised, should be arranged with 'dry' and 'wet' working areas. The dry area contains all the items and equipment used before the prints are processed. The wet area is where the processing takes place. They should be reasonably far apart to minimise the risk of splashes reaching the dry working surface while you are handling wet materials. The enlarger, boxes of paper, negatives, printing timer, shading cards, contact frame and scissors should be positioned within easy reach of the dry bench.

Along the wet bench are the solution stocks, developing trays or dishes, process timer, print tongs and print washing bath or sink. You would normally set things out in the sequence in which they are used. But it does not really matter whether you work left to right or the other way around as long as the arrangement is in a logical order.

The enlarger

The enlarger provides the means of projecting, with light, an enlarged image of the processed negative (or, in certain cases, slide) on to a sheet of light-sensitive photographic paper.

In principle, the enlarger is a projector set upright and mounted on a column above a baseboard or flat working surface. An image is projected from the enlarger 'head' on to the board on which the photographic paper is positioned. The enlarger head may be raised or lowered on the column by a knob or crank control to adjust its distance from the baseboard and thus vary the size of the image as required. In a basic type of enlarger, the head consists of a lamp-house containing a special white diffused or 'opal' enlarger lamp and reflecting interior. Below this is a condenser system which concentrates the diffused light on to the negative which is positioned in a carrier immediately below. On some simple enlargers there is no condenser but only a diffusing sheet to ensure even illumination of the negative area. However this arrangement is rather wasteful of light. A condenser is much more efficient in collecting light and obtaining the maximum contrast from the projected image.

The lens of the enlarger is mounted below the negative carrier and is connected to it by

bellows or an adjustable tube. If the enlarger head is raised or lowered to give an image of a different size, that image must be refocused by adjustment of the lens distance. This is by a control similar to the one operating on the enlarger column to raise or lower the whole head. On an 'automatic' enlarger the two functions are combined and the projected image is always sharp whatever its size.

Features of an enlarger: **A** Control to raise or lower enlarger head for different degrees of enlargement. **B** Lens focus control. **C** Lamp focus adjustment (few models). **D** Lamp. **E** Filter drawer. **F** Condensers. **G** Lens. **H** Swing filter. **I** Negative carrier. **J** Film in carrier (inserted into carrier slot). **K** Enlarging easel or masking frame. **L** Baseboard.

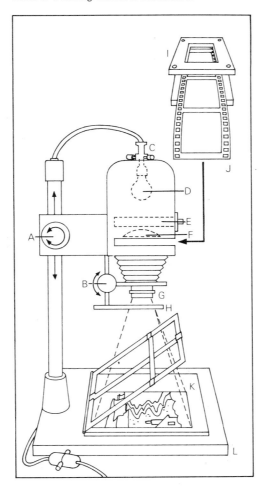

The ideal condenser system should be of a focal length to project into the lens an image from the lamp which is of maximum evenness. As the lens distance can vary, some enlargers allow the lamp distance to be adjusted to compensate, though the highly diffused lamps and reflective lamp-house interiors of modern enlargers make this refocusing less important than it once was.

Some enlargers are designed to accept negatives of one size only, usually 35 mm, but many are suitable for making enlargements from negatives of any size up to, say, 6 × 6 cm or 6 × 9 cm. If you are enlarging from a different size of negative you use an enlarger lens of different focal length – typically 50 mm for 35 mm and 80 mm for 6 × 6 cm negatives, i.e.: lenses similar in focal length to the standard camera lens for those formats. With an enlarger that may be used for two such differing formats, when you change lenses you also have to change condensers to give full and even illumination of the negatives in each case. On many enlargers this is a fairly straightforward procedure.

It has already been suggested that you buy the best enlarging lens that you can afford. This need not be the one with the widest working aperture. Other features worth noting for enlarging lenses are: apertures that can be clearly read in dim light, with click stop intervals that can be counted in the semi-darkness if need be; aperture control that can be reached with ease when the lens is in the mounted position; and a mount size that may be fitted to your enlarger. Some enlargers use interchangeable lens panels held by a simple catch, and these are easier to interchange than lenses that must be unscrewed. Some modern enlarging lenses are designed to give their best performance near maximum aperture to shorten exposure time. Cheaper lenses may need to be closed down to a medium aperture even to give near-equivalent performance, with attendant lengthening of the exposure.

Some enlargers have a filter tray or colour drawer immediately above the condenser. This accepts filters used in colour printing or for multi-contrast printing paper in which the contrast grade is changed by filtering the light source. An enlarger designed primarily for colour printing uses a diffused source and mixes the filtration by three separate controls to vary the percentage of each colour constituent, cyan, magenta and yellow.

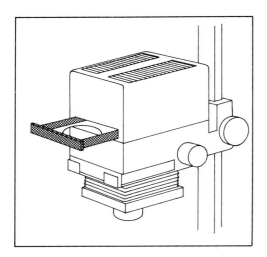

Filter drawer accepting colour filters for making colour prints, control filters for multi-contrast black and white paper, or opal diffuser.

The negative carrier is a device for holding the negative absolutely flat while being projected on to the baseboard. It consists of two plates, sometimes hinged, and is opened to insert the negative then closed and placed in the carrier slot. Once in, the negative is normally clamped tight but there is usually some

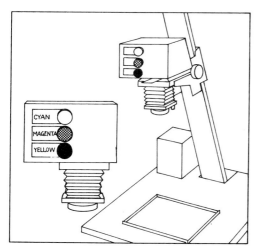

An enlarger fitted with a 'colour head' has separate controls to mix the three complementary colours used in making colour prints. This is a quicker and more convenient method than adjustment with separate filters, but a colour head is more expensive than a black and white enlarger with a colour drawer.

Enlarging easel or masking frame. The margins are adjustable along a scale of measurements. This device holds the paper flat and allows precise positioning for making the print. The sliding masks produce white borders on the prints.

means of releasing it so that it can be moved about while in the projection position. Many enlargers also have movable masks which can shade off the margins or unwanted parts of the negative and project only the image to be printed. Some carriers for 35 mm film hold the negative by its edges but others, and those for larger formats, generally hold the negative between two glass plates to ensure flatness. On the more elaborate type of enlarger the negative carrier can be tilted to correct perspective distortion in the image. Often, for very great degrees of magnification, the enlarger head may be swung around so that an image may be projected on to the floor.

The switch for the lamp is usually on a flexible lead to avoid touching the enlarger itself and possibly causing vibration during the exposure.

Enlarger accessories

The paper is held in an easel or masking frame on the enlarger baseboard. With this you can compose the picture by arranging the projected image on it, and then inserting the paper, knowing that it will be in the correct position. Some frames have adjustable masks to produce various sizes of border or to hold different sizes of paper flat during the exposure; others allow borderless prints.

A focus finder is a useful aid for focusing the image on the baseboard. It is not an essential item, but it is a great help. The most common type consists of a small mirror which reflects an image of the negative on to a small but highly magnified viewing screen at a distance equivalent to that of the baseboard itself. Having roughly focused the negative the finder is positioned under the light from the enlarger somewhere near the centre of the projected image. With a final adjustment of focus on the enlarger the grain of the image comes into view and the image is therefore sharp.

Two other useful aids are the enlarger timer and enlarging exposure meter. Sometimes these are combined into a single unit. The timer simply switches the enlarger light off after the requisite time for exposure has been given. You could, of course, do this yourself, but the timer is very accurate, counts automatically and, with long exposures or those involving corrective printing techniques, leaves you free to manipulate shaders or get on with other things. With an enlarging exposure meter it is possible, once correct exposure has been established, for one print to determine suitable exposure times for all subse-

Electronic exposure meter and print timer. A sensor positioned under the enlarger light reads the light from the negative to be printed. This is then set on the timer which switches off the enlarger lamp after the required exposure has been given.

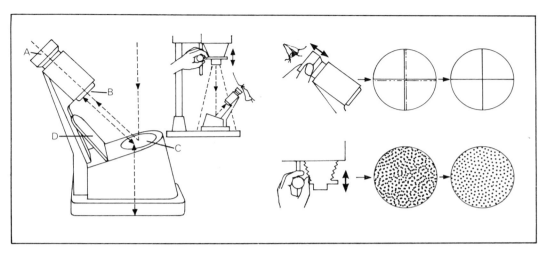

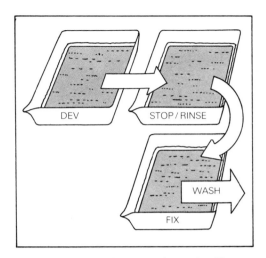

Focus finder used to focus the image with precision on the enlarger baseboard. **A** Eyepiece. **B** Light receptor with reference point. **C** Mirror. **D** Dust cover. Light from the enlarger lens is reflected up into the eyepiece. The finder must first be adjusted for individual eyesight by focusing the eyepiece on a reference point (cross). To ensure that the image on the baseboard is sharp, adjust the enlarger lens focus control until an image of the film's grain appears sharpest.

The three solutions for processing a print. The stop is optional but the first rinse is essential; plain water may be used. Fixing is followed by a final wash under running water.

The temperature of solutions. A dishwarmer (*top*) or heating unit to raise the temperature of solutions in dishes. A large dish (*centre*) filled with water at the correct temperature serves as a water-jacket for the smaller dish of solution.
An electric immersion heater (*bottom*) or bottle of hot water can rapidly raise the temperature of solutions.

quent prints, whatever their size or the lens aperture. You then set this exposure on a timer or, with a meter/timer, the instrument may give the correct exposure automatically.

Safelight

Photographic materials can be safely handled under certain lighting conditions using a coloured light source or 'safelight' recommended by manufacturers for their materials. Orange is the most common colour of safelight used when handling bromide printing paper for making black and white enlargements. A typical beehive-type safelight uses a standard or pygmy 15 watt clear lamp over which the orange cover fits. A safelight can stand on a shelf, on the work-bench or be hung from the wall or ceiling, but it should not be closer than four feet to the material. If, in a large room, you need more light, you should add another safelight – not increase the power of bulb fitted to the existing one. This could spoil the materials you are using and possibly damage the safelight itself with heat. Generally, however, the lamp provides enough light to see by at the recommended working distance. Another type of safelight is of box form and

accepts slide-in filters. This is often designed to be hung on the wall.

Other darkroom equipment

Other darkroom items are measuring flasks, a thermometer, a dish heater and of course the essential dishes themselves. A set of four is advisable for the three main stages, developing, stop-rinse and fixing, plus a final wash. Dishes can be identified by colour and may be purchased in coloured sets although this is not essential. It is important, however, to maintain the correct temperature of solutions contained in the dishes, in particular the developer. This may be done with a dishwarmer, a submersible heater or some kind of water-jacket such as a larger dish containing solution at the correct temperature within which the tray of solution is lying. You can also submerge a bottle of water at the correct temperature in the solution and periodically interchange it with others.

Prints may be handled with special tongs and although you may prefer to use your hands (with or without rubber gloves) note that photographic chemicals can irritate sensitive skin. If in doubt use tongs, one pair for each dish to avoid cross-contamination.

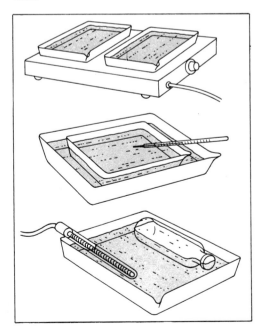

The invisible image

Pressing the shutter on your camera does not produce a photograph. It is merely the first step in a process that ends only when you reach a finished print or slide. When sufficient light reaches the film's light-sensitive emulsion it registers an image. But this image is invisible – or it would be if you were able to inspect the exposed film in the dark.

The image only becomes visible when it is processed; so before that stage it is only a potential or latent image. No one is completely certain just how a latent image comes to be formed at all, though there has been more than one theory. The only concern to the practical photographer, however, is the knowledge that the latent image does form and that the film must be exposed to the correct amount of light for that image to form correctly.

Latent image to negative

After the photograph has been taken the next step is development. The film is loaded into a container which allows it to be processed. The developing stage is almost as critical as the exposure if the best results are to be obtained from the film. But is is far easier to get it right; it is simply a matter of submerging it in the solution for the right time and at the right temperature, both factors which are easily measured. The result of processing the film is a visible negative image. As the film remains sensitive to light at that stage the image still cannot be examined with the eye, although there is no need for this anyway. The film is rinsed and, if a colour negative, put in a stop-bath solution which positively arrests all further development by neutralising those chemicals remaining from the first stage

The next step is to fix the developed image and, while doing so, dispose of all the unexposed and, consequently undeveloped areas of the picture to leave a clear film. In the case of colour films a bleaching process is needed before, or combined with, the fixing stage. The film can now be examined in the light. After a final rinse it is allowed to dry. The image appearing on the black and white film is a negative; all tones appear as an exact reverse of those seen in the original subject that was photographed. A colour negative looks like a rather similar, but dilute, version against a pale orange dye-mask background and with a set of curious-looking colours which are complementary to those in the original subject.

Negatives to print

The negative is ready for making prints. This can be done in two ways. Both require a light to be shone through the negative on to light-sensitive printing paper. You may make a print the same size as the negative itself i.e.: a very small print for reference purposes, just to get some idea of how the picture would look if it were enlarged. The negative is placed emulsion side down (shiny side up) in contact with a sheet of printing paper with its emulsion side facing upwards and a light is shone through the negative and on to the paper.

The paper is then developed, stop/rinsed and fixed (by a process rather similar to that used for the film, but taking a much shorter time), washed again and finally dried. This is known as a contact print.

If the picture is worth producing in a larger size it is put into an enlarger and its image projected on to the photographic paper which is then developed, stop/rinsed, fixed and washed again in the same way and then dried. This is an enlargement.

The whole printing process for contact

The negative positive process which forms the basis of most photography. **1** Film is exposed to light to form a latent, invisible image of the subject. **2** This image becomes visible on development. It is a negative; light areas of the subject are represented by dark, dark areas are undeveloped. **3** The negative is washed to remove chemicals. **4** The image is fixed and undeveloped areas become clear film. **5** The film is washed again to remove all trace of fixer. **6** The film is dried. **7** Printing: light passes through the clear areas of the negative on to light-sensitive printing paper. **8** The light cannot pass through the dark areas; a latent invisible image is formed on the paper. **9** The paper is developed and an image appears with light and dark areas the reverse of those on the negative. This positive image corresponds with light and dark areas of the original subject. **10** The print is washed. **11** It is fixed. **12** It is washed again to remove chemicals. **13** It is finally dried.

Negative image as seen on the film after development (*left*) and a positive print made from it (*right*) in which all the tones appear as in the original subject.

prints or enlargements can take place under a safelight so you can see what you are doing all the time. You can see the image on the paper emerge as you develop it although the actual quality of that image can only be judged reliably in ordinary lighting and when the print is completely dry. The process for colour printing from negative film is described on page 123.

Slides

The sequence of events for processing a colour slide film, after exposure, is different. Of course some colour slide films include in the purchase price the cost of processing by the manufacturer. Indeed, some films may not be processed at home anyway. It is also debatable whether a colour slide film is actually worth processing yourself as the commercial services available today are so efficient and often include in the cost the mounting of each

slide in a frame, ready for projection.

Briefly, the sequence for processing colour slides is: first, black and white development, during which each colour sensitive component or emulsion layer is converted to a black (silver) negative image only in those areas that were exposed to light. This is followed by a rinse. The film is then 'fogged' chemically to expose all the areas that were not previously exposed, nor developed at the first stage. These areas are then colour developed to give a complementary colour dye image in each layer except in those areas containing the black image (where the primary-colour-sensitive component responded to the colours of the original scene). A bleach bath then removes all blackened silver areas produced by the first developer and leaves an image consisting of dyed gelatin complementary-colour layers only. This is finally fixed, washed and dried. Viewed against a light source the various combined complementary colours add up to a representation of the scene in its original colours.

Prints from slides

Making colour prints from slides has become increasingly popular in recent years. It has several advantages, irrespective of whether or not you processed the original slide film yourself. You can view the original slide as well as prints made from it. The process is simple and reliable and the lasting qualities of the prints are as good or better than those of colour prints made from negatives. The disadvantages of the process are its greater cost and the fact that slides tend to be of high contrast, and so unsuited to making prints. You should therefore choose slides with a soft range of colours and few deep shadow areas. The colour quality of the prints can be as good as that made by the negative-and-print process.

An outline of the process is given on page 123 but full working details are supplied with the materials purchased. Many manufacturers can supply sampler kits consisting of small quantities of the requisite chemicals and sheets of printing paper, usually in small sizes.

Developing black and white films

Developing a black and white film is probably the easiest stage of the whole photographic process.

For correct development the film must be immersed in the solutions in such a way that they act evenly over the surface and are maintained at a suitable temperature for the processing time recommended by the manufacturer. With a developing tank processing is a straightforward job. No proper darkroom is needed; all you have to do is load the tank with the exposed film in the dark, say in a cupboard or at night with the curtains drawn, or even under the bedclothes. Or you can do the loading inside a special light-tight changing bag that has two holes through which you put your hands. This can be used in normal lighting, anywhere. Once the film is loaded into the tank the remainder of the process can take place in daylight. The tank consists of a plastic

Preparing 126 film for tank loading. Break the cartridge at the centre section. Remove the pieces of cartridge and unspool the film.

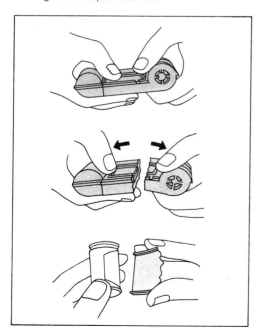

or metal drum with a tight-fitting top and containing a spiral on to which the film is threaded.

Different makes of spiral load in different ways. As you have to load it in the dark, practise first in daylight using an old piece of film. Only when you can do it reliably with your eyes closed should you attempt to load the actual film in darkness.

Plastic tanks are relatively inexpensive and, for a beginner, often the easiest to load. Metal tanks are more expensive and last longer but can be tricky to load until you are familiar with them. They then become quicker to load than the plastic type. They may also be force-dried in the oven (on a low temperature setting) to prepare them quickly for further use, which plastic tanks may not. Although metal tanks are unbreakable, with very rough use the spiral could become distorted and refuse to load.

Some people find it easier to load a tank by submerging the tank and film in a basin of water. Loading underwater is satisfactory provided you then go ahead and process the film before it dries. Dry loading can be done hours, or even days, before the film is actually processed – though it is advisable to tape the tank lid down with a written reminder of the film type and speed.

With a daylight loading tank you can load the spiral in ordinary light. After inserting the cassette and threading the film end on to the reel you close the tank. You then wind the film on to the reel and cut the end free using controls on the outside.

If you mix your developing solutions from powder form, be sure that all chemicals are fully dissolved before use. Never make up smaller quantities using only part of the contents of the pack because the various constituents are probably not evenly mixed. Follow the recommended dilutions and time and temperature combinations for the developer. Ensure that all solutions – developer, stop bath, fix and final wash are at approximately the same temperature as sudden changes can harm the film. Do not cut short the fixing time with ordinary fixers; if necessary you can buy rapid fixers that can do the job in a minute or so. You may toughen the emulsion permanently to resist physical damage by immersion in a hardener mixed with the fixer. This takes longer than the period required for rapid fixing.

Developers

Several different types of developer are available for use with normal black and white films which influence the performance of the film you use and the quality of the negative you produce with it. There are developers that suit certain films more than others, partly depending on the results you are seeking. A basic or general purpose developer is the MQ or PQ type which serves equally well for developing films or prints. The contrast of such negatives is usually soft to medium and the grain rather prominent. The processing times are quite short. This type of developer is not really the most suitable for small format negatives. 'Fine grain' developers yield low contrast negatives with minimised grain structure with films of any speed. Developing times are longer and effective film speed is reduced. The 'acutance' type developers give an effect of enhanced sharpness by a clear differentiation between the edges of images. This counters the loss by diffusion that characterises modern thin film emulsions. It is used with medium speed film. Speed-increasing 'high energy' developers are used where the effective sensitivity of a fast film must be boosted further. This is accompanied by a marked

Opening a cassette in darkness. Snip off the tongue. Lever off one end of the cassette. Pull out the spool and film.

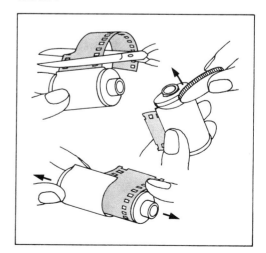

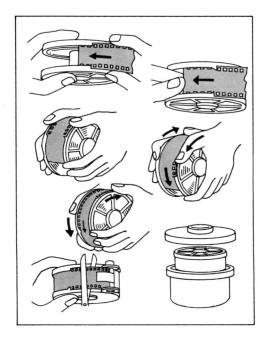

Twist-loading spiral. Insert the film end in the outer edge, pull it through and then feed it by alternately rotating the two halves of the spiral in different directions. Cut off the film end, insert the spiral in the tank and screw on the top.

Centre-loading spiral. **A** Curve the film by pinching the sides between the fingers and attach one end to the clip on the spiral centre. **B** Rotate the spiral to feed the film into the grooves. **C** A loading device can help by keeping the film curved.

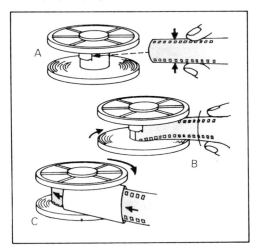

increase in grain. It is possible to double or treble the ASA speed.

The keeping qualities of developers vary widely and dilution usually shortens their storage life. Consequently, many are kept in concentrated form until used. A few deteriorate so rapidly that they are stored in two separate stock solutions that are mixed immediately prior to use. These include certain fine grain and special high contrast developers. Most fine grain developers, however, have a very long storage life and the re-usable type may even be replenished with a special solution to replace exhausted developing agents. Acutance, and high energy developers keep badly and should be discarded after use. Prolonged development, whether or not it increases effective film speed (according to developer types) increases the density and contrast of the negative image and the coarseness of its grain. Under-development, particularly when accompanied by over-exposure, results in negatives of low contrast and reduced overall density.

Under- or over-development can be used when you need to reduce or force contrast for particular subjects. To reduce negative contrast you would over-expose and under-develop; to increase it, you could under-expose and over-develop. You can only effectively compensate for negatives under-exposed in error by using a speed-increasing developer. Normally with such developers you up-rate the film to, say, twice or three times its usual ASA speed.

Developing black and white film. **1** Prepare the developer and fixer at the correct dilution and temperature. **2** Pour the developer into a loaded tank. **3** Agitate by inverting the tank repeatedly for ten seconds every minute. **4** Pour out the developer after the recommended time. **5** Rinse the film by filling and emptying the tank several times with clean water. **6** Pour out the water. **7** Pour in the fixer. **8** Agitate as before. **9** After the required time for fixing (and hardening if included) pour out the fixer. **10** Rinse under running water for ten minutes to remove chemicals. **11** Add a few drops of wetting agent to water to prevent water droplets forming to cause drying marks. **12** Pour out water. **13** Hang the film to dry in a warm, dust-free atmosphere.

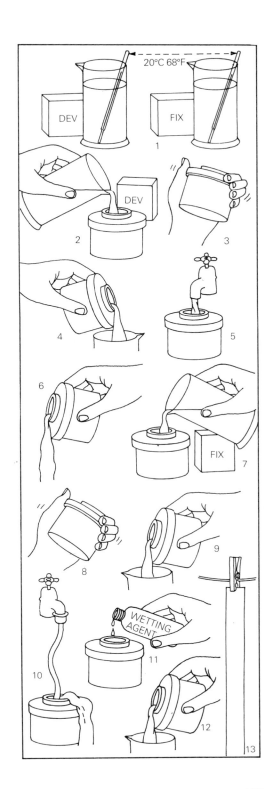

Printing black and white

Before making any prints be sure that the darkroom is dust free and that all working surfaces are clean. Set out all the equipment you will need within easy reach, make up the solutions and have them at the correct temperature (nominal standard room temperature is 20°C or 68°F) arranged in the order of the process: developer, stop/rinse, fixer, wash.

Contact printing

Reference prints can be made of every negative to help you find or assess quality before you select those worth enlarging (the principle of contact printing was outlined on page 116). There are several ways to make such prints but the easiest is to use the enlarger as a light source. First cut the film into lengths that will fit side by side to fill a standard sheet of enlarging paper in one direction or the other (the strips should also fit the negative sleeves you have selected for filing). Insert the empty negative carrier in the enlarger (without this in position most enlargers leak light), switch on the enlarger lamp and adjust the height to a position that covers the paper size chosen. Switch off the darkroom light and swing the enlarger's red safety filter into position. Position a sheet of enlarging paper in the red rectangle projected on to the baseboard and arrange the negative strips, emulsion side down (shiny side up), on this. Place a clean sheet of glass on top. Swing the red filter away and make an exposure. (Determining the right exposure is discussed below.) Now process the print. If your negatives vary greatly in density you may have to make more than one print with different exposure times. Or you can divide them into groups of more or less equivalent densities before attempting to make a contact print. You can buy a special contact printing frame which holds the negatives securely and is much more convenient to use than a loose arrangement under a glass sheet. But the glass sheet method is satisfactory for occasional use. If you do not have an enlarger you can use a desk or angle-lamp as a light source. You need a low-power lamp, e.g. 15 watt, to avoid exposures that are too brief to control accurately. Do not have the lamp so close to the paper that it is lit unevenly.

Making enlargements

Having selected the negative to be enlarged make sure that it is free from scratches or dust. If it is scratched look at any alternatives. If it is very dusty, pass a lens-cleaning brush lightly over the surface, and follow this with a puff from a blower brush or photographic compressed-air duster on both sides. Open

Exposing the print. To give greater exposure to a large part of the image use a shading card **A**. To withhold exposure from a small part use a selective shader **B**. To increase exposure in a small area use a card with hole **C**. Keep all shaders moving during the exposure to avoid making a hard line.

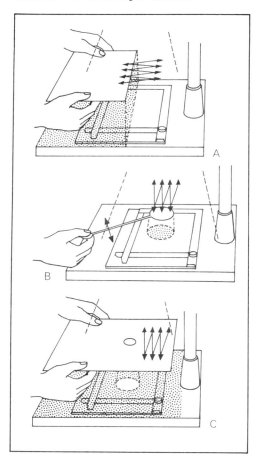

the negative carrier and clean the glasses (if any) with lens cleaning tissue and finish off with the blower brush. This should be done for every negative. Being careful at this stage can save you much, or any, retouching of the final print.

Insert the negative emulsion side down, close the carrier and place in the enlarger. Open the lens to full aperture. Switch on the enlarger lamp and align the edges of the negative with the edges of the projected rectangle by moving the negative with the carrier in the released position. Then clamp it. Move the enlarger masks (if any) to align with the edges of the picture and to exclude any light borders. Adjust the masks on the masking frame to fit the required paper size and place the frame on the baseboard. Next raise or lower the enlarger head and compose the projected image within the masking frame area using either the whole or a part of the picture. Focus the image approximately, then place the focus finder near the centre of the image area and adjust fine focus in the way previously described (page 114). Then close the lens diaphragm two or three stops and switch off the enlarger.

Making a test strip

You now have to make some tests to determine the correct exposure and contrast grade of paper to use with the negative you are printing. You should have at least grades 2 (normal) and 3 at your disposal. Once you have found the correct exposure this gives you some guidelines for future prints (and, if you have one, allows you to calibrate your enlarging exposure meter.

Start with grade 2. Insert a sheet in the masking frame, take a sheet of card and, holding it under the lens, switch on the enlarger light. Make a series of exposures in steps across the paper for say 5, 10, 15, 20 and 25 seconds. Switch off the light and put the paper in the developer. The paper should be 'slipped' under the solution to cover the whole sheet immediately. Do not use too much solution. Tip the dish up so that all the developer is at one end. Tuck the sheet under this then lower the dish to let the solution roll back across the whole sheet. Rock the dish gently for the recommended time. Remove the print, hold it up to drain for a moment and put it in the stop/rinse, then into the fixer for the time required and then to the wash. Switch on the

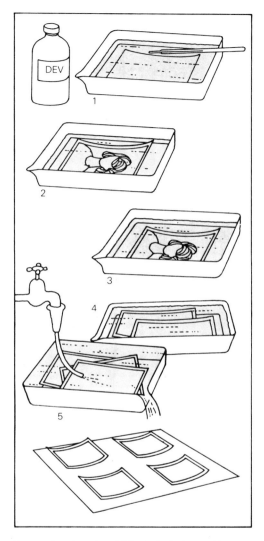

Processing the print. **1** Mix the solution and keep at correct temperature. **2** Develop the print for the recommended time and the image appears. **3** Stop/rinse. **4** Fix. **5** Wash in dish under running water. Lay prints face upwards on blotting paper to dry.

light and examine the print. Choose the best strip (or try the same series again at a different aperture setting if necessary).

A good print

Choose the strip on the test paper that gave you the best result and expose a whole sheet

of paper for this time. When printed, examine this under normal lighting.

A good print uses the whole range of paper tones available from black to white with a smooth graduation through the intermediate tones. Excessive highlight and shadow and lack of mid-tones ('soot and whitewash') indicates too high a contrast grade of paper, and a 'muddy' print that lacks clear highlights or deep shadow suggests that the contrast grade is too low. If the shadows are black but the highlights are heavy and lack sparkle, try giving slightly less exposure to the next print. If the highlights look washed out and the shadows are not quite black anywhere, then make another print giving more exposure. With difficult prints, or if you are trying to get the best from your negative, you may have to shade, or spot print some areas of the picture during exposure to give more or less light in those parts. The negative is capable of recording a far greater range of tones than printing paper and, consequently, most prints have to be a compromise, accommodating such tones as give the most pleasing effect overall.

If you use an enlarging exposure meter you calibrate it for the ASA speed of the printing paper and the exposure time, (once you have achieved a satisfactory print by the test strip method). The meter then recommends exposure times for all subsequent prints. Some meters take spot readings of particular areas of the image; others make general readings of the light reaching the printing paper.

Your processed print can now be dried. Resin coated (RC) paper dries naturally within an hour or so in a warm room, provided that surface water has first been wiped or squeegeed off. Fibre-based paper can be put in a print dryer which, with a glazing sheet, gives a high sheen to the surface of glossy paper. Glossy RC papers are self-glazing and no RC paper should be force dried with a heater. Both RC and fibre papers are available with various other types of surface finish.

Retouching

White specks on prints can be retouched or 'spotted' with water-soluble black paint on a fine-point brush, or on matt and semi-matt surfaces with a soft pencil. Black spots can be removed with a sharp pointed scalpel or craft tool.

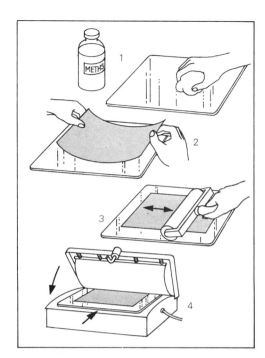

Glazing. **1** Clean the glazing plate with spirit. **2** Lay the wet print on it face downwards. **3** Squeegee to remove excess water and ensure close contact. **4** Insert in heated print dryer for rapid dry/glaze.

Retouching the print. Spot in white dust marks with watercolour on brush. Scrape out black spots or use pencil on matt or semi-matt surfaced papers.

Colour processing and printing

The emulsion of a colour film is made up of three layers, each sensitive to light of a different colour. The top layer responds to blue, the centre layer to green and the bottom to red. On development, these three layers produce, respectively, yellow, magenta and cyan dye images – complementary colours to the three primaries (of light). The colours in the subject photographed affect the layers to different degrees, according to the primary colour content of each.

In a colour slide film the portions of the three sensitive layers that responded to the colours of the original subject are first developed to form a negative black-silver image. The film is then chemically 'fogged' and processed in a colour developer. This establishes in each layer a positive dye image of the complementary colour in areas that were not affected by the colours of the original subject. Along with this comes a second black-silver image. The film is then bleached and fixed to remove the black-silver image from all areas and only the positive dye image remains.

The combined complementary colours subtract all colours from white light passing through the slide, leaving in each area only the colour that was present in the original subject. A blue sky for example, affects the top layer (blue-sensitive and yellow dye producing) in the first exposure, leaving the other two (magenta and cyan producing) layers to be colour developed after fogging. The final blue image is made visible by the subtraction of other colours from white light; magenta subtracts the green, cyan subtracts the red, leaving only blue.

How to process the film

The film is loaded in the developing tank in the same way as for black and white film. Processing is carried out with chemicals supplied in kit form for use at home.

The tank and quantities of each solution should stand in a basin of water at the temperature recommended by the manufacturer's working instructions. Set the timer for the recommended time and fill the tank with the first solution. Start the timer and agitate the solution in the tank by inversion for the time stated, then stand the tank in the basin. Repeat this periodically for the recommended time and finally pour the solution out. Repeat for all subsequent solutions. It is crucial to maintain exactly the right temperature for each solution, using an accurate thermometer and checking constantly. Colour negative processing with a typical kit has five main stages: colour development, bleaching, rinsing, fixing and stabilisation. Colour slide processing is more complicated because of the fogging procedure to reverse the image: first development (black negative image) rinsing, reversing (fog), colour development, conditioning, bleaching, fixing, rinsing and stabilisation. The final stages in each case are washing and drying the film. The wash should be continuous in flowing water at the correct temperature for the time suggested. The film should be hung up to dry after all surface water has been shaken or squeegeed off. Ensure that the squeegee has been thoroughly washed because grit trapped between it and the film can produce a deep scratch in the emulsion which is still soft at this stage.

Colour printing

The main difference between making a print from a colour negative and working in black and white is that the light must be filtered to balance the colours of each negative to produce a print with good colour rendering. An accurate assessment of exposure must be made, as with black and white, but the processing must be more accurately controlled for time and temperature. Test results obtained by different combinations of colour filters may be compared with a chart or 'ring around' which shows a nominally correct print and various degrees of wrong colour balance to enable you to make a quick correction of the error.

Alternatively, a colour analyser may be used to determine a suitable colour filtering combination for each negative, but this is not a cheap gadget. Colour balance is controlled either by the additive or subtractive method of filtration.

Making test strips to find the correct colour balance in additive colour printing. Each filter is positioned in the light path **A** in turn. A test, **B**, stepped upwards and across, is made for different exposure times, with two of the three filters **C**, using an opaque card shader **D**.

Additive primary colours of light, red, green and blue and their combined effects; e.g. blue and green light added together give cyan. Subtractive 'primaries' are magenta, cyan and yellow. White light through yellow and magenta filters removes (subtracts) blue and green light leaving only red.

THE ADDITIVE PRINCIPLE

THE SUBTRACTIVE PRINCIPLE

with) the enlarger lens. The print is given successive exposures through the red, green and blue filters so that the total equals the required exposure. Balance is controlled by giving more or less exposure time with any filter according to the correction needed in the print. If you need more yellow in the print you increase the blue exposure time and reduce that for the other two. It is a simple but time-consuming process which needs care in handling the separate exposures.

The subtractive principle

The subtractive method uses yellow, cyan and magenta filters of various strengths placed

Colour print processing drums. They ensure that the whole print is covered evenly by the developer.

together in a filter drawer under the enlarger light source, or on a colour enlarger set on dials calibrated for these strengths.

Prints can be made from colour slides and the usual method is to enlarge on to special colour printing paper for slides such as Cibachrome or Ektachrome. Working instructions are supplied with materials and suitable pro-

cessing kits are available. After exposure, the print is loaded into a processing drum in darkness. The processing may then be carried out by normal lighting. Rotation of the drum gives even development with a minimal volume of solution. The solutions are poured in and out of the drum through a light-trapped spout at one end. A rack with a crank at one end and rocker device ensures thorough agitation. Some drums are incorporated in a special dish water-jacket which also accepts bottles of solution so that the drum and the solutions are maintained at an equal temperature throughout the process; this can be monitored constantly with a thermometer. More sophisticated units have a motor to rotate the drum. It is also possible, though less convenient, to process colour prints in trays as in black and

Motor driven print processor. The tank, bottles of solution and measuring flasks are kept at a uniform temperature by being surrounded by water which is constantly checked with a thermometer.

white printing. After final washing the prints can be air dried in a rack.

The chemicals used in colour printing can be strongly corrosive and it is advisable to wear rubber gloves and to add to the solutions any neutralising chemical supplied with the kit immediately before you throw it away.

Using the print processing tank. When the paper has been inserted (*above*) and the top screwed on, the solution is poured in through the light-trapped spout. The tank is rolled back and forth (*centre*) on a flat surface to spread and agitate the solution. The solution is poured out (*bottom*).

The additive principle

The additive principle requires three primary colour filters under (or combined as a unit

Copying and duplicating

Although commercial services are available for making copies of drawings or paintings, and also for duplicating slides, you may find it more convenient to do the job yourself. For occasional use you can set up the camera on a pile of books and secure the illustration in an upright position, firmly supported by another pile. Less rigid subjects and those of large size should be taped to the wall or laid on the floor with the camera positioned overhead on a tripod. The spread of the tripod legs limits the maximum size but with an extension arm or the counterweighted arm of a lighting stand you may be able to position the camera well clear of the tripod, even though it is then less solidly supported.

. For frequent copying you can make a copy stand with a camera sliding on rails and an upright mounting board at one end. For most subjects, lighting would be provided by lamps at either side, but the board may have a replaceable centre section into which you can fit an opal sheet to diffuse light when a transparent copy subject is to be lit from behind.

Special copying stands are available for vertical work. With some, you can copy areas up to 20 inches in width. An accessory arm may be available to convert an enlarger into a copy stand. The head assembly is removed and the camera bracket is mounted in its place.

An improvised copying set-up with the camera on a pile of books and the subject fastened to another. The lens is level with the centre of the area to be copied. You can copy horizontally with the camera on a tripod or with the illustration on the floor and the camera on an extension arm above it.

Home-made copying bench. The bench consists of a camera-mounting sliding along grooves in parallel wooden rails. The copying board is mounted upright on the rails and at right angles to them. The work to be copied is supported by the board, but the centre section may be removed and replaced by an opal glass or plastic sheet to act as a diffuser for subjects to be lit from the rear. Two identical lamps on flexible arms are positioned at 45 degrees to the copy surface for normal work. Failing this, a single lamp may be used from a great distance. Where rear illumination is needed a lamp or flash can be positioned behind the opal sheet, far enough away to cover it evenly with light.

For close-up copying, vertical stands are made that attach to the bellows unit of SLR cameras. A slide copy attachment may be fitted on the end of this arrangement. With your own slide copier you make duplications of all, or selected parts of your slides, adjusting the composition or making a large slide from a small section.

Centring and lighting

The camera must be central and square-on to the subject or artwork being copied.

A macro stand can be attached to a bellows unit for convenient close-up copy work or for the photography of very small objects. For steadiness, a cable release is used (a double release for non-automatic bellows).

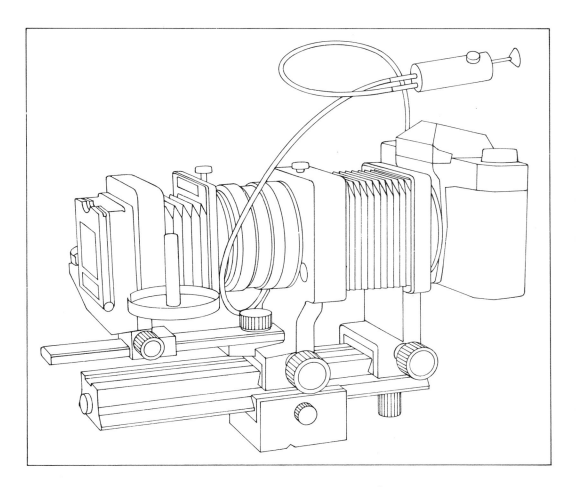

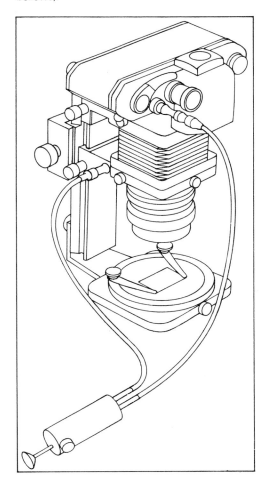

A bellows unit may accept a slide copying unit to allow copying of individually mounted slides or pictures on uncut strips of film. The slide is backed by an opal diffuser and the whole unit may be pointed at the sky or another light source to provide illumination.

Factory-made copiers will be square; with an SLR camera it is easy to adjust the centring through the finder. Non-reflex cameras are far less suitable as, with these, you must adjust either the subject or the camera, so that the lens and not the viewfinder is central, yet the whole area of the subject is covered. To check centring, mark lines bisecting the copy surface in each direction, open the empty camera and place tissue across the film plane. Centre the markings and lock the camera in position. Artwork centred on the board will then be centred in the camera too.

Lamps must be arranged to give completely even illumination over the whole area to be copied. Two diffused flood lamps or flash units should be positioned at 45 degrees, one at each side, equidistant to the surface and sufficiently distant for even illumination vertically. You can test for evenness by placing a pencil perpendicularly to the centre and adjusting the lamps until the shadows either side of it are of equal density. With a single lamp you can only get sufficiently even lighting if it is positioned at a very great range. The exposure times needed are then lengthy. The illustration must be quite flat and preferably without glass, as it can cause reflections. With glass use a pola screen. Any frontally positioned lamp would throw reflections straight into the camera lens. You can reduce reflections in the glass from the camera and surroundings with a large black card with a hole in the centre just large enough for the camera lens to look through.

Slide shows

There are two ways to look at slides, in a viewer or with a slide projector.

Viewer

A slide viewer is a small illuminating box that may be held in the hand. It provides an even and diffused light behind the slide which you view from the other side through a large magnifying lens. The light in the viewer runs from standard dry cell batteries and, as an alternative, it can often accept a house mains current supply through a suitable step-down transformer which may be bought for the price of a few rolls of film. The hand viewer is cheap, light and easily transportable and can be used quickly without any previous preparation. Against these advantages, however, the light source may occasionally flicker, there is little feeling or realism in viewing the small image and certainly no sense of occasion. Slides are inserted one by one, which is slower than using a magazine-loading projector, and only one person at a time can use it with any comfort.

Projector

It is much more exciting to view slides as images projected on a screen. The breathtaking realism of projected slides with their brilliant and accurate colours have a strong appeal for everyone.

To show slides in this way you need an efficient projector, a suitable screen and a room that is large enough to project the image across but that can be darkened if the slides are shown during the day. The whole family, or even a hall full of people can view and comment on the pictures just as if they are watching a film. With a slide show there is a sense of occasion.

Some slide projectors accept single slides. With a hand-operated two-slide changer you load and unload one while the other slide is being projected, so the slides are shown one after the other without a break.

Others use magazines which you pre-load with slides in the right order. You then just press a remote-control button to move from one slide to the next. A good projector will not

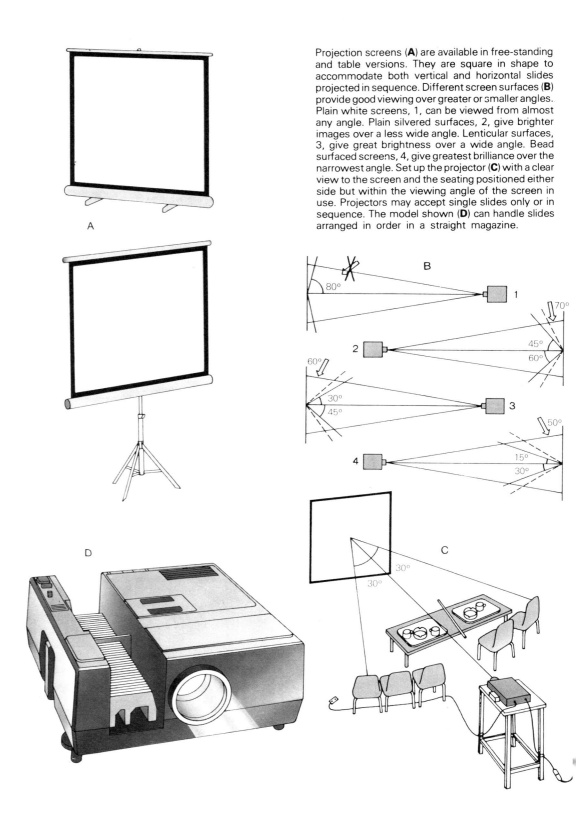

A

D

Projection screens (**A**) are available in free-standing and table versions. They are square in shape to accommodate both vertical and horizontal slides projected in sequence. Different screen surfaces (**B**) provide good viewing over greater or smaller angles. Plain white screens, 1, can be viewed from almost any angle. Plain silvered surfaces, 2, give brighter images over a less wide angle. Lenticular surfaces, 3, give great brightness over a wide angle. Bead surfaced screens, 4, give greatest brilliance over the narrowest angle. Set up the projector (**C**) with a clear view to the screen and the seating positioned either side but within the viewing angle of the screen in use. Projectors may accept single slides only or in sequence. The model shown (**D**) can handle slides arranged in order in a straight magazine.

B

C

jam while changing slides. The low-voltage lamp of a modern projector develops little heat to buckle or damage the slide while being shown, and the lens will give a reasonable sized image, say 3 ft × 4 ft in any room. A few projectors have a zoom lens available which permits continuous image-size adjustment from a fixed projector distance. Some have remote focus control or automatic focus control that sharpens up slides that 'pop' out of focus while being projected. Glass mounted slides are less prone to this than those in plain mounts.

Setting up

You may set the screen up in front of a wall and position the projector at a distance to throw a focused image of suitable size onto it. You can project on to a white wall or a large sheet of card; a sheet is not a good substitute unless it is free of creases and held completely flat. The projector height should be above the heads or between seated viewers and level with the centre of the screen to prevent distortion where the image is larger at the top than at the bottom. Most projectors have fine height and level adjustments, but if the projector tilts upwards the screen should tilt downwards towards it.

Screens are available with several types of surface. Bead screens give a brilliant white image over a narrow viewing angle. Plain white screens are less bright but can be viewed from almost any angle. Lenticular screens combine the two features (with a surface embossed with a reflecting pattern of grooves), and these last two types are suitable for large, widely spaced audiences.

Set the projector on a solid support; you can use books to obtain the right level. Keep the power cable away from any place where people might trip over it, or block the route with a chair.

Sort out your slides into the correct order before you give a show. Make sure they are free from dust, the right way round and not upside down. If you mark one corner of each slide with a spot containing a number you have an instant reference when preparing a show in a hurry or fumbling in the semi-dark to correct an error. Finally, *always have a spare projector bulb* and *do not give too long a show*. Better to leave people wanting more than having had too much.

Glossary

Aperture. The various openings or relative apertures calibrated as *f* numbers which are marked on the diaphragm control thus: *f*5.6, *f*8, *f*11, etc.

Aperture diaphragm. Variable opening within the lens which controls the amount of light that is allowed to pass through.

ASA speed. Like DIN, a calibration of effective sensitivity of a film processed under standard conditions. A rating is supplied for every film type sold.

Auto exposure metering. Camera exposure system in which exposure readings are obtained and set by the camera itself.

Bracketed exposure. Technique sometimes used where reliable readings are difficult to obtain. In addition to the basic indicated reading additional pictures are taken at other exposure settings (for example, one stop either side) to ensure a satisfactory result.

Carrier (enlarger). Support which holds the negative (or slide) flat to project an image for enlargements.

Colour temperature. A measurement of the relative 'warmth' or 'coldness' (whiteness) of a light source, i.e. its colour quality. Calibrated in Kelvins (K).

Contre-jour (against the light). Conditions in which the main light comes from behind the subject rather than from in front, often giving interesting edge-lit and outlining effects.

Depth of field. The zone in front of, and behind the focused distance within which any object appears acceptably sharp. This depth increases with distance, with smaller apertures and with lenses of shorter focal-length.

DIN speed. German standard rating for sensitivity, used in many countries.

Diopter lens. Supplementary close-up attachment lens that fits over the camera lens and allows it to focus at much shorter ranges than normal.

Fill light. Light used to reduce the density of shadows cast by the key light and to decrease the overall contrast of the picture.

Flash sync. Facility in a camera to ensure that the firing of the flash coincides with the opening of the shutter.

Focal length. Distance from a measured optical point in a lens to a position behind it at which it forms a sharp image when focused at infinity.

Focal plane shutter. Shutter consisting of fabric or metal blinds with a variable-width slit that moves across immediately in front of the film surface.

Focus finder. Optical device used on enlarger baseboard to magnify a small area of the projected image and so assist with fine focusing to a level that will record more effectively on the film.

Guide number. System of relating subject range, aperture and light output of a flash with film of a particular speed to aid exposure calculation with non-automatic flash units.

Hardener. Additive which toughens the gelatine surfaces of the processed film to protect it from physical damage.

Incident light readings. Method of exposure determination by taking an average reading of all light falling on to the subject, as viewed from the camera position.

Instant film. Any film system in which the final variable image appears within a minute or two of exposure due to the action of a process integral with the material.

Key light. The dominant light falling on a subject and normally producing the main modelling and texture effect.

Leaf shutter. Type of shutter consisting of several overlapping thin metal leaves, which open and close when the shutter is operated; normally positioned within the lens system of a camera, adjacent to the diaphragm.

Macro lens. Camera lens with exceptionally close focus capability whose optics are designed to give high quality images at short, rather than medium or long focus distances.

Microprism. An area of focusing screen covered with a pattern of minute prisms which fragment the view. When the lens is correctly focused on a subject the fragmentation disappears.

Opal Sheet. White translucent glass or plastic sheet used to diffuse light and thereby make it illuminate evenly.

Parallax error. Error in framing a picture due to the difference between the view seen through a finder compared with that actually covered by the camera lens, which is in a different position.

Pentaprism viewfinder. Viewfinder in which the focusing screen image is seen through an optical system that inverts and laterally reverses it for normal viewing.

Pola filter or screen. Screen positioned in front of the lens that allows light to pass only if it is polarised (normally) in one plane. It may be used to eliminate reflections in water and non-metallic surfaces and to darken some blue skies in colour photographs. It requires an increase in exposure to compensate for the loss of non-polarised light.

Power winder and motor drive. Electrically driven film transport as a separate or built-in unit. It allows rapid shooting sequences.

Pre-focus technique. Pre-setting the focused distance of a lens so that a subject that would not normally allow time for focusing appears sharp.

Rangefinder. Optical device by which the camera lens may be focused positively on the subject, e.g. by split and coincident images.

Reflected light reading. Method of exposure determination by taking a reading of the light reflected from the scene or subject.

Resolution or resolving power. The ability of a lens or a film to reproduce the fine details.

Self timer, or delayed action release. Device for delaying the firing of the shutter for a period of up to 8-15 secs. after pressing the release.

SLR (single lens reflex). Camera with a common lens for both viewing and taking the picture and consequently giving the same image in the viewfinder as that formed on the film.

Squeegee. Rubber blade or hard roller used to clear surface liquid from photographic materials.

Swing filter. Small red safety filter positioned below the enlarger lens that allows the projected image to be inspected without exposing the printing paper positioned under it.

Teleconverter. Afocal attachment which fits between the lens and the camera body, effectively increasing the focal length.

Through the lens (TTL) metering. Exposure meter that reads the level of light in the scene through the camera lens.

Transparency (slide). Positive image on film suitable for viewing by projection or in a hand viewer or for making prints by the reversal process.

Tungsten film. Film whose colour rendering is designed to appear natural when exposed by the light of photolamps.

Twin lens reflex. Camera whose separate viewing lens is mounted directly above the lens that takes the picture, and reflects an image on to a viewing screen. The screen image is usually of approximately the same size as that registered on the film.

UV Filter. Filter placed over the camera lens to reduce the effect of ultra violet radiation in the picture.

Zone focusing. Setting the lens focus at a particular position so that the depth of field is arranged to cover a particular range of distances; for example, to render both foreground and distant subjects sharp at the same time.

Zoom lens. Lens in which the focal length or magnifying power may be continuously varied over a particular range.

Index